NINETEENTH CENTURY INTERIORS

CHARLOTTE GERE

NINETEENTH CENTURY INTERIORS

An Album of Watercolors

Edited by
JOSEPH FOCARINO

with 100 illustrations, 70 in color

THAMES AND HUDSON

Contents

Preface

This volume *Nineteenth Century Interiors: an Album of Watercolors*, is presented for the general public as well as the collector and scholar; it includes a brief history of nineteenth-century interior decoration and the painted depiction of it. We have chosen a format similar to those of the chiefly royal and princely albums of interiors of the nineteenth century which still remain intact. They are usually bound in leather and have a medallion, coat of arms, coronet, or name in silver on the cover. Inside there are thirty or forty watercolors of interiors in the principal houses or palaces of one family and those of its relations. Collections of such watercolors still exist in the Royal Library at Windsor Castle, showing the numerous residences of Queen Victoria, and albums are owned by the Queen of the Netherlands, the Princess of Hesse, and the Prince of Bavaria; an example with views of the Hofburg painted by Johann Stephan Decker is now in the Metropolitan Museum of Art. Only one of these albums, the Wittelsbach Family Album owned by the Prince of Bavaria, has been published: a sumptuous book printed in a limited edition. A collection of exterior views (*Darmstädter Bauten vor 1850*) was issued five years ago by Moritz, Landgraf of Hesse.

Several notable collections of watercolors of nineteenth-century interiors have been assembled in recent years. For this volume, and an exhibition held at The Frick Collection in New York from May 21 to August 23, 1992, we have chosen two of these collections, a European and an American, formed in the last two decades.

One of these is an ideal illustration of the history of interiors in the nineteenth century, spanning the entire period and much of the European world, and exemplifying the history of taste in interiors and the watercolor depiction of them. The other collection presents a very rare example of an album showing a single princely family's taste and life. Here we can see how furnishings were moved from house to house, and how tastes in decoration changed over the years.

The painting of rooms for their own sake, rather than as a background for figures, was known throughout Europe during the last century, but it flourished above all in central Europe, particularly in Germany and Austria, where most of the artists were professional. Some very important painters, like Franz Alt and Eduard Gaertner, are represented here. There are also paintings by amateurs, almost always female and British.

Charlotte Gere has presented more information about the artists themselves than we have had in other studies of interiors published in the last thirty years. There is also a much more detailed investigation about the furnishings in the rooms and the way the furniture was used. Three years ago Mrs. Gere made a distinguished contribution to our knowledge of this subject in her large volume *Nineteenth-Century Decoration*. In her present study of two collections of watercolors, she has found out a great deal of new and fascinating information about artists and artistic traditions, and about interior decoration all through the century. We are deeply in her debt for her vivid recreation of rooms and the lives of the persons who lived in them.

Miss Bernice Davidson, Research Curator of The Frick Collection, has represented the Collection all through the preparation of this book and of the exhibition held in connection with its publication. Mrs. Gere has given thanks to many others in her acknowledgments which follow immediately. I wish to express the gratitude of The Frick Collection to those named below and, above all, our many thanks to her and to the owners of the two collections who have eagerly and most helpfully made the book and exhibition possible.

Charles Ryskamp
Director, The Frick Collection

Acknowledgments

My greatest debt of gratitude is owed to Charles Ryskamp for inviting me to undertake the fascinating task of cataloguing the drawings in this exhibition. Professor Mario Praz was the first to recognize the incalculable value of contemporary paintings and drawings to the history of interior decoration. I have made extensive use of his book, first published in 1964, and of subsequent studies of the subject by John Cornforth and Peter Thornton, both for the general history of the subject and to illuminate details. Many friends and colleagues have helped with particular problems: Frances Collard, Victoria and Albert Museum, London; Frances Dimond, Royal Library, Windsor Castle; James D. Draper, Metropolitan Museum of Art, New York; William Drummond, London; Sara Elliott, Hazlitt, Gooden & Fox, London; Ewa Heine, Polish Radio Service, Warsaw; Robert Isaacson, New York; Ed and Virginia Lafond, Mechanicsburg, Pennsylvania; Alistair Laing, The National Trust, London; Philippe Morel, Rome; Dr. Michael O'Hanlon, Museum of Mankind, London; Michael Snodin, Victoria and Albert Museum, London; Dr. Clive Wainwright, Victoria and Albert Museum, London; Dr. Jon Whiteley, Ashmolean Museum, Oxford; and Michael Whiteway, Haslam & Whiteway, London. Dr. Bernice Davidson of The Frick Collection has provided advice and moral support as well as arranging the many practical details of both exhibition and catalogue. The meticulous text editing is the work of Joseph Focarino, Editor at The Frick Collection. Other administrative tasks have been undertaken by Susan Galassi, Assistant Curator of the Collection. My husband has, as ever, stinted neither time nor trouble to advise, to improve on my text, and to eliminate mistakes; I am responsible for those that have inevitably survived his rigorous scrutiny.

Charlotte Gere

The Art of the Interior:
Interior Decoration in the Nineteenth Century

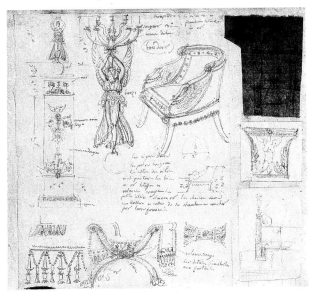

Fig. 1. Charles Percier. Detail from a Sketchbook of Drawings for Furniture and Objects, Showing Designs for a Candelabrum Produced by Pierre-Philippe Thomire. Metropolitan Museum of Art, New York, Elisha Whittelsey Collection, Elisha Whittlesey Fund, 1963 (63.535).

It is appropriate that the term "interior decoration" should have appeared for the first time in print in the first year of the nineteenth century. The initial installment of illustrations to the *Recueil de décorations intérieures* by Charles Percier (1764-1838) and Pierre-François-Léonard Fontaine (1762-1853) was issued in Paris in 1801 (see fig. 1), and the series was finally completed and published as a book in 1812. Meanwhile, in England Thomas Hope (1769-1831), influenced by his friend Percier, had published in 1807 an account of his remarkable London mansion which he entitled *Household Furniture and Interior Decoration*, intended as an English counterpart of the *Recueil* (see fig. 2). This was followed only a year later by *A Collection of Designs for Household Furniture and Interior Decoration* by George Smith, self-styled "Upholder Extraordinary to HRH the Prince of Wales." Within less than a decade the concept of an independent art of "interior decoration" was established.

That this interest in interior decoration had a direct bearing on the taste for interior views is evidenced by the fact that so many of them show rooms that must just have been decorated and newly arranged. It is apparent — the Viennese drawing room by Franz Alt dated 1872 (no. 32) is a particularly good example — that professional paintings of completed schemes were commissioned by the owners, or possibly by the decorators. Detailed scrutiny of these drawings has revealed several rooms decorated and furnished under the direction of Karl Friedrich Schinkel (1781-1841), the celebrated German architect. One of them, in Schloss Werki near Vilna (Vilnius in modern Lithuania), designed by Schinkel for Prince Wittgenstein in 1837, was depicted in 1840 not long after its completion (no. W19). It may be assumed that the Schinkel rooms occupied by the Wittgenstein family in Berlin are also shown soon after they were finished (nos. W6, W20).

The publications of Percier and Fontaine and of Hope were illustrated with outline engravings of rooms of their own devising. These have the severe unused appearance of designs rather than of views of actual living quarters, and in fact both publications belong in the tradition of engraved pattern-books established as early as the seventeenth century. The same chilly perfection pervades *Plans, coups, élévations des plus belles maisons et hôtels construits à Paris et dans les environs*, published in 1802 by the architect J.C. Krafft and the engraver N. Ransonette. Like the earlier pattern-books of Daniel Marot and Giovanni Battista Piranesi, these engravings of beautiful late eighteenth-century and Directoire rooms were an inspiration to architects and decorators. One of the plates in Krafft and Ransonette shows the exquisite and much-admired Neoclassical bedroom installed by Percier for Mme. Récamier in her house in the fashionable rue de la Chausée-d'Antin. The young architect Robert Smirke, who was later to lead the Greek Revival movement in England and become celebrated as the builder of the British Museum, visited Paris in 1802 and made a watercolor of the

13

room, which differs in several details from the plate in Krafft and Ransonette. Smirke was an accomplished watercolorist, as can be seen from the many drawings executed during his travels on the Continent between 1801 and 1805, of which this is one. His father was an obscure Academician and illustrator and his brother Nicholas a talented topographical artist. Cast shadows and aerial perspective provide the element of realism missing from the spare linear representations in the earliest nineteenth-century publications, and place Smirke firmly in the emerging genre of interior view-painting.

The Taste for Interior Views

The depiction of rooms for their own sake, rather than as background to a narrative, anecdotal, or portrait painting, germinated, reached its fullest flowering, and died within the space of one century. It was not unusual for such interiors to form a group, representing different aspects of several rooms. They were intended to be placed in albums rather than to be framed and hung, and remained an almost secret possession — though a visitor to the private apartments at Windsor remarked, "Of sketches of Balmoral, Rosenau, Osborne and the favourite apartments of the Queen at her different residences, there are many scores," suggesting that a number of Queen Victoria's treasured souvenirs were on view (from *The Private Life of the Queen*, published anonymously in 1897 and almost immediately with-

drawn). When interior views went out of fashion in the second half of the nineteenth century, their very existence seems to have been forgotten. They were rendered obsolete by the development of a photographic camera capable of focusing on a great depth of field and thus able to do the job of the interior view-painter much more quickly and no less efficiently.

Significantly, these interior photographs were also issued in handsomely bound albums, and — photographic firms being more businesslike than painters — there is usually a record of the person who commissioned the views, in many cases the decorator responsible for installing the scheme so meticulously recorded. Some of these albums survive, giving an invaluable picture of decorating taste in the period 1880-1910, before they too were forgotten, like the albums of paintings they had superseded. Mario Praz's rediscovery of this minor but fascinating art barely thirty years ago (his pioneering *Illustrated History of Interior Decoration* was published in 1964) was a revelation, and the historic no less than the aesthetic importance of the subject is now recognized by a group of informed collectors.

Interiors in the Eighteenth Century

The precise origins of the taste for interior view-painting in the late eighteenth century are difficult to discover. Praz (1964, pl. 118) singled out an anonymous painting of a room in the

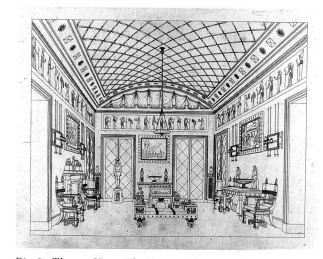

Fig. 2. Thomas Hope. The Egyptian Room in the Duchess Street Mansion. From "Household Furniture and Interior Decoration," 1807.

Prinz-Max-Palais in Dresden dated 1776 as possibly the first example of an unpeopled room painted for its own sake. Since then one or two others have come to light (cf. Cornforth, 1978, pl. II, for a seventeenth-century example, and Clemmensen, 1984, pls. 5, 6, for paintings of Danish rooms dating from the 1750s and 1760s), but they are very rare. Pencil and pen-and-ink records of furnished interiors are less rare, and seventeenth-century examples survive, but they were not executed with any artistic intentions and must have been, like maps, purely for information or reference.

A most interesting record of the arrangement of a suite of rooms in eighteenth-century Paris consists of the nine tiny but minutely detailed panels by the miniature-painter Louis-Nicolas van Blarenberghe (1716-94) set into the lid, base, and sides of a gold box dated 1771, and known as the Choiseul Box. They show rooms in the Duc de Choiseul's Paris house in the rue de Richelieu. In each the owner himself appears, either receiving visitors to whom he expounds his collection, or reading documents, or being helped into his coat by a valet. The back panel is a perspective view of the Grande Galerie at the Louvre.

Not only do these exquisite miniatures have all the fascination and intimate charm that we have come to associate with this genre, but they are of great interest for the history of collecting. The box has been the subject of an absorbing investigation by Sir Francis Watson, whose identification of the paintings hanging in Choiseul's bedroom and dressing room, the *cabinet*, the *premier cabinet*, and the *cabinet octogane* gives a fascinating glimpse of the taste of the period (cf. Kenneth Snowman, *Eighteenth Century Gold Boxes of Europe*, 1990, appendix I, pls. 438-42). There is much to be learned also from these beautifully preserved miniatures about the colors in vogue at that date — which seem startlingly vivid and strong to our eyes, conditioned as we are to the faded survivals in historic houses — and also about the way in which furniture was then arranged.

The walls of Choiseul's bedroom were a vivid blue, matching the bed-hangings, with *boiseries* of ivory and gold. The boldly patterned parquet floor, with its radiating circular motif, is repeated with variations in the pink, white, and gold *premier cabinet* and the smaller, rich green and gold *cabinet octogane*. The patterned floors are particularly conspicuous because the furniture is ranged with careful formality around the walls, the almost universal practice at that date. The study is painted in a subtle bluish-white, and the dressing room in creamy ivory heavily embellished with gilding. Of Choiseul's friend and contemporary Mme. de Pompadour, Nancy Mitford remarked (*Madame de Pompadour*, 1954, p. 148): "The walls of all her rooms were either bluish-white and gold, or painted in bright pastel colours by members of the Martin family. The horrible *'gris Trianon'*, a dreary, yellowish grey, which now spoils so many French houses, was

invented by Louis Philippe; nobody in the eighteenth century would have thought of using such a depressing colour to paint their rooms."

It is hard to accept that such a sophisticated group of interior views as those on the Choiseul Box should have emerged without precedent from an artist who otherwise favored events in the open air — balloon ascents and other such gatherings. The following passage suggests that the depiction of rooms was not unknown in eighteenth-century France. Writing in 1822 of Charles de Rohan-Chabot, Comte de Jarnac, who was a close friend of the Dauphin and was at the latter's deathbed in 1765, Laetitia Matilda Hawkins (quoted in F.H. Skrine, ed., *Gossip About Dr Johnson and Others*, 1926, p. 178) remarked: "It is worth mentioning that he was a very neat draughtsman, and could draw and colour the interior of any room with its furniture in due perspective. He drew for me an accurate picture of the Dauphin's death-chamber in a few minutes." The conversations with Jarnac took place in 1806, so his feat of visual memory implies a considerable degree of skill.

Of equal historical interest is the group of watercolors of the interiors at Strawberry Hill commissioned from John Carter in 1788 by Horace Walpole as illustrations to his *Description of Strawberry Hill*. Walpole's collections and architectural remodelling of Strawberry Hill were the most famous and influential manifestation of the Gothick antiquarian enthusiasm in eighteenth-century England. These watercolors have proved invaluable in reconstructing the original appearance of what is left of the house.

Illustrated Periodicals and Publications

Early engraved designs for furniture and room settings followed a diagrammatic formula of plan and elevation. But already in the eighteenth century an element of literal representation is apparent, the schemes being finished with delicate washes of color. By the first decade of the nineteenth century color plates had become a feature of periodicals such as Pierre de la Mésangère's *Meubles et objets de goût* (from 1802) and Rudolph Ackermann's *Repository of the Arts* (from 1808); these were to have a crucial influence on the development of interior views, particularly by amateurs, though such souvenir paintings show not the ideal but the reality. Pattern-books and design periodicals give a misleading picture of a rapid succession of fashionable enthusiasms; in the paintings of actual rooms there is a jumble of styles that reflects both choice and necessity. We are also repeatedly reminded of the importance of pictures, for which little provision is made in published schemes. The idiosyncratic hanging and the charmingly personal choice, often combining great historic masterpieces with family miniatures and memorabilia, are a delightful feature of the hidden private rooms of royalty to which we have access in so many nineteenth-century souvenir paintings.

Fig. 3. After Augustus Charles Pugin. The Cassiobury Park Library. Colored aquatint by Meyer and Lewis from John Britton's "The History and Description with Graphic Illustrations of Cassiobury Park," 1837. Yale Center for British Art, New Haven, Paul Mellon Collection.

Fig. 4. Augustus Charles Pugin. The Cassiobury Park Library. Private collection, New York.

In 1790, the topographical artist Thomas Malton depicted in watercolor the enormous and magnificently decorated library at Sledmere House in Yorkshire in all its formal eighteenth-century perfection, furnished simply with a library table and a chair. Malton was a practiced perspectivist, having labored for two years (1790-92) on aquatint views of houses, including a number of interiors — also very sparsely furnished — by the architect Sir Robert Taylor. The publication of important architectural achievements in colored aquatint illustrations continued in the first half of the nineteenth century with Pyne's superb *Royal Residences* (issued without text from 1815, completed 1819), Nash's *Views of the Royal Pavilion at Brighton* (1826), Buckler's *Eaton Hall* (also 1826), and Britton's *Cassiobury Park* (1837; see fig. 3). It is fascinating to compare Malton's Sledmere library with Augustus Charles Pugin's view of the Cassiobury library (fig. 4) and to note the radical change in the arrangement and use of this type of room. In his 1816 publication on architecture and landscape gardening Humphry Repton had advised (p. 9): "The most recent costume [sic] is, to use the library as the general living room; and that sort of state-room, formerly called the best parlour, and of late years the drawing-room, is now generally found a melancholy apartment, when entirely shut up, and only opened to give visitors a formal cold reception: but if such a room opens into the one adjoining, and the two are fitted up with the same carpet, curtains etc., they become in some degree one room; and the comfort of that which has books, or musical instruments, is extended in its space to that which has only sophas, chairs and card-tables..." The result of this admirable suggestion, as we can see at Cassiobury and at Dingestow Court (fig. 4, no. 25), was usually that the library became filled with the paraphernalia of both drawing room and boudoir, since in much-altered old houses it was not always possible to achieve the communicating rooms envisaged by Repton.

Rooms from the "Olden Times" and the Historical Revival

Parallel with the interest in architecture and decoration was the Romantic interest in the past, viewed, if we are to believe the evidence of Nash's *Mansions of England in the Olden Times* (1839-49; see no. 33), as a perpetual summer of revelry or plentifully provisioned Christmas-time. Nash explained (p. 3) that "not only the domestic architecture of past ages, but the costumes and habits of England in the olden time are brought before the eye; in attempting this the artist has endeavoured to place himself in the position of a visitor to these ancient edifices, whose fancy peoples the deserted halls, stripped of all moveable ornaments and looking damp and cheerless, with the family and household of the 'old English gentleman' surrounded by their everyday comforts, sharing the more rare and courteous hospitalities, or partaking of the boisterous merriment of Christmas gambols." Charles James Richardson, possibly taking his cue from Nash, produced

the first volume of his *Studies from Old English Mansions* in 1841 (see fig. 5, no. 18).

The popularity of these publications, which seem to have been peculiarly English but were highly influential on Continental interior decoration, can be traced to the centuries-old tradition of admitting visitors and tourists to celebrated mansions, of interest either architecturally or because they housed great collections. In her fascinating study of Chatsworth (*The House*, 1982, pp. 86-87), the Duchess of Devonshire quotes from an account of an excursion in 1849: "A party of 500 respectable, orderly and well-dressed individuals have this day... been conducted with the greatest possible attention and politeness, by order of His Grace the Duke of Devonshire, through the stately and magnificent apartments of Chatsworth, its conservatories, grottos, pleasure grounds, and gardens, to their unspeakable gratification, instruction and delight." From the diary of an Irishwoman in the Regency, Mrs. Frances Calvert (quoted in *Cassiobury Park: A Fair and Large House*, Watford Museum, 1985, p. 46), we have a glimpse of Cassiobury in 1816: "We went to Cassiobury House which is very pretty and more full of comforts, curiosities and pretty things than any house I saw."

In 1805, Cassiobury's owner, the Earl of Essex, began to keep a visitors' book (ibid., p. 29). On the first page he wrote these instructions: "The following orders are to be strictly observed by the Housekeeper when the House is shewn at Cas-siobury. To request all persons to put their names in this book. Not to shew the House to more than one set of company at a time. Not to suffer any person to touch the miniature pictures, china or other ornaments, nor to take down any of the books. Lord and Lady Essex's own apartments are not shewn. No person to shew the House except the Housekeeper. The House to be seen between the hours of two o'clock and four every day except sunday." The publication of Britton's views of Cassiobury must have swelled the ranks of the curious. They would have been received with perfect complacency by the housekeeper, who was probably gaining considerable financial benefit from conducting the grateful visitors round the house.

The second edition of Walpole's *Description of Strawberry Hill* (1784), with its engraved illustrations by Edwards, forms a link between the country house guides of the eighteenth century — mainly rather austere catalogues of the paintings — and the color-illustrated publications of the nineteenth. John Carter's watercolors of 1788 must have been intended for a more ambitious edition with hand-colored plates. Meanwhile, Walpole confected new editions by making manuscript alterations and additions to copies of the 1784 *Description* with Carter's watercolors inserted. That Walpole intended his 1784 publication to be an inspiration to decorators is apparent from his introduction (pp. i-iv): "It will look, I fear, a little like arrogance in a private Man to give a printed Description of his Villa and

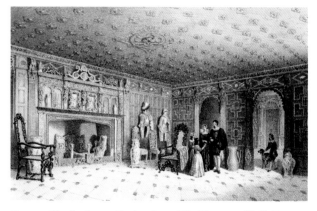

Fig. 5. Charles James Richardson. The Entrance Hall, East Sutton Place, Kent. From "Studies from Old English Mansions," 1841-48.

Collection, in which almost every thing is diminutive. It is not however intended for public sale, and originally was meant only to assist those who should visit the place. A farther view suceeded; that of exhibiting specimens of Gothic architecture, as collected from standards in cathedrals and chapel-tombs, and showing how they may be applied to chimney-pieces, ceilings, windows, ballustrades, loggias &c."

The idea of commissioning a series of watercolor views like Walpole's of Strawberry Hill seems to have occurred at much the same time to Maria Feodorovna, the wife of Grand Duke Paul, son and successor (in 1796) to Catherine the Great. By 1792, a decade after the laying of the foundation stone, her exquisite palace at Pavlovsk was far enough advanced to be the subject of an album of painted views of the rooms. Pietro Gongaza (1751-1831), the celebrated Italian scene-painter who had been summoned to Russia by Catherine's architect, Giacomo Quarenghi, to assist with the decorative painting at Pavlovsk and to provide scenery for theatrical spectacles, is recorded as having made the paintings for the Grand Duchess (cf. Suzanne Massie, *Pavlovsk, the Life of a Russian Palace*, 1990, p. 84). Like Walpole, the Grand Duchess also wrote a detailed description of the completed apartments in 1795 (cf. Chenevière, 1988, appendix II).

Louis Réau described Gonzaga as a "great perspectivist," thus placing him in the same tradition of architectural draughtsmanship as Thomas Mal-ton. The question of who supplied the original inspiration for the Pavlovsk album is difficult to answer. Maria Feodorovna was born Princess Sophia Dorothea of Würtemberg-Montbéliard, and her native Germany was to become the principal center of professional interior view-painting. However, the most important episode in her artistic education was the time spent with Louis XVI and Marie-Antoinette during a trip to France in 1782, where she and Grand Duke Paul travelled incognito as the Comte and Comtesse du Nord. Evidence suggests that by this date in France interiors had already been depicted for two decades. Gonzaga's own training in Italy, and his career in Milan before his arrival in Russia, would have given him an unrivalled grounding in architectural draughtsmanship. Italy was the cradle of perspective studies, and Gonzaga's sponsor, Quarenghi, was a consummate architectural artist. Any of these factors might have prompted the Grand Duchess' commission, but for the answer we are forced back, as so often in the history of taste, on the *Zeitgeist*. The moment for depicting interiors had arrived.

The idea of making these souvenir paintings evidently found favor with the Russian nobility. In 1793 the architect Andrei Voronikhin (1759-1814), who had also worked at Pavlovsk, made a detailed perspective view of Count Stroganov's picture gallery in his palace in St. Petersburg, the alteration and decoration of which was one of Voronikhin's early commissions. Throughout the nineteenth century a taste for accurate, detailed,

and highly finished interior views persisted in Russia, as evidenced by the high proportion of their Russian houses included in the Wittgenstein Family Album (nos. W1-5, W8-9, W12-16, W18). As well as the Russian view-painters, a number of professional artists from abroad, mainly Italians and Germans, settled in Russia to take advantage of the many imperial commissions (cf. Voronchina, 1983, passim).

Professionals and Amateurs in the Nineteenth Century

Gwen John, artist sister of Augustus, wrote in a letter to Rodin: "My room is so delicious after a whole day outside, it seems to me that I am not myself except in my room." The idea that the contents of a room and their arrangement might be the expression of an individual personality and thus artistically interesting must have been behind the impulse that produced many interior subjects. For whatever reason, from the early years of the nineteenth century they were popular all over Europe. Like the topographical and landscape souvenirs of travel popularized in the eighteenth century by patrons who had been on a Grand Tour, most interior views were executed in water-color (or the opaque water-based medium called gouache), and like those travel souvenirs they became a favorite subject with the amateur.

Amateur views have a personal quality that makes them interesting even when they are conspicuous-ly less well executed than their professional counterparts. Views of their own rooms by practicing artists share this attractive characteristic. The artists' rooms included here cover a wide territory, from Rome (no. 8) to London (nos. 28, 34), and provide fascinating insights into the working environment of the artist in the last century. Richard Parminter Cuff's room in Owen's Row (no. 28) gives no hint of his profession of architectural draughtsman, but a companion drawing in a private collection (fig. 6) fills out the story that has emerged from research in local archives. It seems that Cuff's brother, a book-seller and collector who shared his lodgings, must have conducted his business on the premises. A young woman is shown dealing with bills and correspondence at her folding writing desk on a table at the farther end of the intercommunicating rooms in this typical London terraced house built in the late eighteenth century. Books fill every available shelf — even the mantelpiece has been commandeered to support two rows of them — and we can now appreciate the significance of the formally arranged display of volumes on the center table in the other half of the room.

Professional artists who were attracted into this new field were drawn from many disciplines: not only architectural draughtsmanship, but also topographical, landscape, flower, and still-life painting, theatrical scene-painting, china-painting, and miniature-painting. Illustrated periodicals still relied on artists to hand-color the lithographic and aquatinted plates, and this provided

Fig. 6. Richard Parminter Cuff. A Room at 7 Owen's Row, Islington, 1855. William Drummond, London.

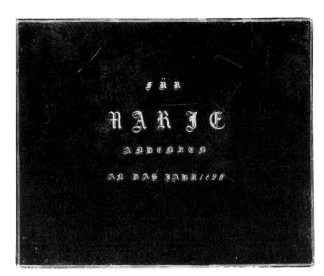

Fig. 7. Cover of an Album by Johann Stephan Decker with Interior Views of the Hofburg in Vienna, 1826. Metropolitan Museum of Art, New York, Elisha Whittlesey Collection, Elisha Whittlesey Fund, 1950 (50.542).

an unrivalled training in watercolor technique. The spirited and rapidly executed interiors of Petworth House and Farnley Hall by Joseph Mallord William Turner are exceptional for an artist of his genius; such highly specialized work usually demanded single-minded application and long hours of patient detailed labor.

The fashion for room portraits spread rapidly, and a number of artists made it their main specialization from the very outset of their careers. The names Auguste Garneray, Giuseppe Naudin, Friedrich Wilhelm Klose, Franz Xaver Nachtmann, Johann Stephan Decker, and François-Étienne Villeret, to mention a few of the most prolific, became known through Praz's book and were promoted by exhibitions and subsequent publications, such as Peter Thornton's *Authentic Decor* of 1984. The subject is now well established with collectors and valued as a source of information for the history of taste. Evidence that this fashionable enthusiasm was even shared by young men up at the university is provided by the group of interiors showing rooms at Christ Church in Oxford attributed to George Pyne, of which a number have recently come to light (cf. Susan Lasdun, *Victorians at Home*, pp. 55, 56, and Gere, 1989, pls. 347-49).

Princely Patrons

One of the most accomplished of the specialists, the admired architectural and topographical pain-

ter Eduard Gaertner (1801-77), represented here by four examples (nos. 20-21, W6-7), submitted his first interior views to the Berlin Academy when he was only twenty-one. These attracted the attention of the Prussian royal family, and he was commissioned to paint rooms in the various royal palaces, while the King also supported his further studies in Paris. Friedrich Wilhelm Klose was Gaertner's near contemporary. He followed much the same path, with valuable royal patronage from Friedrich Wilhelm III, for whom he made views of the Kronprinzenpalais in Berlin in 1830. He established a similar career with commissions from princely German families (cf. no. 23). These are just two of the German and Austrian professionals of whom there are more than any other nationality — probably because the number of royal patrons in the many German kingdoms and principalities sustained the demand for such views well into the second half of the nineteenth century, and stimulated it in other less exalted patrons.

Paintings of royal interiors often exist in several versions — for example, Gaertner's of the Berlin Royal Palace; for the replicated Chinese Room see no. 20 — and it is interesting to speculate how widely they were circulated: among the family, certainly, but was there also some limited public access to these views through exhibition and sale? An album of interiors of the Hofburg in Vienna painted in 1826 by Johann Stephan Decker and now in the Metropolitan Museum of Art, New York, belonged to "Marie," as the chased silver letters fixed to the leather binding affirm (fig. 7).

For a royal or noble owner there would have been a silver crown or coronet, so this presentation album must have been made for a commoner, possibly a member of the imperial household.

Among the earliest German princely patrons was Eugène de Beauharnais, Duke of Leuchtenberg and stepson of Napoleon Bonaparte, who married Augusta Amalia, daughter of the King of Bavaria. He commissioned views of his rooms in Milan, which he had occupied as Viceroy of Italy, and in the Leuchtenberg Palace in Munich before 1820 (no. 22; cf. Thornton, 1984, pls. 294, 297), no doubt recalling Auguste Garneray's watercolors of the rooms at Malmaison painted for his mother, the Empress Josephine, in 1812. It seems likely that Eugène was responsible for stimulating this enthusiasm in the Bavarian royal family. His daughter, Josephina, by marrying into the Swedish royal family, spread the taste northwards.

In 1820 the Queen of Bavaria, Caroline von Baden, involved a group of artists in her project for an album of interiors of the Bavarian royal palace in Munich and the summer residence at Nymphenburg, which she presented to King Max Joseph of Bavaria for his birthday. After the King's death in 1825 the album was partly broken up and rearranged, but more paintings were added by Ludwig I. This Wittelsbach Album survives, in its present form consisting of thirty watercolors dating from 1820 to 1850, recording interiors created between 1799 and 1848. Franz Xaver Nachtmann (1799-1846), a still-life painter employed at the

Nymphenburg porcelain factory, contributed several crisply detailed sheets to the album, notably the painting of Queen Therese's writing room, companion to the one of Ludwig's dressing room included here (fig. 8, no. 11).

The tradition of French royal and imperial patronage started in the early years of the century, with Garneray's abovementioned album of eight views of the interiors and conservatory at Malmaison, the exquisitely remodelled château outside Paris that was to serve as the Empress Josephine's retreat after she was divorced from Napoleon in 1809. Napoleon himself was an important influence in this field through his patronage of Percier and Fontaine and his support of the *Recueil*. He saw the remodelling and redecorating of the former royal residences as an affirmation of his status and of the continuity of his dynasty. During the process of remodelling, Malmaison was very fully recorded in the *Recueil*, which possibly provided the inspiration and the basis for the Garneray album. Napoleon's enthusiasm for this souvenir of his decorating activities may be compared with his passion for classifying, listing, and recording — the domestic equivalent on a tiny scale to the massive scholarship lavished on his Egyptian expedition in 1798, which produced the *Description de l'Égypte*. He inspired a similar enthusiasm in his stepson Eugène and in his second wife, Marie-Louise, who became Duchess of Parma after Napoleon's defeat and exile and in the 1830s commissioned from Giuseppe Naudin views of her apartments in Parma's Grand Ducal Palace.

Fig. 8. *Franz Xaver Nachtmann. The Study of Queen Therese in the Residenz, Munich, from the Wittelsbach Album. Wittelsbacher Ausgleichsfonds, Munich.*

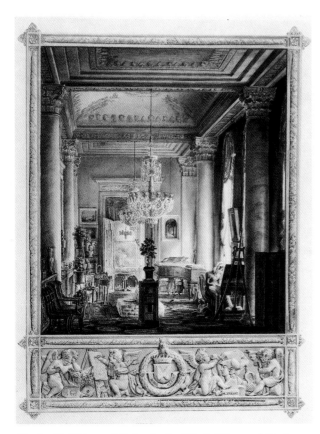

Fig. 9. H. Thierry. A Salon in the Hôtel d'Osmond, Paris. Photograph courtesy of Sotheby's, Monaco.

In 1810 Napoleon initiated the registration and conservation of the *Monuments Historiques* of France; and in 1818 legislation and government funds ensured the continuing protection of the nation's ancient monuments. Similarly, in Berlin in 1815 the architect Karl Friedrich Schinkel set out a memorandum for the Ministry of the Interior on the preservation of ancient monuments and antiquities, an initiative followed in 1818 when the Grand Duke of Hesse passed a law stating that all the ancient monuments in his duchy were to be inventoried. It is perhaps not too fanciful to see some complementary effect in these two interests, the recording and preservation of the monuments of the past and the depiction of the decorating achievements of the present for the benefit of future generations.

Malmaison was one of the most exquisite achievements of Napoleon's enthusiasm for decorating, regarded as Percier and Fontaine's masterpiece and largely reflecting the taste of the Empress Josephine. The château is small — inconveniently so, as was to become apparent when Napoleon's enchanced status necessitated a larger entourage — but the interior architecture has a nobility of scale and a richness that matched its imperial functions. As Maria Feodorovna agonized over every detail at Pavlovsk in the last two decades of the eighteenth century and as the Prince of Wales ordered and rejected scheme after scheme for Carlton House (see no. 1), so Josephine strove to achieve a perfect synthesis of room and contents. The illustrations by Percier and Fontaine and the watercolors by

Garneray show the extent to which a palace was achieved in a building that had started as little more than a modest *manoir*.

There are many reminders of Malmaison in the salon view painted by H. Thierry in the 1820s (no. 2), especially among the ornaments on the mantelshelf and the tea equipment on the table, but the furniture is in the plain and informal style of the Bourbon Restoration. Another drawing signed by this obscure artist is identified as being an interior in the Hôtel d'Osmond in the rue Basse du Rempart in Paris (fig. 9), and it is possible that the salon view also represents a room in that house, built by Brongniart in 1775. The Duc d'Osmond was the brother of Mme. de Boigne, author of celebrated *Mémoires* and friend of the Duchesse d'Angoulême and the Duchesse de Berry, daughters-in-law to Charles X. The Duc d'Osmond married a considerable heiress and would have been in a position to collect works of art — this is certainly the salon of an enthusiastic *amateur* — and to furnish in the latest mode.

In contrast to the imperial splendor of Malmaison, the royal family instituted a more intimate domestic style for the furnishing of the royal palaces. The Duchesse de Berry, who was supremely capable of evoking domestic intimacy even in a royal palace, was depicted by a member of the Garneray family in her private sitting room at the Tuileries (Thornton, 1984, pl. 296). She is shown reading, almost lounging, in the kind of wide "Napoleon" chair with arms of unequal height that was favored by

the Emperor and can be seen in the drawing of his study at the Tuileries made some fifteen years earlier by the miniaturist J.-B. Isabey. The small paintings that the Duchesse de Berry loved — she was a noted patron — cover the walls in densely-hung groups, books fill every convenient shelf, cut-glass decanters and glasses jostle a vase of flowers and a workbasket on the open, baize-lined card table, and the light wooden chairs with their seats covered in figured cut velvet are haphazardly disposed around the room.

Two more views of the Duchesse de Berry's rooms in her suite at the Tuileries show evidence of her interest in art and collecting (Praz, 1964, pls. 167, 168). Her boudoir — combining, as so frequently was the case in the 1820s, the functions of bedroom and workroom — is also densely hung with pictures. The furnishings of a much more palatial room, with plasterwork and painted decoration in the Classical Revival style, include a large, triple-door, glass-fronted cabinet crammed with porcelain. These fine rooms were more than mere showcases; the conveniently placed lamps and the positioning of furniture to take advantage of the light from the large windows indicates that they were well used. These rooms illustrate perfectly how the new informality in the arrangement of the furniture in all private apartments, as opposed to entrance halls and public reception rooms, tends to blur the class differences that would have been so apparent in earlier times. As the century progresses it becomes increasingly difficult with unidentified rooms to guess the status of the owner.

The Malmaison watercolors, begun in 1812, were uncompleted at the time of Auguste Garneray's death in 1824. An inscription on his view of the music room informs us that it was finished in 1831 by his sister. To suggest a lived-in appearance, one of the handsome chairs has been placed in the middle of the room, negligently draped with a shawl, but this cannot really obscure the formality of the scheme. By 1831 the room must have looked decidedly old-fashioned. The greatest difference between the Empire style and that of the Restoration was in the comfort and domestic usefulness of even the grandest reception rooms. The Duchesse de Berry needed so much more furniture because the rooms were now arranged for sitting instead of standing, a reflection of the change in the nature of social life and the demise of the formal reception, where either all would stand or the ladies would sit in a circle with the men standing to face them.

English Interiors

The reason that less is known of the English professionals in this field than of their French and German counterparts is because their names are obscured by those of the printmakers and the publishers of the handsome volumes to which they contributed. Joseph Nash's views of Tudor rooms for *The Mansions of England in the Olden Times* lose little in reproduction, but he found it worth his while to make later replicas in watercolor (see no. 33). The popularity of views of rooms in historic houses is attested by the number of artists of a

24

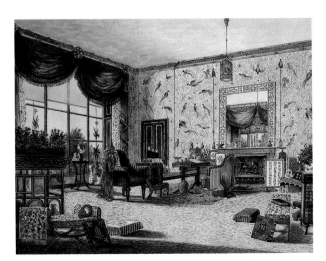

Fig. 10. "W.A.D." The Chinese Room at Middleton Park, Oxfordshire. Photograph courtesy of Christie's, London.

stature hardly less than Turner's who turned to this subject matter: Thomas Shotter Boys, David Cox, William Henry Hunt, and David Roberts, for example.

A pool of invaluable specialists existed in the many topographical and architectural artists who supplied the demands of the apparently inexhaustible English taste for landscape and the "picturesque." John Chessell Buckler (1793-1894), a noted topographer as well as architectural draughtsman, had been making interior studies as a sideline from early in his career. His watercolors of James Wyatt's new Tudor-style rooms for the antiquary Thomas Lister Parker at Browsholme in Lancashire were done as early as 1808, nearly twenty years before the publication of *Views of Eaton Hall* (1826), for which he made the watercolors (see Cornforth, 1978, pls. 35-37). The Eaton Hall views provide a record of the house as decorated in the Gothic taste before its complete remodelling by Alfred Waterhouse in the 1880s, in an ornately painted version of "reformed Gothic." It has since been demolished.

William Pyne (1769-1843) and John Britton (1771-1857) relied on the talents of a group of highly accomplished contributors like Richard Cattermole (1795-1858), James Stephanoff (1787-1874), Charles Wild (1781-1835), and Augustus Charles Pugin (1762-1832), French émigré father of the architect A.W.N. Pugin. Augustus Charles Pugin was responsible for the Royal Pavilion views, for many of the plates in Rudolph Ackermann's *Re-*

pository, and for the Cassiobury Park plates. His drawing for the library at Cassiobury (fig. 4) demonstrates the extraordinary skill of the engraver. On the basis of this roughest of sketches a minutely accurate and detailed illustration has been produced (fig. 3). It is interesting to see that some slight liberties have been taken with the facts; a fully fitted carpet has been substituted for the thin and crumpled rug that stops well short of the edge of the floor. Pugin's most exquisite drawings are those for *The Royal Pavilion at Brighton* in delicate pencil outline touched with color, inevitably coarsened in reproduction (cf. John Morley, *The Making of the Royal Pavilion Brighton*, 1984). Interesting evidence of the influence of such publications can be seen in the Pavilion-derived decoration of the Chinese Room at Middleton Park (fig. 10, no. 15).

The other three contributors, Cattermole, Stephanoff, and Wild, with further artists whose names are even less well known, supplied the beautiful watercolors for Pyne's sumptuous *Royal Residences.* George IV's elegant palace Carlton House was being demolished from 1826. The details of its decoration and furnishing over more than three decades are known from innumerable documents in the Royal Archives, but it is the twenty-four plates in *Royal Residences* that provide incomparable visual evidence of the taste of the royal connoisseur and collector. The large-scale watercolor of the circular dining room included here (no. 1) supplements the valuable insights provided by Pyne's publication.

Pyne's views are only a small part of the royal collection of interiors. Queen Victoria was an enthusiastic patron of the genre, commissioning souvenirs of her travels and her many residences. Watercolors in the royal albums of English, Scottish, and Continental rooms present a spectrum of Victorian decorating taste. Visits to France and Germany are commemorated by paintings of the Château d'Eu showing the Queen and Prince Albert with the family of Louis-Philippe in 1844, of Compiègne, where they were received by Napoleon III and the Empress Eugénie in 1855, and of Rosenau, Prince Albert's birthplace, visited in 1845 with other family residences that were also depicted. In Scotland, Balmoral was shown both before and after its complete transformation by the Queen and Prince Albert, and Holyrood is shown newly decorated by David Hay for a royal visit. Much-loved Osborne on the Isle of Wight was well recorded, as was Buckingham Palace, with watercolors showing schemes that are still largely unchanged.

The considerable number of English amateurs ensured a wide coverage of every class of dwelling. The houses of the gentry were particularly well represented (nos. 15, 25), as there were frequently artistically accomplished members of the extended families that congregated on their large country estates. Similarly, the daughters of the vicarage could often be relied on to record the interiors (fig. 11, no. 36). Romantic fascination with the simple life inspired the building of a number of rustic retreats and "cottages" — often the substantial and

well-equipped playthings of royalty and the rich — and these as well as the poverty-stricken dwellings of the rural poor often formed the subject matter of interior views. Curiosity about the living conditions of the poor seems not to have been regarded as offensive. Hippolyte Taine, during his travels in England in 1861 (*Notes sur l'Angleterre*, trans. Edward Hyams, 1977, p. 129), made an expedition into the country with a friend: "The tenant of one of these cottages was a day-labourer, married, father of six children, and earning twelve shillings a week.... My introductions to these people were performed with consideration and courtesy; they were asked to excuse us for troubling them, and to allow the visiting French gentleman to see the cottage. They at once consented, smiling kindly." Taine noted, with somewhat patronizing surprise: "his little house was clean: the blue-patterned plates were ranged in good order above a dresser. The iron fireplace was tidy. I had already seen cottages of this class elsewhere; almost always, at least in one room, there is an old carpet on the floor. There is often wallpaper, chairs of well-polished wood; small framed prints; always a bible and sometimes a few other books — works of piety, modern novels, how to rear rabbits, and so forth. In short, more articles of use than in our own poorest cottages."

Foreseeing the future trend in architecture and decoration, Charles Eastlake included an illustration of the interior of just such a poor country cottage in his influential *Hints on Household Taste* (1868). It was this genuinely rural architecture and

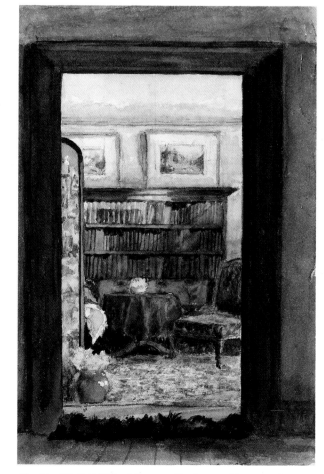

Fig. 11. "R.C.P." The Library at Brabourne Vicarage. Private collection, New York.

Fig. 12. Alexandre Prignot. A Scheme for a Moorish Smoking Room, 1873. Hazlitt, Gooden & Fox, London.

its interior arrangements and furnishings that were to form the basis of the vernacular style, rather than the toytown farmyards and picnicking pavilions of the aristocracy. Nowadays Monet's house at Giverny, with its brilliant yellow and soft blue rustic schemes, is considered to be a greater inspiration than the grand Neoclassical formality of Malmaison.

The English Amateurs

If the largest group of professional view-painters are German and Austrian, almost all the many amateurs are English. This fact was evidently appreciated at the time. Martha Bradford (née Wilmot), in Vienna in 1819 with her husband, the English Chaplain, was received by the Empress (*More Letters from Martha Wilmot: Impressions of Vienna, 1819-29*, ed. The Marchioness of Londonderry, 1935, p. 44), who enquired graciously "whether I was fond of drawing, as most of my countrywomen were. I replied that I was fond of it, but *malheureusement* I did not know how to draw." Mary Ellen Best, whose main subject matter was interiors painted in watercolor, is classified as an amateur though she considered herself to be a professional artist. She married Johann Anton Sarg, a German from Nuremberg, and spent more than twenty years of her career in Germany, continuing to paint assiduously in spite of a growing family.

In the course of his researches into the history of English decoration, John Cornforth began to look out for such largely forgotten amateur works. By 1978 he had collected enough for a substantial book — *English Interiors 1790-1848: The Quest for Comfort*; subsequently he went on to find many more, and by 1986 he was able to number more than 250 examples (not including those of the industrious Mary Ellen Best). No doubt country house libraries and local record offices will yield still more charming souvenirs of English nineteenth-century domestic life.

Cornforth discussed the complex reasons for this proliferation of mainly female amateur talent. Leisure and prosperity, improvements in domestic convenience (notably lighting and heating), the home-oriented habits of Victorian society, and the social mores that gave women greatly increased responsibilities and power in their own domain, all these contributed to the practice of this art and to appreciation of the results. But one of the most important factors was the willingness of the provincial professional watercolorist to act as a drawing master. Painting was regarded as a desirable accomplishment for young ladies, and a governess who could offer this branch of instruction could command a larger salary, though the more promising pupils were often taught by an established artist who needed to supplement his income. In *Pride and Prejudice* (Jane Austen, 1813) we are reminded of the importance to a young woman of instruction in the polite arts. Lady Catherine de Bourgh inquires of Elizabeth Bennet:

"Do you draw?"

"No not at all."

"What, none of you?"

"Not one."

"That is very strange. But I suppose you had no opportunity. Your mother should have taken you to town every spring for the benefit of masters."

We are offered a glimpse of how much a skill in drawing was assumed to be part of a cultivated education from the remarks of John Claudius Loudon (*An Encyclopaedia of Cottage, Farm, and Villa Archtecture and Furniture*, new ed. 1836, p. 799) on the furnishing of a modest library: "I do not think that drawings and drawing implements would be out of their place in a library. The ladies would generally draw; and every country gentleman ought to have some knowledge at least of architectural drawing, so as to be able to design the buildings to be erected upon his estate, which are now often built from the coarse plans of ignorant workmen."

For Queen Victoria's children the best tuition was available, and the talent of her eldest daughter, the Princess Royal, flourished under instruction from William Callow, whose influence is so plainly visible in a more-than-competent watercolor of her private sitting room at Potsdam in 1874 (cf. Gere, 1989, pl. 54). Her skills had greatly matured since her girlhood tutelage by the illustrator Edward Corbould, which had inspired a less painterly representation of her boudoir in Berlin, executed in 1858 (cf. Jane Roberts, *Royal Artists*, 1987, p. 126). Further evidence for both the nature of the tuition and the choice of subject matter is provided

by two unfinished watercolors of the drawing room and library at Bignor Park, Sussex, by Thomas Hardwicke the Elder, drawing master to Miss Hawkins, the owner's daughter (Cornforth, 1978, pls. 92, 93).

A rare instance of a male amateur choosing subject matter of this sort is provided in Dearman Birchall's representations of his newly decorated dining room and library at Bowden Hall in Gloucestershire (David Verey, *Diary of a Victorian Squire*, 1983, pls. 4, 5). Birchall (1828-97) was a cultivated Victorian country squire, friend and patron of Dante Gabriel Rossetti and Edward Burne-Jones; through diligent attendance at drawing classes in nearby Cheltenham he reached a high level of competence, as the views of his house and rooms bear witness.

Much of the work of one prolific amateur, Charlotte Bosanquet, is preserved in "The Bosanquetini or select views of several mansions, villas, lodges, and principal Residences of a distinguished family," consisting of two big albums in the Ashmolean Museum, Oxford. True to the promise of the teasingly grandiloquent title, the albums show how such a collection was built up in the 1840s and 1850s through visits within the large and ramified Victorian families. Nearly all the rooms in Charlotte Bosanquet's watercolors show a stylistic jumble that has not been subjected to the ministrations of a decorator, perfectly exemplifying Loudon's "Beau Ideal of an English Villa" that "every thing should be arranged, both here [in the library] and

Fig. 13. Anna Alma-Tadema. The Gold Room at Townshend House, London. Royal Academy of Arts, London.

28

in the drawing-room as if the persons using the rooms had been employed in some way or another" (Loudon, 1836, p. 799). Loudon recommends "all sorts of writing-cases and implements" or "unfinished writing and open books or portfolios" to contribute to this effect, and it is true that these and other negligently disposed trifles often feature in nineteenth-century paintings of rooms.

The amateur's grasp of perspective and idea of scale is often faulty or nonexistent. Minute figures move around vast apartments furnished with diminutive chairs and tables in front of enormous windows draped with voluminous folds of fringed fabric. Nonetheless, these usually well-grounded amateur artists were aware of the rules of perspective and endeavored to follow them. Lady Lyttelton (*The Correspondence of Sarah, Lady Lyttelton,* 1912, p. 179), staying in 1813 in a St. Petersburg apartment over three shops in the Nevsky Prospect, spent the day recording her surroundings:

"busy drawing the room. Head full, partly of vanishing points, horizontal lines, planes and angles; partly of journey to Moscow...."

The amateur artists rarely attempted state apartments in palaces; their works are evocative of the pleasures of domestic life, away from the formality of public and reception rooms. The artless arrangement of furniture to take advantage of light or heat, the well-equipped writing table, the abundance of flowers and plants, the idiosyncratically disposed pictures and ornaments all remind us of the arts of living — collecting, reading, music, pastimes such as painting and embroidery, botanizing, and parlor games — so assiduously cultivated in the nineteenth century. The figures that appear in some of these interior views play a subsidiary role to that of the room itself, but they serve to emphasize the fact that we are being offered a glimpse of a wide spectrum of householders from the past century.

1. *The Circular Dining Room at Carlton House, London, 1819*

CHARLES WILD (1781-1835)

Watercolor and gouache heightened with white, 18 x 15 in. (45.7 x 38.1 cm)

In 1783 Carlton House in Pall Mall was presented to the twenty-one-year-old Prince of Wales (later King George IV) as his London residence. The site of the house occupied the whole width of the present Waterloo Place and part of the ground covered by the Athenaeum Club on the west side and the (former) United Services Club on the east. On the garden behind were later built Carlton House Terrace and the Duke of York's Column and Steps. After barely forty years, during which it was altered out of all recognition, the house was abandoned and soon demolished. Nothing remains of the "perfect palace" except the columns from the screen between the front courtyard and the street, which were used for the portico of the National Gallery in Trafalgar Square.

The problem with Carlton House was that it was too small for the Prince of Wales and even more so for the reigning monarch that the Prince became when he succeeded his father in 1820. Henry Holland used the site as well as he could, but it offered little scope for expansion and was inconveniently close to the public street. James Wyatt's adaptations compounded the problems arising from the physical limitations of the space. The Prince had lavished huge sums of money on its decoration, altering and embellishing ceaselessly in his restless quest for perfection. Furnishings and fabrics were ordered and never used; marble chimneypieces torn out and replaced; chairs and tables no sooner installed than sent down to Brighton for the Pavilion; rooms changed their function as well as their colors and

arrangement. But as soon as George IV had moved into the larger, more secluded, and potentially more convenient Buckingham Palace he set about an elaborate (and unpopularly expensive) program of rebuilding and redecoration. Carlton House became redundant. Its maintenance would have been an unjustifiable extravagance, and the only solution to the problem was to pull it down and to recover some of the expense by letting the site on building leases. Its destruction was an incalculable loss to British architecture and decoration and to the urban landscape of London. The twenty-four minutely detailed plates in William Henry Pyne's *The History of Royal Residences* (1819) are thus a record of exceptional importance. But for them, and the survival in other palaces of the furniture and fittings, the only visible monument to the taste of George IV would be the Pavilion at Brighton. The history of Carlton House and its decoration is described in detail in the catalogue of the exhibition *Carlton House: The Past Glories of George IV's Palace*, held at The Queen's Gallery in Buckingham Palace in 1991 (see pp. 214-16, no. 93, for the Circular Dining Room).

This watercolor shows the circular room on the principal floor after its transformation into a dining room. It is on a much larger scale than the drawings made for Pyne's publication and the figures are more prominent, but it shows the room at the same point in its complex decorative history. Pyne describes not only the color scheme, which we can see, but also the materials used for the decorative details. The giant porphyry-colored scagliola columns with bronze capitals had survived from the first decade of alterations under Henry Holland, as had the ceiling painted to simulate a cloudy sky. Originally the Music Room, then in the 1790s the Second Drawing Room, in 1804 it was converted into a dining room. The completed scheme was predominantly orange,

pale blue, red, silver, black, and green. The reddish columns supported a stucco frieze of bronze-colored putti holding swags of foliage and a cornice of silvered anthemion decoration on a lavender ground. The light blue silk curtains and pelmets were ornamented with cut-glass stars. The chairs were upholstered with orange leather and the ottomans covered in blue silk deeply swagged and edged with silver fringe to match the curtains. Pyne described the enormous chandeliers in the Rose Satin Drawing Room as the finest in Europe; those in the Circular Dining Room are no less magnificent.

Charles Wild, a pupil of Thomas Malton and an accomplished architectural draughtsman, was responsible for drawing the interior views of Carlton House for Pyne's third volume, twenty-four of which are in the Royal Collection at Windsor Castle. The drawings were exhibited at the Society of Painters in Watercolours in 1817 and 1818, and were identified in the hand list as being for Pyne's publication. This view differs from the illustrations since it is on a much larger scale and is in a vertical format. Given access to the palace, it is possible that artists so privileged took the opportunity of making views of it for exhibition and sale. In 1819 Wild showed "Part of the Circular Room, Carlton House" at the Society of Painters in Watercolours' exhibition (no. 19). Thereafter he returned to painting churches and church interiors, his preferred subject matter.

Literature: Gere, 1989, frontispiece.

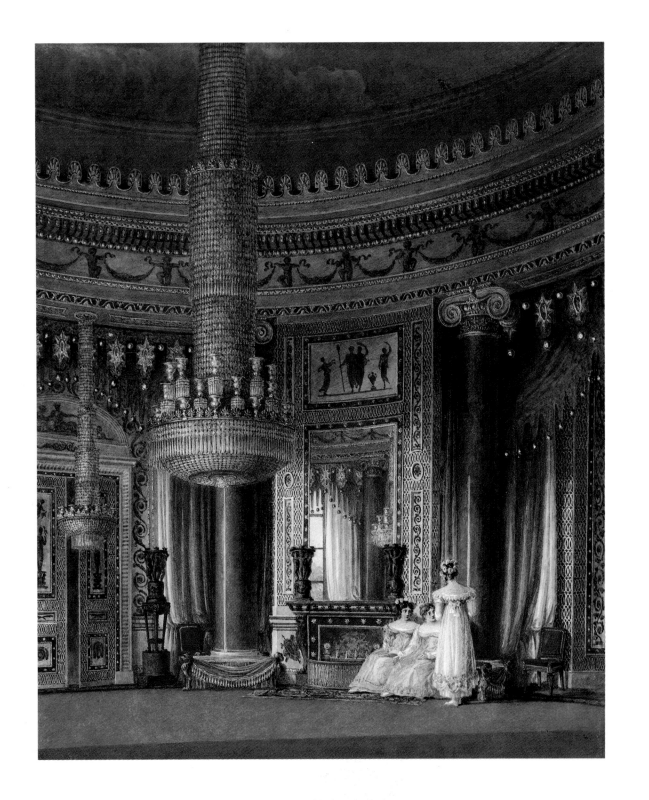

2. *A Salon in the Empire Taste*

H. THIERRY (fl. 1820s)

Watercolor and gouache, 10⅞ x 16⅞ in. (27.5 x 42.9 cm)
Signed lower right "h Thierry"

Parallels here with Percier and Fontaine's decorative schemes for Napoleon at Malmaison and Fontainebleau include the candelabra on the mantelpiece (see fig. 1), designed by Thomire in the form of a winged Victory in patinated bronze with ormolu candle-holders and bases. The two cut-glass bowls in the tea equipage surrounded by rings holding silver-gilt spoons and knives, respectively for sugar and butter, are like those made for the Empress Josephine; among the *maîtres-orfèvres* who enjoyed imperial favor, both Odiot and Biennais specialized in table services including glass liners in mounts of chased silver-gilt like these. The gilt and patinated bronze chandelier in the center of the room is similar to the one provided by Percier and Fontaine for Josephine's music room at Malmaison. Both the round tables and the console between the windows are in the Empire style, but the chairs are in a form that was not introduced until after the Bourbon Restoration in 1814. On a pedestal in the far right corner of the room is a reduced replica of the Apollo Belvedere; a pedestal in the near right corner seems to be awaiting a companion piece.

The blue-and-buff color scheme, which is continued in the adjoining room, sets off the bas-reliefs above the doorcase and the overmantel mirror. Conspicuous among the closely hung collection of pictures is a moonlit seascape by Claude-Joseph Vernet or one of his many imitators, flanked by similarly moonlit scenes beneath which can be seen a pair of interiors in heavy gold frames. Unusually, the blue silk swagged pelmets have been made deep enough to allow the windows to open inwards without impediment. The deep blue velvet upholstery of the chairs and of the sofa to the right of the fireplace matches the gold-bordered cloth on the central table and the fabric concealing the chain of the chandelier. The black sofa in front of the pianoforte may be covered with leather or horsehair. The floor is of polished parquet without coverings of any kind.

The artist who signed "h Thierry" has proved elusive. A sculptor named Hilaire Thiery is recorded, as is an architect, Hilaire Tierry, who spent the latter part of his career in Philadelphia. It is also possible that the artist was one of the brothers Thierry, architectural lithographers and illustrators who worked for Gottfried Englemann, the Parisian publisher of lithographs and color-plate books. The highly accomplished artist of this drawing could well have benefited from the incomparable training in the technique of watercolor acquired from the practice of hand-coloring lithographs and aquatints. An interior signed "H. Thierry" of a room in the Hôtel d'Osmond in Paris (fig. 9) was sold by Sotheby's in 1984 (Monaco, December 8, 1984, lot 133).

Literature: Gere, 1989, pl. 204.
Exhibited: Hartwick College, Oneonta, New York, 1987, no. 17.

3. *A French Restoration Bedroom, 1823*

BOUILHET (fl. 1820s)

Watercolor over graphite, 7 x 5⅞ in. (17.8 x 15.7 cm)
Signed and dated lower left "Bouilhet 1823"

The plainness of the decoration and furnishings seen here give a deceptively modest impression, almost of a cottage dwelling, but the proportions are those of a *manoir* or château and the furniture is in the very latest style. The lofty room, with its walls panelled in pale grey and its floor of white polished boards, looks down onto the grey roof of an arcaded building, possibly stables, on the far side of a courtyard. The black-and-white marble fireplace across one corner supports an ormolu clock under a glass dome, flanked by lidded glass urns and a pair of small ormolu candlesticks. The overmantel mirror reflects the hangings of the alcove opposite. On the walls are a few framed drawings — the largest a portrait of a man in knee breeches who seems to be playing a musical instrument like a hurdy-gurdy — and four circular miniatures in black frames. The table covered with a blue cloth may have been intended for a toilet set. The window is dressed with embroidered and fringed white muslin draped asymmetrically over a cornice pole; inner curtains, also white, are hung from a wire two-thirds of the way up. The bed alcove, lined with a grey-and-white trellis, is similarly draped, but the bed itself is hidden by a sofa.

The visible furniture consists of the sofa and a matching pair of chairs all upholstered in brilliant blue piped with white, a tall, six-drawer chest with a white marble top, a bedside cabinet with a black marble top (this type of cylindrical *table à chevet* was still something of a novelty, having been introduced into the bedroom furnishings only in the Empire period), and a needlework rug with a pattern of roses on a ground of the same blue as on the sofa and chairs. In 1823 all these must have been new, since they are the plain, unornamented, solid furnishings of the Restoration period, a contrast to the ornate, gilded, and ormolu-encrusted taste of the Empire. The ornaments, consisting of the ormolu clock and candlesticks, the glass urns, and a pair of biscuit porcelain busts under a glass cover on the chest of drawers, are discreet, but they too are in the latest fashion.

This interior is executed with a delicate precision suggestive of the technique of the miniaturist. The textures of wood, marble, and fabric and the play of light are rendered carefully but without the understanding of atmospheric effects natural to a landscape — or portrait — painter. "Bouilhet" may be identifiable with the miniaturist Bouillet, a signed work dated 1795 by whom is recorded by Bénézit.

4. A Room in a Florentine Palace, 1824

ITALIAN (?)

Watercolor and gouache with accents of gold paint over graphite, 7⅛ x 11 in. (18.0 x 28.5 cm)
Inscribed on the old mount "Cabinet de ma mère à Florence, 1824"

This drawing comes from an album put together, probably in the 1850s and 1860s, by a member of the ancient noble Polish family of Fredro, the best-known member of which was the dramatist Count Alexander Fredro (1793-1876). Born in Surochowo in Galicia, then part of Austria, he joined the Polish army aged sixteen and saw service in Napoleon's Russian campaign of 1812. In 1814 he was in France and became acquainted with modern French literature and drama. On his return to Poland he left the army and settled down to writing successful comedies and looking after his estates.

The Fredro Album concerns another branch of the family that lived mainly abroad, moving from one European city to another: Florence in 1824 as this drawing shows, Warsaw in 1828, Dresden from 1835 to 1837 (see no. 9), Weimar until 1840, and then for the next three years Nice. On the evidence of the album, the family consisted during these years of a mother (there is no reference to the father) and two children, a boy and a girl who, to judge from their apparent ages in a drawing dated 1828, would have been born respectively in about 1820 and 1824. Count Fredro's two children, also a son and a daughter, were not born until some years later, nor do the assumed ages of the children in the album fit the children of Count Fredro's brother.

The album, which seems to have been compiled by the daughter, contained a number of drawings by her brother C.M. Fredro, who developed a talent for caricature. A series of comic drawings records a visit that he made in 1848 with his friend Charles de Talleyrand to Rochecotte, the French château belonging to the Marquise de Castellane, great-niece of the Duc de Talleyrand-Périgord. The final section of the album consists of postcards and photographs of Cannes and Nice in 1864 and a record of the compiler's travels in Germany in 1865.

No regard has been paid to the eighteenth-century *grisaille* decoration of the Florence *salone*, which must in 1824 have seemed decidedly out-of-date. A contemporary portrait has been hung right in the middle of the architectural fantasy on the far wall, and a tall pier glass in a carved gold frame partly obscures the feigned statue of a nymph in a shell-topped niche. In 1852, having returned from Venice where she had been staying in an apartment in the Casa Wetzlar (now the Gritti Palace Hotel), Effie Ruskin recoiled from the "vulgar trimness" of their newly furnished London house. "In Italy," she wrote to her brother George (M. Lutyens, *Millais and the Ruskins*, 1967, p. 8), "we drove in nails and pasted things on the walls without minding where or how, here it seems horrible the mere idea of touching any place, everything is so dreadfully in order."

The furniture, clearly chosen for comfort rather than effect, ranges in date from the French Louis XVI ormolu-mounted table beneath the pier glass to the *bergère* armchair in the right foreground, which appears to be of the same date as the drawing. Standing to the right of a table on which rests a portable writing desk is a child in a white frock and long pantalettes, possibly the son, who in 1824, would have been about three years old.

The drawing is not signed, and the album does not supply any evidence to identify the artist.

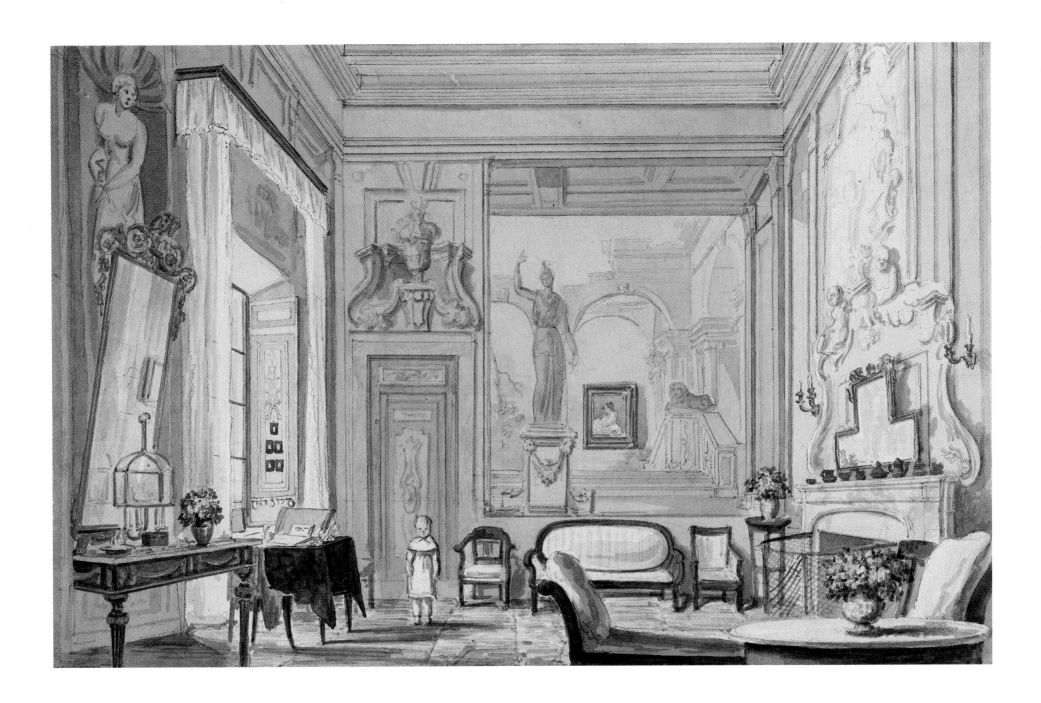

5. *A Salon in the Palazzo Satriano, Naples, 1829*

L. IELY (fl. 1820s)

Watercolor over graphite, 9½ x 14½ in. (24.1 x 36.8 cm)
Signed lower right "L. Iely," inscribed on the original mount
"Salon à Naples au Palais Satriano chez *Mdme* Candide,
1829"

The seventeenth-century Palazzo Satriano was the ancestral home of General Carlo Filangieri di Satriano, premier of the Two Sicilies; he was the son of Goethe's friend the "noble but impoverished" philosopher and writer Gaetano Filangieri. Situated on the fashionable promenade at Chiaia, overlooking the eighteenth-century pleasure gardens of the Villa Nazionale with the sea beyond, the palace was enlarged in the eighteenth century under the direction of Ferdinando Sanfelice (1675-1748). The Neoclassical interiors were the work of Gaetano Genovese (1795-1860), described as "*l'ultimo architetto neoclassico, operante nell'ambiente napoletano*" ("the finest Neoclassical architect working in Naples"; see Arnoldo Vendutti, *Architettura neoclassica a Napoli*, 1961, pp. 344, 347). Genovese had arrived in Naples from Eboli in 1822 and in the 1830s worked on decorative schemes for the royal palaces in Naples and at Caserta, notably the throne room in the Palazzo Reale (1837).

As was usual in Naples, the salon is furnished and decorated plainly, with the minimum of upholstery and hangings befitting to the climate. A marble — or marbleized — dado topped by a floral wallpaper border in the French taste runs round the walls, which are painted pale green up to a frieze of swags on a grey ground picked out in white. The striking border to the green-painted ceiling, done either in plaster or in *trompe-l'oeil*, simulates fabric. The next room in the long enfilade visible through the open door is papered in wide stripes of green and white to tone with the first room. A toilet table can be seen in the room at the end of the vista, probably a bedroom and the last in a suite of rooms comprising the living quarters of "*Mdme* Candide." The usual Continental habit of dressing the windows with muslin draperies has been followed here; the polished tile floor is bare of coverings. The chairs are of pale wood upholstered in blue stripes to match the built-in banquette on the end wall. Like the sewing table with its deep well of silk and its lyre-shaped supports, they are in the English style, popular in Naples through the influence of the British Ambassador Sir William Hamilton. The console with mirror above and the circular marble-topped table in the center of the room are in the French taste, and French-style candelabra in gilt and patinated bronze flank the large clock under a glass dome on the mantelshelf, a novelty in the form of a windmill whose sails were doubtless operated by the clockwork mechanism.

The nationality of the obviously professional artist who signed himself "L. Iely" is a matter of speculation. The name is not recorded in the standard reference books, and it does not sound Italian. It may be the transliteration of a Russian name, and other examples of the artist's work in this genre, if they were to come to light, would supply useful clues to his career. The drawing comes from an album assembled by Comte Paul de Gontaut and his wife, née Princesse Hélène Troubetskoy.

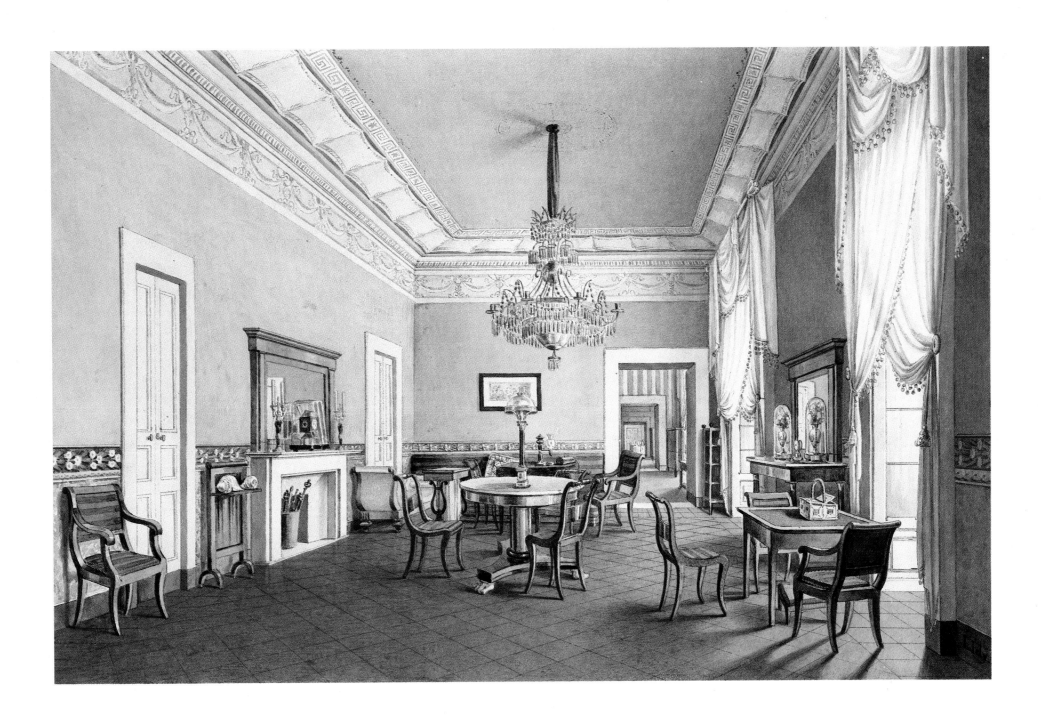

6. *A Drawing Room with a Large Organ*

ENGLISH (1830s)

Watercolor and gouache over graphite, 11⅜ x 17 in. (29.3 x 43.2 cm)

Though this watercolor is neither signed nor dated and bears no inscription, the room it shows is clearly one in a large English country house, and from the costume worn by the figure seated at the organ it can be dated in the 1830s. The incongruity of a Neoclassical barrel-vaulted ceiling with a Jacobean Revival window bay suggests that the exterior of the house underwent a transformation at a later date than the decoration of the interior. The architectural ornament is Adamesque, probably dating from the 1770s, but the ornate window draperies caught up in the claws of a bird with widespread wings are in the Regency style, and may be contemporary with the installation of the window. Henry Holland used this device of swags with a deep edging of fringe in a contrasting color caught in the beak or claws of a bird — usually an eagle — at Southill, the house he designed for Samuel Whitbread, and in the Rose Satin drawing room at Carlton House for the Prince of Wales. It also appears more than once in Ackermann's *Repository*, where it is credited to the upholsterer John Stafford of Bath, one of the most successful provincial decorators, with a reputation comparable to that of Gillow's of Lancaster.

The room evidently served as music room, library, and drawing room. The furniture, which covers a period of about fifty years — from the 1770s to the end of the Regency — reflects a practical rather than a decorative approach to the interior. The crystal-and-ormolu chandelier appears, unusually, to be hung with a counterweighted mechanism for lowering and raising it, presumably to provide the best possible light for reading and writing. On the left is the large Gothic Revival organ, and in the foreground is a Grecian-style library couch with a black-and-gold frame exaggeratedly coiled at one end. On the sofa table are a glass dome covering a number of brilliantly colored stuffed birds on a branch and a portable writing desk open with paper and inkwell ready for use. Before the handsome eighteenth-century marble chimneypiece with blue inserts stand two large Chinese porcelain jars and a rustic tripod — probably imported from China — supporting a great porcelain dish. Another jar and a dish stand on the French-style *bureau plat* or writing table in the center of the room. The chairs are also in the French taste, similar to those made for Southill by Georges Jacob about 1800 and, like those, upholstered on back, seat, and arms.

It is interesting to speculate on the musical life that centered on the splendid organ in this room. Though by no means commonplace, organs were found in a number of private houses, particularly where there was a family chapel. Old organs survive at Knole and Hatfield, and Handel himself played on the Legh family instrument at Adlington Hall in Cheshire. At the Bosanquet family seat, Dingestowe Court (see no. 25), there is a seventeeth-century instrument rebuilt in the eighteenth century, and the organ in the chapel at Ashridge House in Hertfordshire was made by Thomas Elliot in 1818. A drawing of about 1810 for the Great Room at Wynnstay shows an organ as part of the fixtures (see Frances Collard, *Regency Furniture*, 1985, p. 10). The Gothic Revival organ in the present drawing probably dates from the late eighteenth century, since the drawing itself is clearly earlier than the great surge of Gothic initiated by Pugin in the 1840s.

In this large and elegant room there is no attempt at a formal arrangement of the fine furniture and porcelain, and the eighteenth-century decoration has not been modified to suit the Gothic-style organ. It is tantalizing not to be able to identify the house, since however negligently arranged, the contents reveal not only sophisticated taste but also considerable expenditure. The execution of the watercolor betrays the inconsistencies of the amateur, but the feeling for light and atmosphere compensates for the coarse, inelegant, and obtrusive underdrawing.

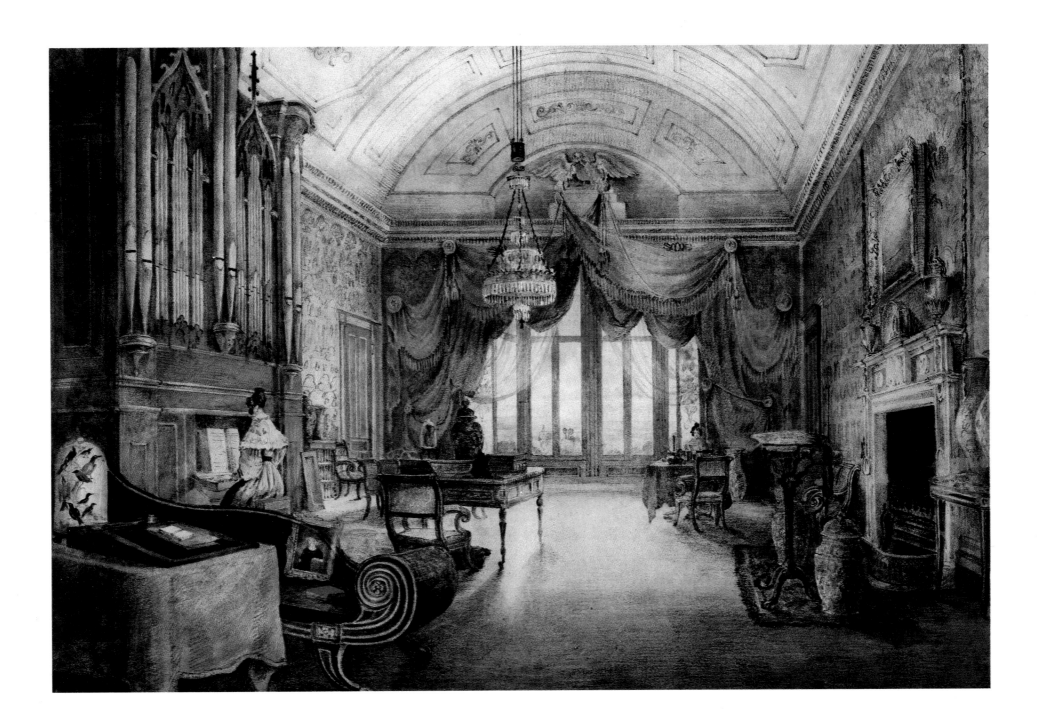

7. *A Prussian Officer's Quarters, c. 1830*

GERMAN

Pen and ink and watercolor over graphite, 5¾ x 11 in. (14.6 x 28.0 cm)

The green-and-red jacket hung over the chair back and the plumed helmet, red-and-white sword belt, three swords, and red-and-green peaked forage cap on the stand beside the chair show that this delicate watercolor represents the quarters of a Prussian cavalry officer in the early years of the nineteenth century. The outer room is furnished plainly but not uncomfortably for study and leisure. The occupant evidently had to deal with paperwork, since a red document case, partly hidden by the white glass shade of a lamp, is hanging on the wall above the chest of drawers, and the room is equipped with a writing table with a superstructure of shelves for books. Just visible in the inner room — which may have been where he slept — is a bookcase also filled with books. Above the desk hang many little portraits, one of which appears to be a silhouette. By the doorframe is a wall clock — possibly a cuckoo-clock — worked by counterweights and pendulum. Leisure is catered for by playing music on the zither that lies on the table and — taking this view as evidence — by painting in watercolor. The favored exercise is fencing; foils and masks are hung on the firescreen, which has been pushed behind the chair standing by the large black iron stove.

The simple but stylish decoration consists of trellis-pattern wallpaper panels edged with wide blue borders. Plain white curtains, held back by cloak pins, mask blue roller blinds that match the wallpaper borders. The cloth on the table in front of the sofa is embroidered to echo the bold grey-and-pink pattern of the upholstery. The openwork scrolled pedestal of the table shows

knowledge of the recently mastered techniques of laminating and steam-molding to create light curving forms.

At this period army officers were taught the use of watercolor as part of their training in mapmaking. Their technique in pen and ink and wash was often of professional standard, and for landscape it served them well. The problems of interior views were different. Though this view is carefully executed, the faulty grasp of perspective and of the effects of light betray the amateur.

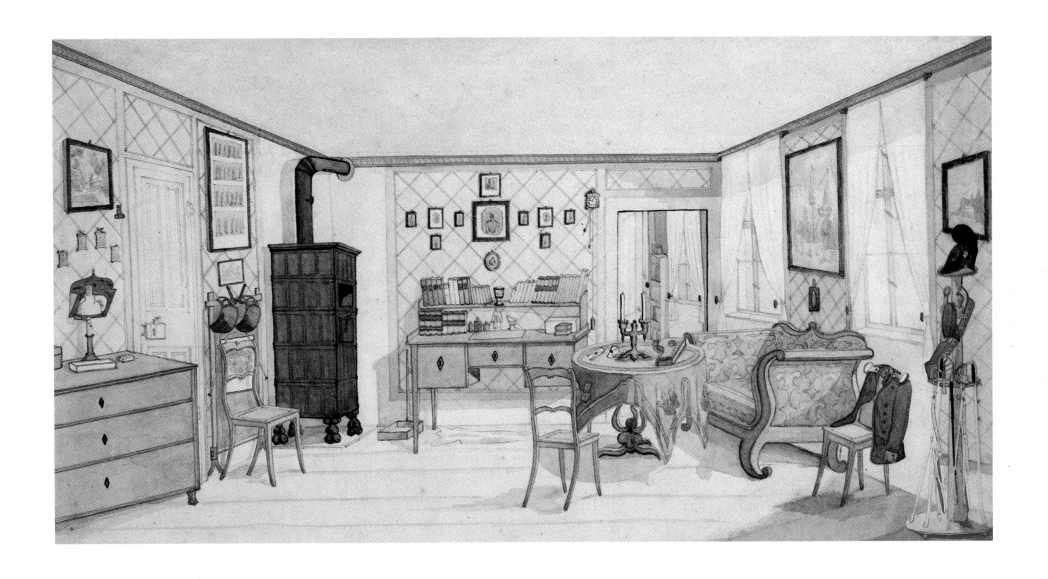

8. *A Studio in the Villa Medici, Rome, 1835*

Eugène Lacroix (fl. 1829–78)

Watercolor with scraping out for highlights, 9 x 12⅞ in.
(22.9 x 32.7 cm)
Signed, dated, and inscribed lower left "à M Constant. D. /
Eugène Lacroix / Rome 1835"

From 1803 onwards the Académie de France in Rome has been housed in the Villa Medici on Monte Pincio. The winners of the coveted Prix de Rome were given free board and lodging for the three or four years of their stay. In 1817 the newly arrived Léon Cogniet painted a picture of himself in his room reading a letter from home (Cleveland Museum of Art; repr. *From Revolution to Second Republic*, Hazlitt, Gooden & Fox, London, 1978, no. 24). Though the room is austere, furnished very simply with an iron bedstead, a mahogany commode, a plain wooden chair, and a writing table, Cogniet did at least enjoy the luxury of privacy; but the studio represented in the drawing by Lacroix was clearly used by more than one *pensionnaire* both for working and for sleeping. Wash-hand stands and looking glasses have been pushed in wherever a space can be found among the clutter of canvases, casts, portfolios, and work in progress, and the striped curtain on the right must conceal folding beds which would have been set up at night.

To judge from the painted frieze of landscapes and armorial cartouches, the room is on the *piano nobile*; if so, the only one that corresponds in the off-center placing of the window and the position of the two doors facing one another at that end of the room — in the drawing the door on the right is barely sketched in outline — is the Camera delle Imprese, a room immediately to the south of the large *salone* in the center of the entrance front of the villa. The decoration of this room dates from 1587 (see P. Morel, *La Villa Médicis*, I,

1989, p. 414, fig. 606; the dating and iconography of the painted decoration will be discussed in III, chap. VII, in preparation).

By the curtained alcove stands a portable easel on a pointed leg which could be driven into the ground for painting in the open air. Hanging on the wall above is a pair of pistols, an essential precaution against the risk of encountering brigands while on sketching expeditions in the Campagna. The snake and tortoise on the floor are presumably pets introduced into this upstairs room by the inhabitants. The long multicolored muffler hanging over the curtain suggests that the weather may still have been cold, but if so the light was already strong enough to necessitate the half-curtain in the window.

Eugène Lacroix was a landscape painter and lithographer. In 1835, the date of this drawing, he published three lithographs of Rome. He exhibited from 1841 onwards, and is last recorded in 1878 as the winner of a silver medal. The "M. Constant. D." to whom the drawing is dedicated may be Lacroix's near-contemporary Constant Dutillieux, a landscape painter and teacher who was also a lithographic publisher.

Exhibited: Hartwick College, Oneonta, New York, 1987, no. 19.

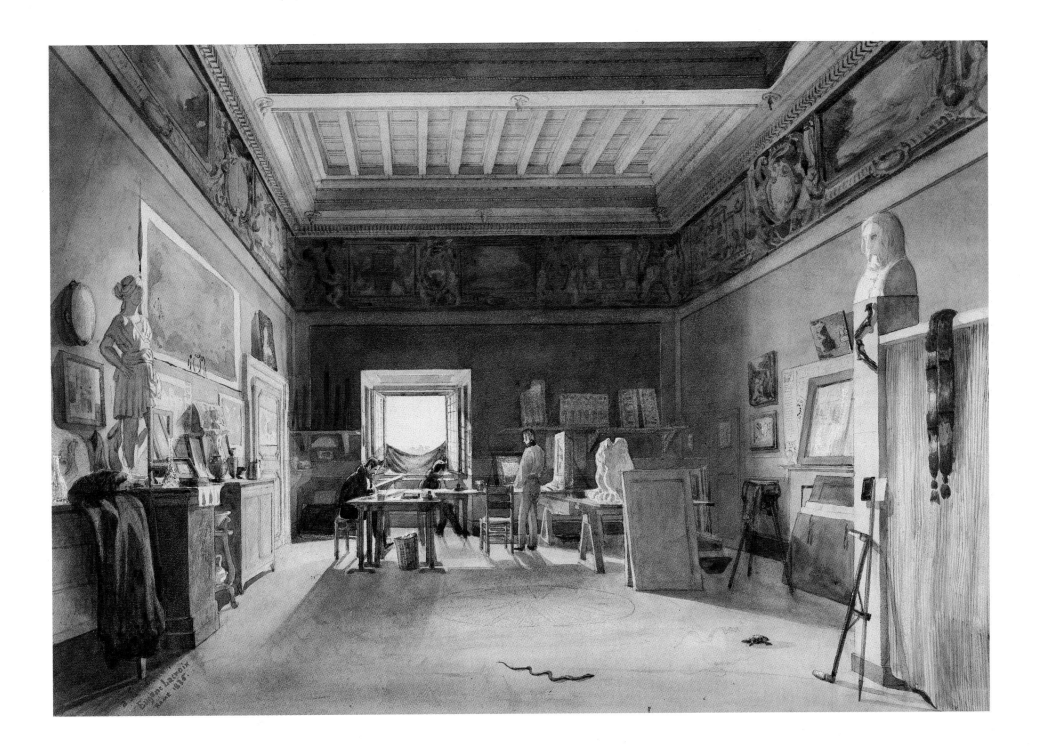

9. *A Room in the Reuss Palace, Dresden, 1835/37*

C.M. FREDRO (?) (fl. 1830s-1840s)

Watercolor and gouache over graphite, 13⅛ x 8⁹/₁₆ in. (33.2 x 21.7 cm)
Inscribed on the old mount "Cabinet de ma mère à Dresde. Palais Reuss. 1835-37"

This drawing, like the one dated 1824 of a room in a Florentine palace (no. 4), comes from the album put together by a member of the Polish Fredro family. More than a decade later we find the same branch of the family in Dresden, in one of the palaces belonging to the princely house of Reuss. The tall room is decorated with a blue-and-buff striped wallpaper and border. The windows are curtained in white with a matching fringe, and between them is a mahogany-framed pier glass reaching from floor to ceiling. The floor is of parquet in a diagonal pattern. Under French influence German woodworkers in the eighteenth century had become skilled in the art of parquetry, and it continued to be used for floors after carpets had become common elsewhere.

The decoration and furniture of the room are in the English late eighteenth-century taste, which was popular in Germany at this date. They resemble the schemes featured in Wilhelm Kimbel's influential *Journal für Möbelschreiner und Tapezierer*, published in Mainz and Frankfurt between 1835 and 1853. The unremarkable plain wooden chairs and tables, one covered with a plaid cloth, are in the simple style found even in royal residences in Berlin; a drawing of Princess Augusta's "muslin cabinet" in the Kronprinzenpalais, Unter den Linden, done in 1829 shows a pair of chairs of this same design, by Karl Friedrich Schinkel (see Thornton, 1984, pl. 323).

The two figures seated in the window at a table laden with books and writing and painting equipment, and watched intently by a dog, are probably the young C.M. Fredro and his mother. The screen behind them provides shelter from the draught and serves to display a number of unframed drawings. Other small framed works are hung in the window embrasure. It is possible that the present drawing is by C.M. Fredro himself, who in 1836 would have been about sixteen years old.

The turbulent history of Poland in the nineteenth century condemned many families to a life in exile, but it was also quite usual for aristocratic families to spend most of their time pursuing the cultural and social amusements of city life, leaving their estates to be run by overseers. In spite of the peripatetic life led by the family they evidently kept their place in the highest circles, as evidenced by C.M. Fredro's friendship with Charles de Talleyrand. In 1824 in Florence the family occupied a handsome painted *salone*, and even this more modest room is in a princely palace.

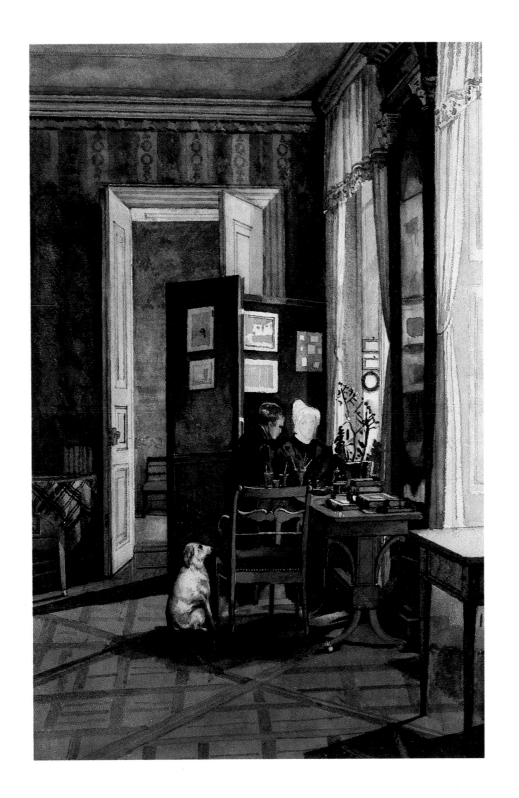

10. *The Study of Czarina Alexandra Feodorovna,
1835*

SOTIRA (fl. 1830s)

Watercolor and gouache heightened with white over pen
and ink, 10¾ x 16 in. (27.5 x 40.5 cm)
Signed and dated [date effaced] lower right "Sotira / 1835"

Frederica Louisa Charlotte Wilhelmine, daughter
of King Friedrich Wilhelm III of Prussia, was
born in 1798. In 1817 she married Nicholas
Pavlovitch, son of Czar Paul I, and to conform
with imperial custom converted to the Orthodox
faith and took the Russian names of Alexandra
Feodorovna. Nicholas succeeded his brother,
Czar Alexander I, in 1825. He died in 1855 and
was succeeded by his son Alexander; Alexandra
Feodorovna died in 1860.

Though betraying a great debt to French taste,
most of the furniture in this noble room, with its
coffered barrel vault and fine collection of paint-
ings, is Russian from the 1820s and 1830s. The
magnificent ormolu chandelier and the exquisite
flowered carpet represent the finest Russian
workmanship. The large suite of banquettes and
armchairs of pale wood — possibly the popular
native birch — with figured blue upholstery is in
the elegant style introduced in the 1820s. The
chairs with their open scrolling arms are like the
example in Karelian birch designed by the
architect Vasily Petrovitch Stasov (1769-1848), a
distinguished Russian Neoclassicist, for the
Catherine Palace at Tsarskoe Selo (Victor Ken-
nett, *The Palaces of Leningrad*, 1978, pl. 33).

In each window embrasure stands a plant-filled
jardinière framed by delicate muslin inner cur-
tains. There are no heavy outer curtains, which
suggests that this view was painted in summer;
indeed there is no heat source visible, neither
stove nor grate, so it may be that the room was
habitable only in the summer months. Between
the outer pairs of windows are consoles with
ceiling-high looking glasses that would have
reflected and diffused the light from the ormolu
winged Victory candelabra in the manner of
Thomire (cf. fig. 1). The range of five windows,
with their ingenious diagonal pelmet arrange-
ment centering on the middle window, is mir-
rored in the symmetrical placing of the furniture
on each side of the door on the facing wall.
Before the two corner banquettes, which with the
scroll-armed chairs form conversation groups,
are round tables covered with embroidered vel-
vet cloths and littered with books and albums.
Two great classical marble vases on pedestals,
echoing the two kneeling marble nymphs be-
tween the windows opposite, flank the cup-
boards, the tops of which are crowded with
Greek and Etruscan antiquities; the screen masks
the door in the center of the wall. The Czarina is
seated at a plain writing table at the far end of the
room surrounded by a clutter of little work tables
and occasional chairs which relieve the over-
contrived symmetry of the room.

This large and magnificently appointed room was
probably in the Winter Palace at St. Petersburg,
the official residence of the imperial family since
the time of Catherine the Great. But it is not
possible to verify this, since the palace was
devastated by fire in 1837 and completely rebuilt,
under Stasov's direction, in 1837-39.

As for the mysterious Austrian artist who signed
"Sotira," his best-documented period, by virtue
of the group of surviving works from the Witt-
genstein Album, is the time he spent in Russia
from 1835 to 1838. This drawing shows that he
enjoyed imperial patronage.

Exhibited: Pierpont Morgan Library, New York, 1985, no.
68; Hartwick College, Oneonta, New York, 1987, no. 11.

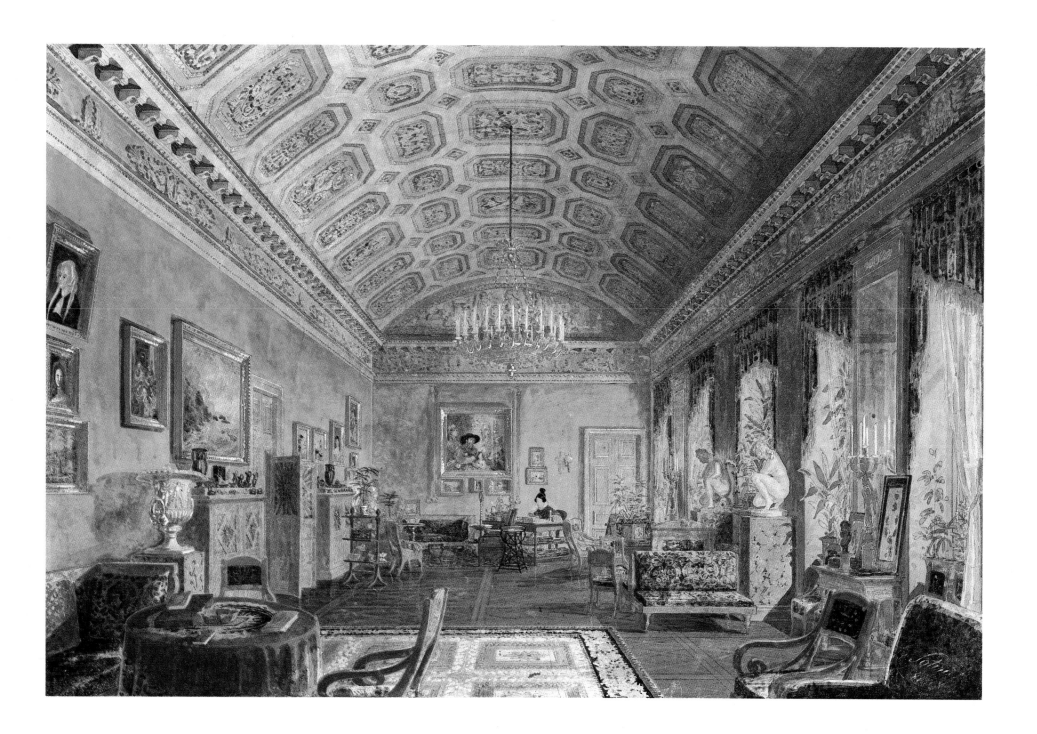

11. *The Dressing Room of King Ludwig I in the Residenz, Munich, 1836*

FRANZ XAVER NACHTMANN (1799-1846)

Watercolor and gouache over graphite and pen with black ink, accents of gold paint, 8¾ x 11¼ in. (22.2 x 28.6 cm)
Signed and dated lower right "Nachtman 1836"

Philhellene and creator of nineteenth-century Munich, King Ludwig I of Bavaria (1786-1868) succeeded his father, Max I Joseph, in 1825, but he had already embarked upon the transformation of his capital more than ten years earlier. Profoundly inspired by his Grand Tour of Italy in 1804-05, he immediately began accumulating treasures of antique sculpture for his planned Glyptothek. His momentous meeting with the architect Leo von Klenze took place in 1814. The Glyptothek was to be the first of Klenze's many buildings for Ludwig and his family, which were to give Munich a classical character unrivalled in any other town in Germany. The additions and alterations to the Residenz date from Ludwig's accession.

The Alte Residenz at Munich was built between 1598 and 1616 for Elector Maximilian I and occupies a long frontage on the Residenzstrasse between the Hofgarten and the Max-Joseph-Platz. Nachtmann's intricate painting shows a room in the Königs-Bau, a new wing built by Klenze in 1826-35 on the Max-Joseph-Platz, in imitation of the Palazzo Pitti in Florence. King Ludwig's vaulted and coffered dressing room with its elaborate program of decoration had a pendant in Queen Therese's equally sumptuous vaulted study (Nachtmann's view is preserved in the Wittelsbach collection; see fig. 8, and Hans Ottomeyer, *Das Wittelsbacher Album*, 1974, pl. 25). The style of painted decoration in both these rooms derives ultimately from Raphael's Vatican Loggie, a fruitful source of inspiration for much

revived Renaissance decoration in the nineteenth century. King Ludwig's dressing room was painted with scenes from Classical literature and poetry; Queen Therese's study celebrates German Romantic literature.

Klenze attended to every detail, making drawings for the furniture of marmoreal white and gold, for the tabourets and consoles as well as thrones and suites of settees and chairs, and even for the candelabra and mirror frames. The designs, many executed in a simplified form, were based on ancient Greek models (see Hermann Schmitz, *Deutsche Möbel des Klassicismus*, 1923, pls. 189-94). The Festsaal-Bau, another new wing on the Hofgarten side, was built in the revived Renaissance style for Ludwig by Klenze in 1832-42.

The legacy of Ludwig's building mania was bequeathed to his grandson, Ludwig II, born in 1845 on his grandfather's birthday — even at exactly the same hour. Inspired not by the Classical world but by myth and symbolism, the younger Ludwig left a more eccentric heritage than his grandfather.

Franz Xaver Nachtmann was one of the first of the German professionals engaged to paint interiors for the royal albums that proliferated in the 1830s and 1840s. He was involved from the early 1820s with building up the Wittelsbach Album for Queen Caroline of Bavaria, and he made replicas of some of these views for the Hesse family album at Darmstadt. A series of views of rooms occupied by Princess Elizabeth of Bavaria in Munich and at Tergensee Castle is preserved at Potsdam.

Literature: Gere, 1989, pl. 214.
Exhibited: Pierpont Morgan Library, New York, 1985, no. 67; Hartwick College, Oneonta, New York, 1987, no. 20.

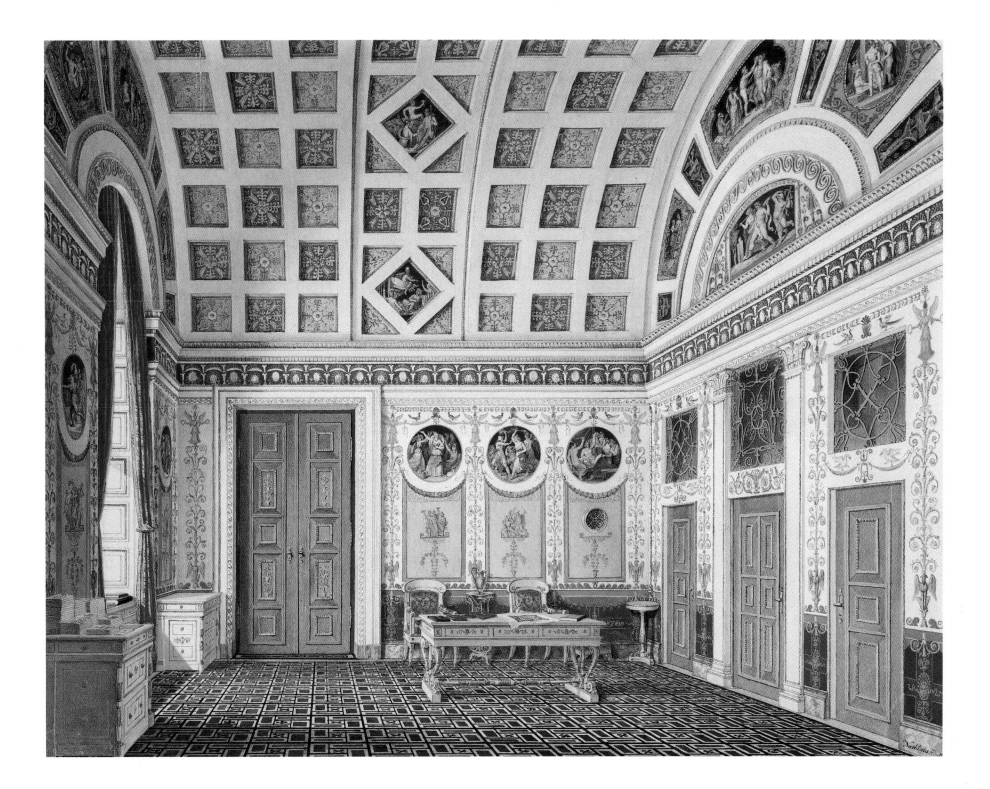

12. *A Russian Winter Garden, c. 1835-38*

Vasily Semenovic Sadovnikov, attrib.
(1800-79)

Watercolor and gouache over graphite, 9¼ x 11¾ in. (23.5 x 29.8 cm)
Two imperial Russian inventory labels affixed to the old backboard

Though uninscribed, unsigned, and undated, this is clearly a view of the winter garden at Pavlino (cf. no. W2), probably drawn by one of the three artists who worked on the other Pavlino drawings when the Wittgenstein Album was being assembled. It remained unidentified because the winter garden was not included by Praz with the rest of the Wittgenstein interiors in his *Illustrated History of Interior Decoration.* The winter garden has been prepared for a ball by covering its tiled floor with large squares of parquet. An alcove for sitting-out, furnished with a white-covered sofa, is enclosed by an awning outside the French windows. The lighting has been improved by the substitution of a chandelier holding eight Argand lamps for the simpler one holding only three candles shown in the other drawing.

On the occasional chairs in the left foreground are a small bouquet of flowers and a cashmere shawl. Shawls were fashionable in the 1830s and were particularly highly prized in Russia. Turkish and Indian ones were sold by Bokhara merchants in the market in Moscow. Lady Londonderry (Seaman and Sewell, 1973, p. 64) describes being besieged by importunate shawl sellers: "My whole morning was spent among the Persians and shawl merchants who made a positive fair of the anteroom. I finally bought a magnificent one for which I was first asked twelve thousand roubles." The Russian Kolokolskaya shawls, which were woven by serfs, were of the finest tapestry-work delicately patterned with flowers.

The plants covering the pergola and climbing up the columns seem to have grown since the same view was painted by Carl Kollman in 1834; this drawing may date from the following year, when the Viennese artist Sotira was working at Pavlino, or from 1838, when other views there were recorded by Sotira and by the Russian artist Vasily Semenovic Sadovnikov (1800-79).

It was a delightful Russian habit to hold parties in the large winter gardens attached to the great houses. When the Prince of Wales entertained his sister-in-law, the Grand Duchess Maria Feodorovna, in London in the early 1870s, a ball was held in the great conservatory of the Royal Horticultural Society at South Kensington, which was decorated with masses of plants in pots imported for the occasion. To judge from the drawing made in 1834, the floral display in the Pavlino winter garden did not have to be much augmented to provide the magnificent show of roses, clematis, and ferns that made the setting for the entertainment.

This atmospheric but scrupulously explicit drawing might be by Sotira, who was responsible for so many of the Pavlino views, but those are all signed and dated. Of the other two artists who recorded Pavlino, Kollman does not seem to have been sufficiently skilled, to judge from the 1834 winter garden drawing, to render, as here, the light gleaming on the polished parquet floor. Sadovnikov was a highly skilled watercolorist who specialized in landscape, buildings, and interiors. He made a panorama of the Nevsky Prospect in St. Petersburg, and his glowing, light-filled street scenes are peopled with lively, well-observed figures. He was a member of the team of architectural specialists commissioned to record the new buildings and their interiors that were added to the Hermitage and Winter Palace after the fire in 1837.

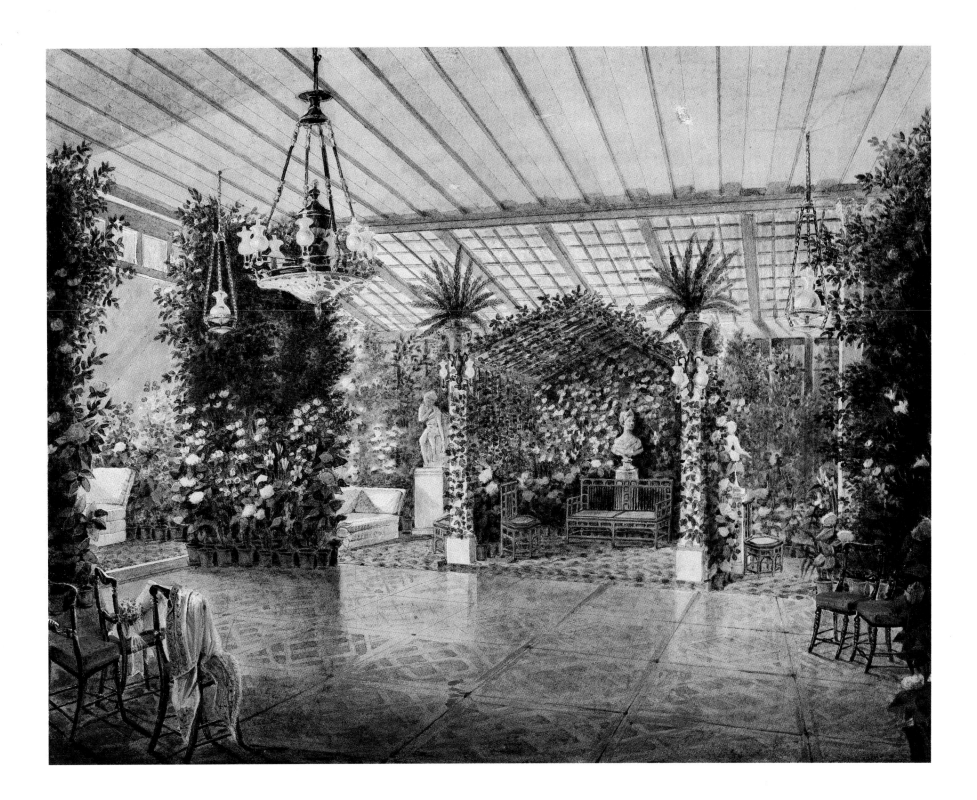

13. *The Study of Grand Duchess Cecilia von Oldenburg, 1839*

ERNST CHRISTIAN ANTON VON LAUTZOW
(fl. 1830s)

Watercolor and gouache with accents of gold paint and gum arabic, 9¾ x 13 in. (24.7 x 33.0 cm)
Signed lower right "E von Lautzow," inscribed on the reverse "Arbeitszimmer der Grossherzogin C von Oldenberg, gemalt von [word erased] 1839," from the Oldenburg Family Album

Cecilia von Oldenburg (1807-44) was the third wife of Grand Duke Paul Friedrich Augustus (1783-1853), hereditary ruler of the Duchy of Oldenburg in Schleswig-Holstein. Part of the Federation of the Rhine in 1808, Oldenburg was annexed by the French in 1811 and recovered by Duke Peter Friedrich Ludwig of Oldenburg, who was given the title of Grand Duke by the Congress of Vienna in 1814. Cecilia was the daughter of Gustavus IV Adolphus, King of Sweden, who was deposed and exiled in 1809 following Sweden's defeat in the war with Russia of 1808-09. She died four days after the birth of her only child, Duke Elimar von Oldenburg.

The progressive and cultivated Grand Dukes were responsible for developing Oldenburg as a modern city on Schinkelesque Neoclassical lines in the 1820s and 1830s. Carl Heinrich Slevogt, the court architect responsible for the classical additions to the grand ducal palace, had spent his formative years in Berlin. Slevogt died in 1832 and was succeeded by Heinrich Strack, a pupil of C.F. Hansen.

Cecilia von Oldenburg's study is dominated by a life-size portrait, almost certainly of the Grand Duke, in military uniform. A large-scale bronze figure of Psyche with gilded wings is reflected in the looking glass that rises almost to the ceiling on the far wall, making the serene pair of landscapes flanking it look almost insignificant. The fine suite of Biedermeier furniture is evidence of the important patronage of the Dukes of Oldenburg; some of their furniture survives in the Oldenburg Landesmuseum, including a Greek Revival sofa and a sofa table in the English style as seen here. Otherwise the room is decorated with a delicacy typical of Biedermeier taste and a lightness of color particularly associated with Scandinavia.

The pale yellow walls with trails of flowers are matched by the cream-ground needlework carpet embroidered in squares with flowers. The ceiling is painted a dusty pink, with the discreet plasterwork picked out in white and finished by a grey molding. The suite of mahogany furniture includes a heavy desk with ormolu mounts as well as a more feminine *secrétaire à abattant*, with its gilded black-leather writing slope open. The sofa table is placed before the upholstered sofa rather than behind it, as is so often — incorrectly — the case nowadays. The four armchairs with their dramatically curving backs, reminiscent of Antique models, are suplemented by a comfortable reclining chair drawn up to the writing table. A leather document case on the chair beside the writing table is awaiting attention once a place can be cleared among the clutter of little portraits and views. The pair of large, two-handled gilt vases, decorated with an oval medallion of roses on a dark ground, look Russian; presentation pieces from the Imperial Porcelain Manufactory, of which the Czar was justly proud, were treasured by many European ruling families. The small tables conveniently placed about the room include a round sewing box on a tripod support and two of the popular English-style quartetto tables that could be nested together. The sewing equipment has evidently been put to good use in providing the cushions and the embroidered footstool under the sofa table.

The artist is an accomplished amateur, possibly a member of the family. Among the little paintings on the desk there seem to be interior views, perhaps scenes of other rooms in the Oldenburg Palace that would eventually go towards forming an album like the one from which the present view came.

Literature: Gere, 1989, pl. 206.
Exhibited: Hartwick College, Oneonta, New York, 1987, no. 21.

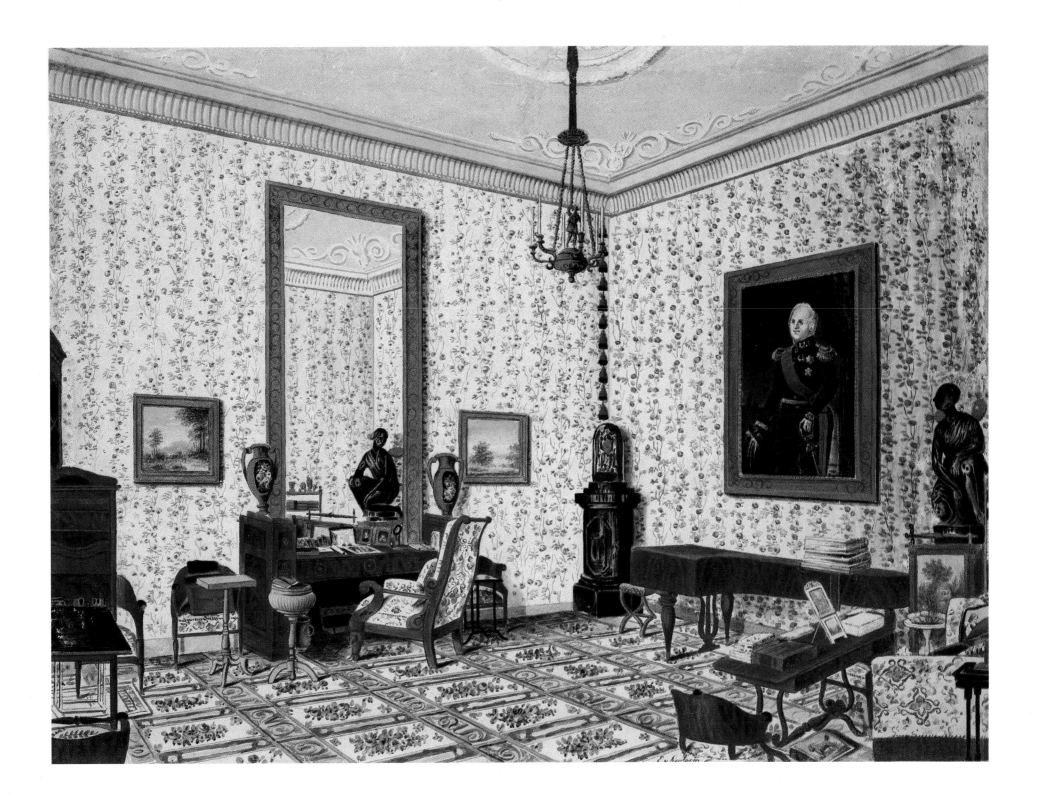

14. *A Bedroom in a Russian Dacha, 1839*

RUSSIAN

Watercolor with touches of pen and blue ink over graphite, with gum arabic, 7¼ x 9½ in. (18.2 x 24.2 cm)
Inscribed in Cyrillic characters on the old mount "spal'naya v Kishkovskoi dachi 1839 goda"

The inscription identifies this as one of the rooms in the dacha (i.e., a single-story wooden country house) belonging to the Kishkovsky family. Though not opulently furnished, the room is by no means unsophisticated. The decoration on the coved ceiling is picked out in blue; the walls are papered with an elegant wide stripe in blue and yellow; the floor is close-carpeted; and the curtains match the daytime covers of the bed-divan, with its bolsters made to form arms at each end. The bed in the French style was a considerable luxury in a country where even the Czar often slept on a folding campaign bed in his study. The writing table between the windows is furnished with a pair of candlesticks, and a tall looking glass fills the wall in front of it. Books occupy a small set of hanging shelves on the wall by the door, and next to the shelves, on top of a cabinet, is a mysterious mechanical device under a glass cover. The door of the cabinet, mounted with a flowered porcelain panel, possibly encloses shallow drawers of the type used by collectors or lepidopterists.

The chairs are fine examples of late Neoclassical taste, the writing chair being a considerable curiosity. It appears to be made of metal, possibly steel and gilt bronze, with the seat of gilt-bronze woven mesh. Steel and gilt furniture produced at the Tula armory works in the eighteenth century was prized in Russia, though it was almost unknown elsewhere. (The fireplace and *garniture de cheminée* of Tula steel now in the Victoria and Albert Museum in London was given to Catherine Wilmot by Princess Dashkova.) The manufacture of furniture and ornaments at Tula was forbidden by law at the time of the Napoleonic wars, and the prohibition was never rescinded. However, other factories must have been supplying metal furniture in the nineteenth century, as a suite of chairs in a boudoir at the Hermitage was depicted as late as 1871.

Inconspicuously placed in the far corner of the room is a sculpture of a kneeling boy that appears to derive from the same model as the one shown twice in the Wittgenstein's house, Pavlino (nos. W5, W14).

The unknown artist who drew this room was not incompetent, but perhaps not quite sufficiently accomplished to be a professional. As the taste for such interiors grew, many tried their hands at painting them, sometimes family members, sometimes guests. Their names are now almost always irrecoverable.

Exhibited: Hazlitt, Gooden & Fox, London, 1981, no. 64; Pierpont Morgan Library, New York, 1985, no. 69; Hartwick College, Oneonta, New York, 1987, no. 26.

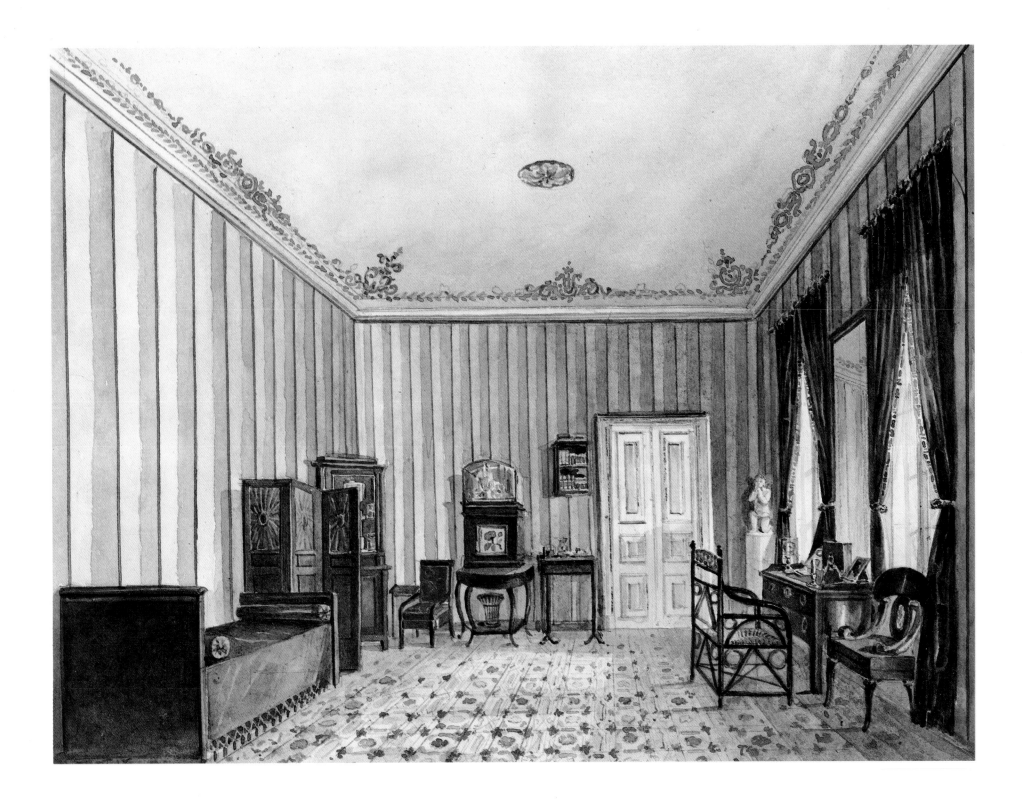

15. *The Chinese Room, Middleton Park, Oxford-shire, 1840*

ENGLISH

Watercolor, graphite, and gum arabic with accents of gold, 9¾ x 12½ in. (25.2 x 31.8 cm)
Signed and dated lower left "1840/W.A.D."

Middleton was a plain Neoclassical building re-modelled for the 5th Earl of Jersey between 1806 and 1810 by Thomas Cundy, Sr. (1765-1825). In 1934 it was demolished to make way for a new house designed by Sir Edwin Lutyens. Thomas Cundy was no innovator, and it is unlikely that he was responsible for the riotous *chinoiserie* of this scheme, though a room hung with Chinese painted paper would have been appropriate to a Regency remodelling. The eighteenth-century enthusiasm for *chinoiserie* reached its height in George IV's Pavilion at Brighton, of which an illustrated description was published in 1824-26, but it is rare to find a tangible expression of enthusiasm for that fantastic Indian-Chinese palace. Most of the Prince's subjects found the unrestrained taste of the Pavilion overwhelming, and from the late 1830s Sino-British relations were strained by the Opium War. This fully evolved Pavilion-inspired treatment of a room was probably the work of deft amateur decorators among the Earl's family or other members of the Child-Villiers household.

At Middleton, as at the Pavilion, there is lavish use of bamboo in the furniture — though here it sits uneasily among the plain Regency library chairs and cabinets — and in the edging of the bright blue frieze decorated with crudely simplified Chinese characters (a device reminiscent of the bordered paper panels in the Chinese Room at the Berlin Royal Palace; compare no. 20). The elaborate swagged portière framing the entrance to the conservatory is a conspicuous example of the Pavilion influence, being a reduced version of the swagged pelmet and curving reveals in the Music Room there. The delicate *chinoiserie* panes in the transom are either painted glass or oiled-paper transparencies. Another view of the room, looking in the opposite direction (see fig. 10 and Gere, 1989, pl. 265; the two views are reproduced together in the catalogue of Christie's, London, December 13, 1988, lots 53, 54), shows a similar swagged and draped border to a large window overlooking the garden. The overmantel mirror in that view is framed with a *chinoiserie* fret of bamboo, and the panels of the shutters and the door have been japanned black and edged with bamboo.

The device of heightening the gilded details of the interior with gold paint suggests that the unidentified artist W.A.D. was familiar with the work of Continental professionals. It is possible that the idea of embellishing interior views with gold comes from porcelain decoration, as a number of the early professionals, like Nachtmann (see no. 11) and Le Feubure (see no. 19), were trained in porcelain factories. Interior views were at the very height of their popularity around 1840. Albums were kept to be handed round after dinner, and must have inspired the many amateurs who made interiors their speciality.

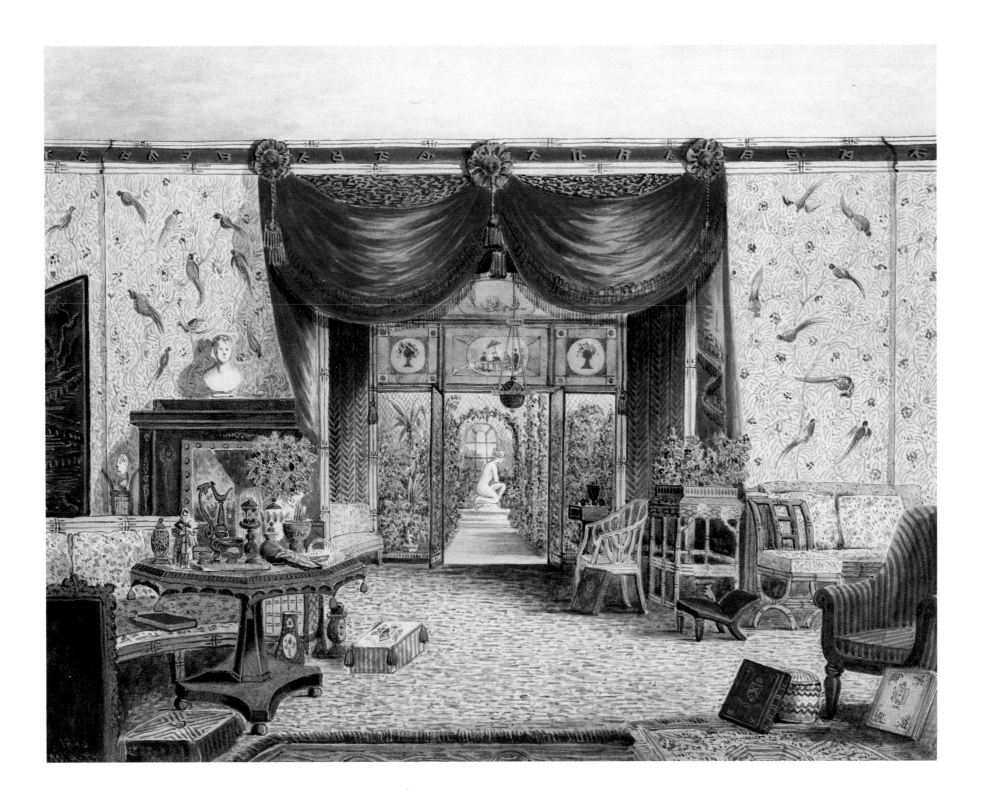

16. *A Room in the Governor's Residence, Hermannstadt, 1841*

M. SEKIM (fl. 1840s)

Watercolor and gouache with accents of gold paint, 14½ x 21 in. (36.9 x 53.3 cm)
Signed and dated lower right "M Sekim/841," inscribed on the reverse "Salon der Grosseltern Wernhardt in Hermannstadt 1835 Paul Freiherr von Wernhardt Gouverneur von Siebenburgen"

The city of Hermannstadt (modern Sibiu) was capital of the remote Austrian province of Transylvania (in German, "Siebenbürgen"), on a plateau amid the Carpathian mountains in the extreme southeast of the Empire between Hungary and Romania. This room in the residence of the provincial governor, Baron von Wernhardt, is decorated in the most up-to-date Viennese Biedermeier style. Its focal point is the large portrait of a man in white Austrian military uniform, presumably the reigning Emperor, Ferdinand I (1792-1875), who succeeded in 1835 and abdicated in favor of his nephew in 1848.

The double windows, also common in Vienna, bear witness to the severity of the climate in this mountainous country. "What can I tell you of Vienna that you do not already know!" asked Martha Wilmot of a friend on her arrival in Vienna in 1819 (Marchioness of Londonderry, ed., *More Letters from Martha Wilmot, Impressions of Vienna, 1819-1829*, 1935, p. 36). "Shall I tell you that it reminds me of Moscow in many respects; we have the same double windows...." Double windows must have been usual in eastern Europe and Russia, but they are rarely depicted. Here they are supplemented by the flowered bolsters that acted as draught-excluders; standard winter equipment, bolsters are frequently found in mid-century interior views.

The two banquettes, the cabinets between the windows, the tall mirrors over them, and the side table on the right are still designed in the severe style of 1830s Biedermeier, but the shapes of the occasional chairs are beginning to display the curving lines of revived Rococo. The room is papered with a boldly patterned stripe and a French, or French-inspired, drapery border of entwined ribbons. The ornamental bellpull is a rope of silk and chenille tassels. The sewing frame in the window and other evidence of feminine occupations suggest that this was a much-used sitting room rather than a formal reception room. The parquet floor is bare of carpet or rugs. Martha Wilmot (p. 20) provides an explanation from her observation of Viennese customs in 1819; remarking on the prevalence of "parqué floors," she points out that one can have "*Carpits* if you chuse to give a daughters dowry for them, and if you do, the *Moths* eat them up to riddles in the summer."

The artist M. Sekim employed technical devices to enhance the details of his views — for example, using gold paint for the gilt frames and other gold objects and opaque white pigment in relief for the wallpaper pattern — that are found in the work of German and Austrian artists, a number of whom received their early training in porcelain decoration. The details of Sekim's career have as yet proved hard to trace. He dates his work in the same way as the mysterious "Sotira" and other Viennese artists of this date, omitting the millenium numeral, and this might indicate a Viennese origin and training; however, the near-amateur level of execution suggests a local artist.

Literature: Gere, 1989, pl. 215.
Exhibited: Hartwick College, Oneonta, New York, 1987, no. 13.

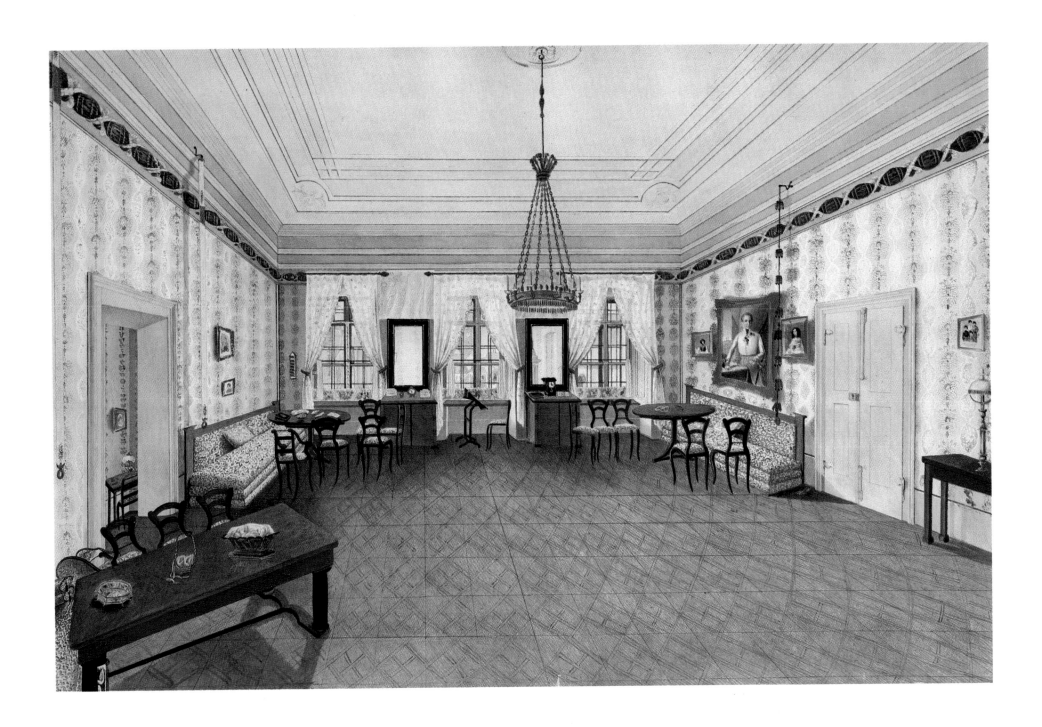

17. *A Salon in the Governor's Residence, Hermannstadt (?)*

M. SEKIM, attrib. (fl. 1840s)

Watercolor and gouache with accents of gold paint and gum arabic, 13⅛ x 16³⁄₁₆ in. (33.3 x 41.2 cm)

This interior could be by the same hand as no. 16; and since the two drawings were acquired together, it may also be of a room in Baron von Wernhardt's house. Though the present room is on a more palatial scale and has a consciously planned opulent scheme of decoration, it is of the same date: indeed, it seems likely that the same Viennese firm has supplied the cabriole-legged occasional chairs. Unlike the sitting room depicted in no. 16, this formal reception room has an unused air; there is an inkstand but no paper on the writing desk, and the shelves are empty of books or ornaments. The imposing curtains, their boldly shaped pelmets finished with large silk tassels, are matched by the upholstery on the chairs. There are lace inner curtains, and visible in the window on the far wall is a painted blind. The scene on the blind of a dancing figure in a shaped panel echoes the still-tentative Rococo curves of the chairs and writing table. The 1840s saw the emergence of the revived Louis XV style that was to endure for more than half a century. The gold fillet edging the walls under the ceiling cove, above the baseboards, and in the corners suggests that fabric has been used here. The damask pattern in rose-red and gold is partnered by the ultimate in expensive luxury — a fitted red-and-gold carpet with a pattern of conventional foliage on which are scattered bouquets of roses. The geometric decoration of the ceiling and the fine chandelier of ormolu and ruby glass may have survived from an earlier decorative scheme.

This artist has the grasp of detail and pattern rather than of scale and perspective that marks the amateur, but there were many levels of competence in this demanding genre. In remote Transylvania there would not have been a wide choice.

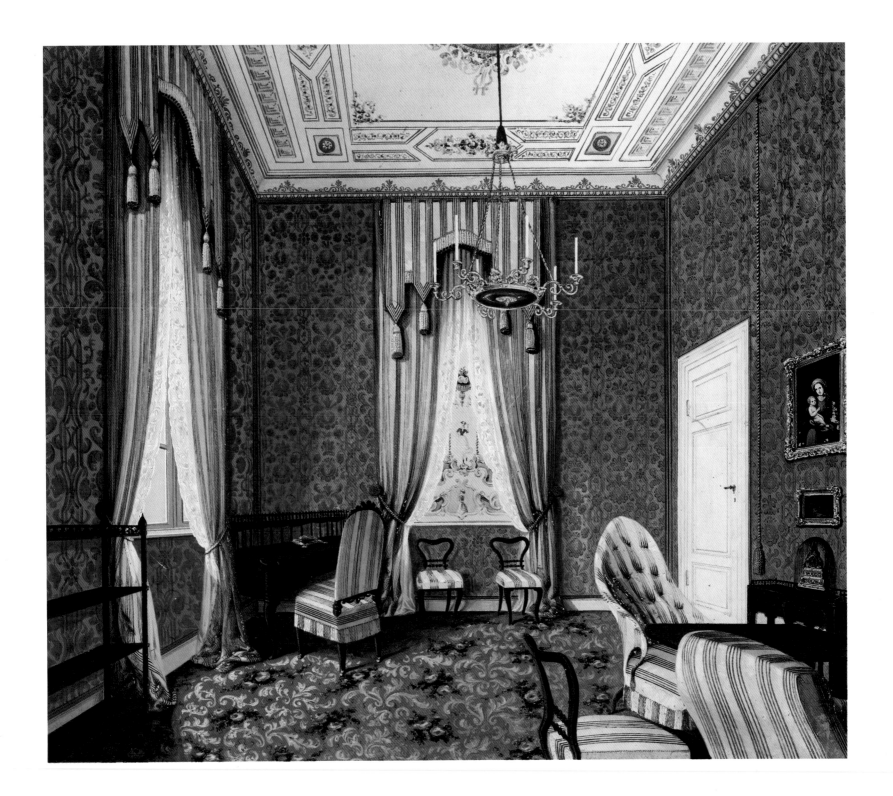

18. *The Entrance Hall, East Sutton Place, Kent, 1844*

CHARLES JAMES RICHARDSON (1806-71)

Watercolor over graphite, 7½ x 12 in. (19.1 x 30.5 cm)
Signed lower right "CJR"

East Sutton Place was the family seat of Sir Edmund Filmer, Bt., M.P., to whom Richardson dedicated the second volume of his four-volume *Studies from Old English Mansions* (1841-48). This "Hall in Gothic Taste" appears in the third volume (1844), with the empty room embellished by a fanciful Elizabethan family of a father and mother with two girls and a boy and a large pet dog (fig. 5). The picture has an accompanying text: "The Hall at East Sutton, the family seat, is a very ancient building, some portions as early as the reign of Henry VIII., the entrance hall contains a screen bearing the date 1570, which is a very interesting specimen of carved woodwork, and there is a handsome dining-room of the style of Elizabeth's reign. In the church nearby are memorials to the seventeenth century Sir Edmund Filmer, his wife and their nine sons and nine daughters."

The entrance hall contains fine Tudor furniture, there are suits of armor hanging on the wall, and on the floor are Chinese jars and a huge leather jug or "jack" of the kind that would later in the nineteenth century be sought eagerly by collectors. It is interesting to see that in the embellishment of his genuinely ancient house Sir Edmund had anticipated both this collecting enthusiasm and the taste for decorating "Olde English" interiors with fine Oriental ceramics. It is not always sufficiently appreciated the extent to which Tudor-style schemes commissioned by artistic collectors were based on authentic examples. It would indeed be easy to mistake this watercolor with its dry precision for a scheme by a fashionable decorating firm of the 1890s, like Lenygon and Morant. Armor had long been an essential ingredient of the antiquarian interior, and a trade in fakes had been flourishing in London for many years.

Richardson, who trained as an architect with Sir John Soane (1753-1837), was a talented architectural draughtsman and owned a large and valuable collection of architects' drawings and designs. These interests contributed to his writings on the subject, such as the *Observations on the Architecture of England* (1837), a volume extensively illustrated with details of plasterwork, moldings, woodcarving, and so on that made it a work of inestimable value to fellow architects. In the 1840s Richardson was drawing and painting the treasures at Goodrich Court for the noted collector Sir Samuel Rush Meyrick, thus feeding his antiquarian inclinations. The *Studies* includes specimens of curious early furniture and objects as well as rooms from ancient houses. Notwithstanding Richardson's well-informed historical approach, the collection has a strong flavor of the romance of ancient houses and their inhabitants, like Joseph Nash's successful *Mansions of England* (see no. 33), the first volume of which had appeared two years earlier.

Exhibited: Hartwick College, Oneonta, New York, 1987, no. 4.

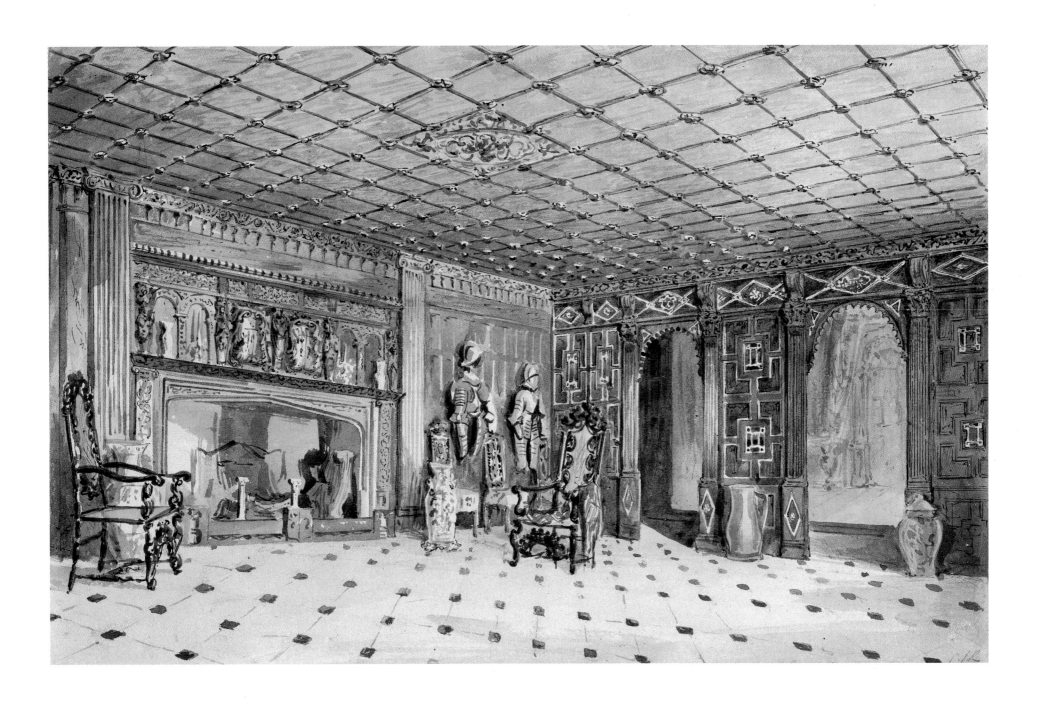

19. *The Bedroom of King Pedro IV of Portugal (Emperor Dom Pedro I of Brazil), Palace of Queluz, 1850*

FERDINAND LE FEUBURE (1815-98)

Watercolor and gouache over graphite, touches of gum arabic, 8 x 12½ in. (22.5 x 31.8 cm)
Signed and dated lower right "Ferd. le Feubure 1850," inscribed on the old mount "Chambre où mourut mon. père, dans le Palais de Queluz"

Dom Pedro, son of João VI of Portugal, was born at Queluz in 1798. Portugal at this date had two sources of prosperity: the wine trade with Britain and the gold from the rich mines in its colonies in Brazil. Owing to the impossibility of yielding to French demands for a ban on trade with Britain after the battle of Trafalgar in 1805, the Portuguese became involved in war with Napoleon. When the invading French troops entered Lisbon in 1807 they found the royal family already departed for Brazil. João succeeded his deranged mother, Maria I, as King of Portugal in 1816, but the family did not return there until 1821. Meanwhile Pedro, as Infante, was instrumental in securing Brazilian independence in 1822, and in 1825 he became the constitutional Emperor; in 1826 he succeeded his father as King of Portugal, but in 1831 he abdicated in favor of his fifteen-year-old daughter Maria da Gloria, while his six-year-old son became Pedro II of Brazil. Dom Pedro died three years later, in 1834, in the very room where he had been born, the Don Quixote Room in the Queluz Palace outside Lisbon.

The inscription identifying the drawing was written by Princess Maria Amelia, daughter of Pedro and his second wife, Amelia Augusta von Leuchtenberg (m. 1829). Maria Amelia, who was only three at the time of her father's death, revisited the Queluz Palace for the first time seventeen years later in 1851. She found the room unchanged.

The royal palace at Queluz is one of the most remarkable Rococo monuments in Portugal. It was built for the Infante Dom Pedro (grandfather of Pedro IV) in 1747-52 by Mateus Vicente de Oliveira (1706-86), as a miniature version of Versailles. The debt is particularly apparent in the entrance courtyard and the celebrated gardens. In 1934 the interior of Queluz was devastated by fire, which destroyed among other things a room hung with a French scenic wallpaper showing a battle in the Greek War of Independence, and which badly damaged the Hall of the Ambassadors. Many imposing state rooms survived, including the Throne Room decorated by Antoine Collin and Silvestre de Faria Lobo (d. 1769), the richly gilded oval Hall of Mirrors (another salute to Versailles), the sophisticated Hall of Tiles (without which no palace in Portugal could be considered complete), the Council Room with its fine floor of Brazilian hardwood, the mirrored Queen's Dressing Room (1774-76), and the circular King's Bedroom recorded in this drawing, which is decorated with episodes from the story of Don Quixote by Manoel da Costa (b. 1755-d. after 1811 in Brazil). Da Costa was a fervent admirer of the French Rococo decorator Pillement, and his delicate little scenes in the ceiling cove and on the overdoors are more spirited than the conventional rendering of Apollo and the Muses on the ceiling.

The King's Bedroom, though sumptuously decorated, was sparsely furnished, not because it had remained unused but because such was the usual practice in Portugal. The necessary furniture was conveyed from one palace to another as the royal family moved from Lisbon to the ancient royal palace at Cintra, and on to the great Germanic castle at Mafra. Queluz was a convenient staging post and eventually became the preferred summer residence of the royal household. William Beckford, writing in 1787, noted the way the ladies of the court habitually sat cross-legged on the floor "Oriental fashion" (*William Beckford's Portuguese Journal, 1787*, ed. Boyd Alexander, 1954, p. 282). The bed and bedside table in Dom Pedro's room are in the French taste, but the rest of the furniture looks English. The special relationship with Britain as longstanding ally and trading partner had resulted in much fine English furniture being in Portugal. Chippendale was greatly admired, and in the early nineteenth century the Duke of Palmella became one of the most important patrons of the Regency designer George Bullock. The boldly radiating patterned floor is probably of Brazilian hardwood.

Ferdinand Le Feubure was a Munich artist. Like Franz Xaver Nachtmann he spent his early career in the studios of the Nymphenburg Porcelain Works. He painted equestrian scenes and views of Munich and was one of the artists involved in the 1830s and 1840s on the decoration of a large dessert service for the Bavarian court. The commission to paint the death chamber of King Pedro must have come from Queen Amelia Augusta, whose family palace in Munich had been depicted in the early years of the nineteenth century for her father, Eugène de Beauharnais, Duke of Leuchtenberg. She was the granddaughter of Max I Joseph of Bavaria, for whom Queen Caroline had made the Wittelsbach Album in the 1820s. Le Feubure contributed a painting of one of the rooms in the Wittelsbach Palace to an album in the Hesse collection at Darmstadt.

Exhibited: Galerie Biedermann, Munich, *Aus einem Album um 1850*, 1981, no. 1; Pierpont Morgan Library, New York, 1985, no. 75; Hartwick College, Oneonta, New York, 1987, no. 23.

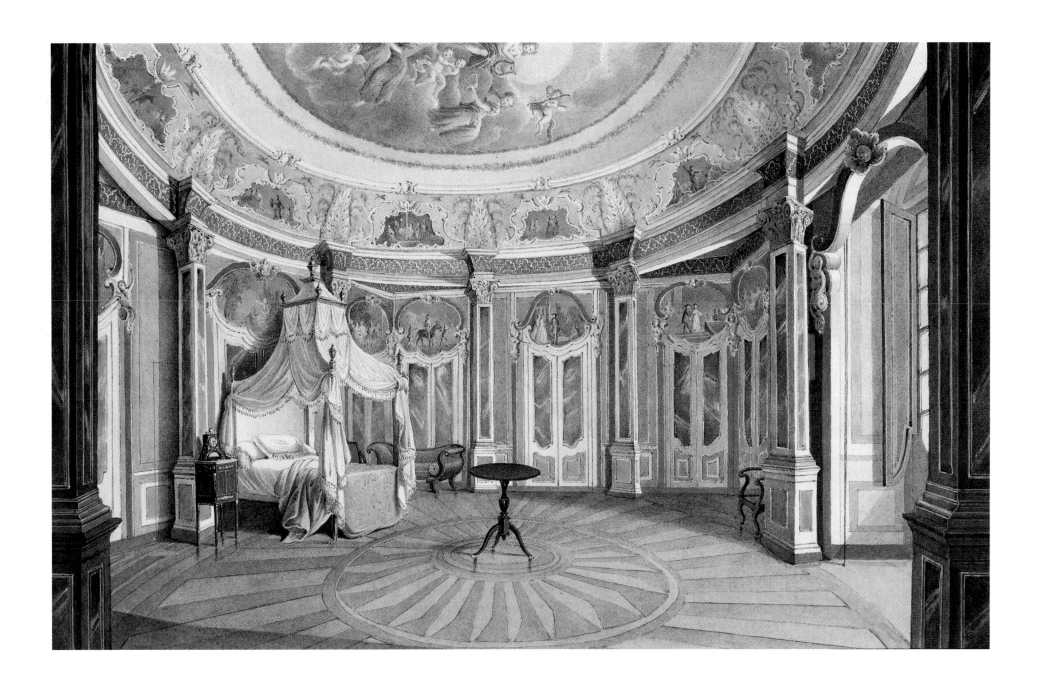

20. *The Chinese Room in the Royal Palace, Berlin, 1850*

EDUARD GAERTNER (1801-77)

Watercolor and gouache over graphite, 10¾ x 14⁵⁄₁₆ in. (27.3 x 36.4 cm)
Signed and dated lower right "E. Gaertner 1850"

The Chinese Room in the Berlin Palace is lined above the panelled chair rail with large pieces of painted Chinese paper framed by wide blue borders decorated with Chinese characters in gold. A suite of black lacquered sofa and side chairs upholstered in brilliant yellow silk, a curving banquette by Birckenholtz in deep blue damask which fills the end wall, and two chairs in seventeenth-century style covered with rose-pink velvet comprise the furnishings of the room, which also houses an impressive collection of Oriental porcelain and black-and-gold lacquered cabinets (for which see the description and disappointingly laconic inventory in Helmut Börsch-Supan, *Marmorsaal und Blaueszimmer*, 1976, no. 29).

In 1826 Schinkel had been called in to renovate part of the seventeenth-century Royal Palace in Berlin, but by the 1850s the palace was used only for official receptions. The Emperor Wilhelm II (succeeded 1888) made it once again the residence of the reigning sovereign and initiated a new period of building activity, but after the First World War it was turned into a museum, and after World War II it was demolished. Gaertner's views of the State Apartments are a valuable record of royal taste and patronage in the 1820s and 1830s (see Irmgard Wirth, *Eduard Gaertner*, 1978, for illustrations of fifteen of the rooms in the palace).

By the time Gaertner's views were painted in the 1840s and 1850s, the rooms were about to be abandoned to dust and dereliction. Visiting the palace in 1858 Queen Victoria remarked: "We went across an open gallery (very cold and inconvenient in winter) to the King's apartments — strange, dark, vaulted, dull rooms, left just as he used them, full of pictures of interiors of churches, — then to the Queen's rooms, fine and large but very cold — full of family pictures and busts..." (quoted in David Duff, *Victoria Travels*, 1970, p. 167). The State Rooms were also part of the tour, but the Queen described only the "Red" and "Black" rooms and the celebrated "Ritter Saal," all in "the richest Renaissance style, with painted ceilings, splendid furniture, &c —, really one of the finest things I have ever seen" (from Queen Victoria's unpublished diaries in the Royal Library at Windsor Castle, quoted with the gracious permission of H.M. The Queen). Like the Chinese Room, these rooms were recorded by Gaertner between 1844 and 1852. The persistent problem of the cold was never solved, for even after the transformation of the palace into a museum many of the rooms were closed in winter. Baedeker warns, "In the cold winter months only the rooms on each floor of the N.W. angle are open."

The present view of the Chinese Room is a replica of one by Gaertner made in the same year, now in the Hesse collection in Darmstadt. The two are of the same size, but the inscription on the other differs slightly: "E. Gaertner fc. 50" (see Börsch-Supan, loc. cit., and Wirth, no. 379). The drawing of the Chinese Room and other views of the apartments in the Berlin Palace of Prince Wilhelm of Prussia and his wife, Marianne of Hesse-Homburg (d. 1846), were made for their daughter Elizabeth, who in 1836 had married Prince Charles of Hesse; they are now in the Schlossmuseum in Darmstadt.

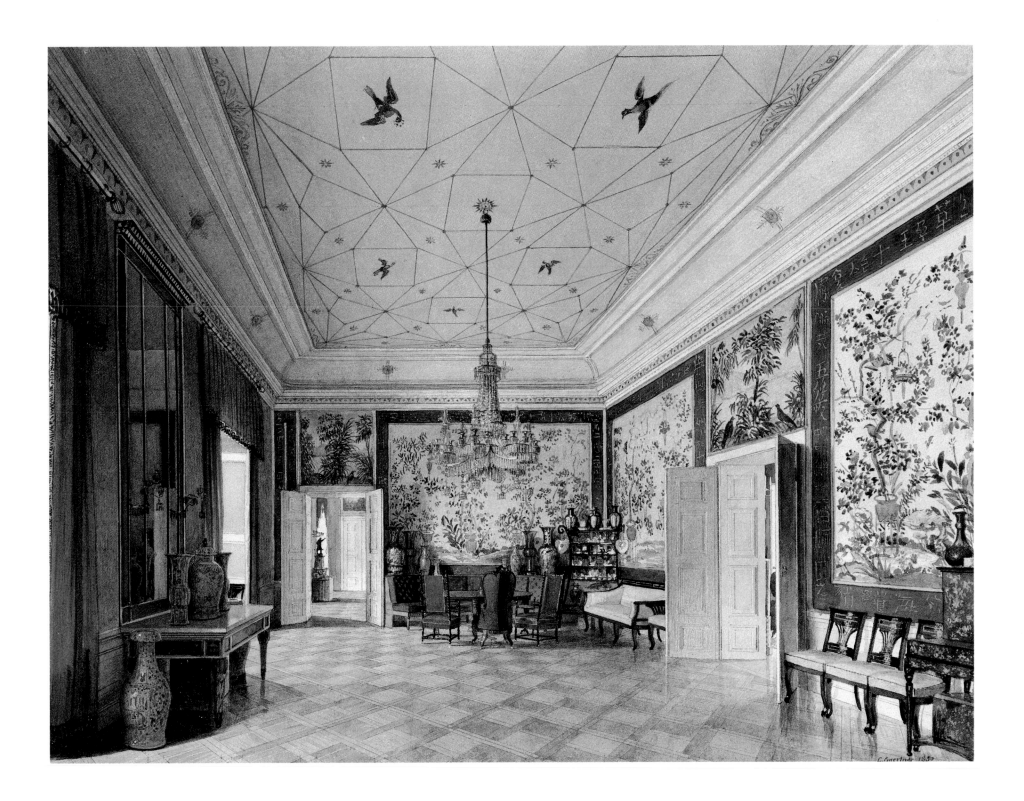

21. *The Study of Prince Karl of Prussia, c. 1848*

Eduard Gaertner (1801-77)

Watercolor and gouache, 7 x 8¾ in. (17.8 x 22.0 cm)

In 1827-28, the great Neoclassical architect Karl Friedrich Schinkel remodelled for Prince Karl of Prussia the Ordnungs-Palais on the Wilhelms-platz in Berlin, built for the Grand Master of the Knights of St. John in 1747. Judiciously combining Antique and Renaissance elements, Schinkel achieved an impressive Italianate building for which he designed richly decorated rooms complete with furniture and fittings. The palace was given to Prince Karl on his marriage to Princess Maria of Saxe-Weimar. Schinkel, working under great pressure to complete the decorations, was unable to make radical structural alterations, but the iron staircase filling the large square entrance hall was justly celebrated for its magnificence and innovatory use of new constructional materials and techniques. The palace suffered extensive damage while in military use during the Second World War and was afterwards demolished.

This room can be identified on the plan on p. 140 of Schinkel's *Collected Architectural Designs etc.* on the first floor immediately next to the staircase well; its two windows were the second and third from the right-hand end of the principal façade. The draughtsman's viewpoint is from a low platform on which stand two yellow marble plinths supporting plant-filled polished stone vases. The function of the platform is unclear, particularly since the entrance to the room is in the corner to the spectator's left. In Schinkel's hurried transformation of the palace, this may have been a hastily improvised and not altogether satisfactory expedient for concealing a change in the floor level.

To the right of the spectator is a large mirror reaching to the ceiling and reflecting part of a room, lined with draped hangings and Moresque cushioned banquettes, visible through the open door in the far wall. At the end of the vista can be seen the plant-filled conservatory shown on Schinkel's plan. The window on the left of the mirror is dressed with a deep fringed pelmet which continues across the mirror and must have been matched by another on the spectator's right symmetrically draped in the reverse direction. The formal Gothic Revival motif of Schinkel's textile wallcovering is overpowered by the boldly patterned and colored carpet. On the far wall, in a frame designed by Schinkel (cf. *Karl Friedrich Schinkel*, Orangerie des Schlosses Charlottenburg, Berlin, 1981, no. 277), is a copy or version of Cristofano Allori's celebrated *Judith with the Head of Holofernes* in the Pitti Palace, Florence.

The large galleried writing table in the foreground fits into a group designed by Schinkel for the Prussian royal family. The one made for Princess Augusta, wife of Karl's brother Wilhelm, is smaller but has many similar details and the same inlaid legs and frieze under the writing top. The gallery of Prince Karl's desk is inset with panels of amber-colored molded glass patterned with the same scrolled motif used for the gilt-metal inserts in the gallery of Princess Augusta's desk. Prince Karl has used the top rail to display a miscellaneous collection of treasures, including vases of malachite that may have been Russian imperial presents. The position of each piece of furniture is marked on Schinkel's plan. In the parts of the room not visible here, another desk and a full-size grand pianoforte can be identified, suggesting that the room was used by both the Prince and the Princess. The japanned furniture was designed in 1828 "aus dem Wohnzimmer der Prinzessin Karl" (1981 Schinkel exhibition catalogue, no. 244). If this drawing belongs with the series of Prussian

royal interiors done in the 1840s and 1850s, it is remarkable that in more than twenty years the room was not altered and we see it exactly as it left Schinkel's hand.

Most of the Schinkel furniture shown has survived. The corner cabinet (no longer containing the glittering display of diamond parures whose effect was multiplied by the mirror glass lining of the sides), the suite of japanned and gilded side chairs and sofa inspired by Schinkel's travels in England (modelled on examples in Lord Lansdowne's London house in Berkeley Square), and the matching black-and-gold sofa table (a version of one designed for the boudoir of Crown Princess Elizabeth in the Berlin Royal Palace) are preserved in the Charlottenburg Palace in Berlin (cf. Johannes Sievers, "Die Möbel," in *Karl Friedrich Schinkel, Lebenswerk*, Berlin, 1950, pls. 128, 140, 150; 1981 Schinkel exhibition catalogue, nos. 244, 246, 247, 258). The sofa table can be seen in the foreground of a view of Princess Elizabeth's room painted by E. Biermann in 1829, with a large embroidered hassock under it as here in Prince Karl's study (Praz, 1964, pl. 22).

The patronage of the Prussian royal family initiated Gaertner's successful career as a painter of Berlin architecture and interiors — his panorama of the city from the roof of the Friedrichwerder church was painted for Friedrich Wilhelm III — and sustained it after his return from Russia, where he had been invited by Nicholas I and spent two years painting a panorama of Moscow. The view of Prince Karl's study must have been a royal commission for presentation to a family member or a member of the Prince's household.

Exhibited: Eduard Gaertner, *Architekturmaler im Berlin*, Berlin Museum, 1968, no. 65; *Berliner Innenraume der Vergangenheit*, Berlin Museum, 1970, no. 17 (coll. Ernst Jürgen Otto, Celle).

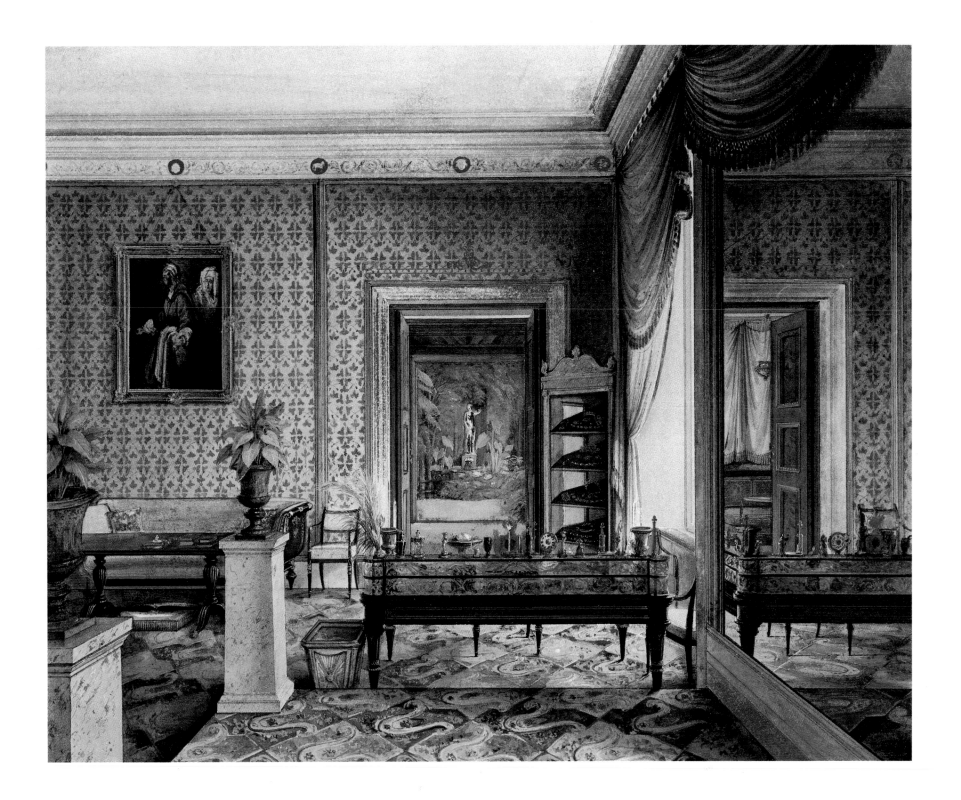

22. A Salon in a Residence of the Duke of Leuchtenberg, 1850

OTTO WAGNER (1803-61)

Watercolor and gouache, 9 x 13 in. (22.9 x 33.1 cm)
Signed and dated lower right "O. Wagner, 1850"

The portrait second from the left in the upper row on the far wall, of a mustachioed man wearing the ceremonial costume devised by Napoleon for those of his family whom he had raised to royal status, seems to represent the Emperor's stepson, Eugène de Beauharnais (1781-1824), to whom he gave the rank of Imperial Highness and the title Prince Eugène Napoléon de France. Napoleon and his brothers were all clean-shaven, but Beauharnais was a cavalryman and usually wore a mustache — though the appendage was temporarily removed to please his mother, the Empress Josephine, on the occasion of his marriage in 1806 to Princess Augusta Amelia of Bavaria. The portrait to the left of his could be of his wife, and the oval head and shoulders on the far right are probably those of his sister Hortense, Queen of Holland and, after the Restoration, Comtesse de St. Leu.

Following the abdication of Napoleon in 1814, Beauharnais retired to Munich, where he died in 1824, having been created Duke of Leuchtenberg in 1817 by his father-in-law, the King of Bavaria. Also in 1817 he commissioned the architect Leo von Klenze to build a palace for him in Munich, which was completed in 1821. Whether this drawing represents one of the 263 rooms in the Palais Leuchtenberg or a room in one of his several more modest country houses cannot now be determined. Though the room is quite large — there is clearly a third window at a level with the spectator — the decoration is not elaborate. In 1816, Klenze had restored and redecorated a summer retreat for the Leuchtenberg family,

Schloss Ismaning on Tegernsee; the curved banquette in the corner of the room is a characteristic Klenze device, derived ultimately from his master, Schinkel.

Between the banquette and the door is a blond wood secrétaire of typical Biedermeier form; on it, flanked by two marble busts, is an eighteenth-century French lyre-shaped gilt clock under a glass dome. The Empire consoles are backed by looking glasses, reaching almost to the ceiling, which reflect fine glass and porcelain garnitures probably dating from 1830-40. The curved black horsehair sofa and the needlework screen in front of the great porcelain stove are later in style, and likely to be almost contemporary with this view of the room. One of the inhabitants of the room so discreetly delineated by the far window could be Leuchtenberg's second son, Maximilian, who had succeeded to the title on the death of his brother in 1835. He married Grand Duchess Maria of Russia, daughter of Nicholas I, in 1839 and died in 1852.

Otto Wagner was a landscape painter and etcher who was trained in Dresden. After some time in Rome he returned to Dresden, but he travelled extensively in southern Germany and Switzerland.

Literature: Rudolf Pressler and Robin Straub, *Biedermeier Möbel*, Munich, 1986 (Galerie Peter Griebert, Grunwald bei München, Germany).

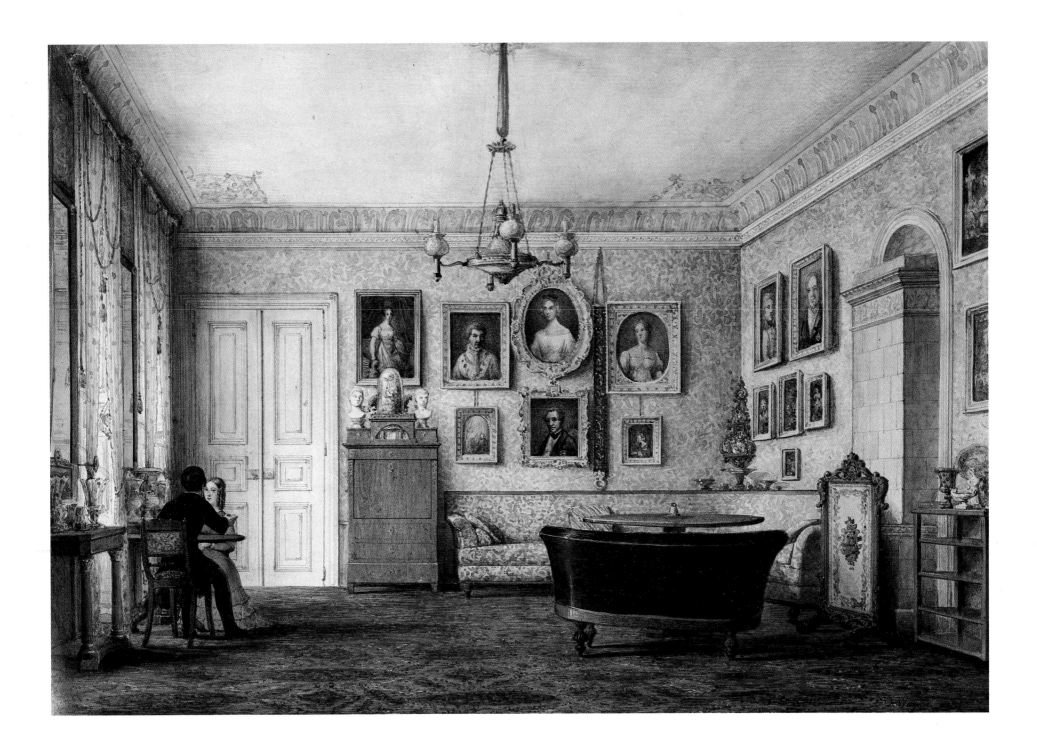

23. *A Room in Schloss Buchwald, c. 1840*

FRIEDRICH WILHELM KLOSE, attrib. (1804-63)

Watercolor and gouache, 9 x 11⅞ in. (23.0 x 31.0 cm)
Inscribed on the reverse "Buchwald"

Schloss Buchwald in Silesia (now part of Poland), the property of Count von Reden and his wife Fredericke von Riedesel zu Eisenbach, was built by Carl Gotthard Langhans, best known for the Brandenburg Gate in Berlin (1789), and his son Ferdinand. Buchwald stands in the wooded foothills of the mountainous Riesengebirge, not far from Breslau (now Wroclaw), where the elder Langhans was active in the second half of the eighteenth century. Set in an English-style garden with Gothic follies, an orangery, and a Classical pavilion commanding a view of the Riesengebirge, it was described by the future President of the United States John Quincy Adams, who paid a visit there in 1800, as an "ornamented farm" (quoted in Erich Wiese, *Biedermeier-Reise durch Schlesien*, 1966, p. 274). Nearby, at Erdmannsdorf, King Friedrich Wilhelm III of Prussia spent the summer months; Schloss Fischbach, the summer residence of Prince Wilhelm of Prussia and his wife Princess Marianne of Hesse-Homburg, was also in the neighborhood, as were Schildau, bought by Friedrich Wilhelm III for his daughter, Luisa of the Netherlands, and the Radziwill castle, Ruhberg. In the summer, these houses were the center of a lively social life for the Prussian aristocracy.

This room, with its green wallcovering bordered by a gold fillet and its overdoors of marbled panels, is furnished in the English style. The bureau-bookcase, the tripod table in the foreground, the nesting table by the entrance to the room at left, and the shield-back chairs are taken from eighteenth-century pattern books like Sheraton's *Drawing-Book*, which had been published

in a German translation in 1794. The chairs may have been made in Germany at the end of the eighteenth century; a similar chair in the Museum für Kunst und Gewerbe in Hamburg has a seat cover finished with a double row of brass nails as here, but it lacks the distinctive curving stretcher. The sofa and matching chairs with embroidered backs and ebonized turned woodwork in the seventeenth-century style must have been inspired by Henry Shaw's influential *Specimens of Ancient Furniture*, first published in 1836. The chair with curving arms facing the sofa is of a type designed by Schinkel after his travels in England in 1826.

Small sculptures, caskets, Antique vases, and a large Venetian glass goblet are arranged round the walls on decorative brackets, set between watercolors of Italian landscapes in gold frames. These and the portrait visible in the next room are probably French. Flanking the bureau-bookcase are figures of boys on pedestals, one holding a Bible and the other praying; they derive from the two orphan boys in the 1825 memorial group at Halle of the theologian and educational philanthropist August Hermann Francke, by the sculptor Christian Daniel Rauch (see Georg Himmelheber, 1990, figs. 30, 31). A similar pair decorated the sitting room of Princess Elizabeth in the Berlin Royal Palace (see Michael Snodin, *Karl Friedrich Schinkel, A Universal Man*, 1991, pl. 73).

The room must have been drawn in summer, for the planked floor is bare and there are no curtains, only a pleated pelmet beneath which can be seen green blinds. The sides of the window embrasure are filled with flowers in two oval jardinières framing a view of trees — mainly conifers — and distant mountains.

The drawing of Buchwald is not signed or dated,

but it is close in style and technique to the views of nearby Fischbach done in about 1840 by Friedrich Wilhelm Klose (see Gere, 1989, pls. 221-22). Klose studied at the Berlin Akademie under Karl Gropius and made his career as an architectural painter. He also worked on a number of views of the Berlin palaces for the Prussian royal family (Praz, 1964, pls. 2, 3, 21, 25, 237-38) and contributed a view of the sitting room in Berlin to the Wittgenstein Album (no. W20).

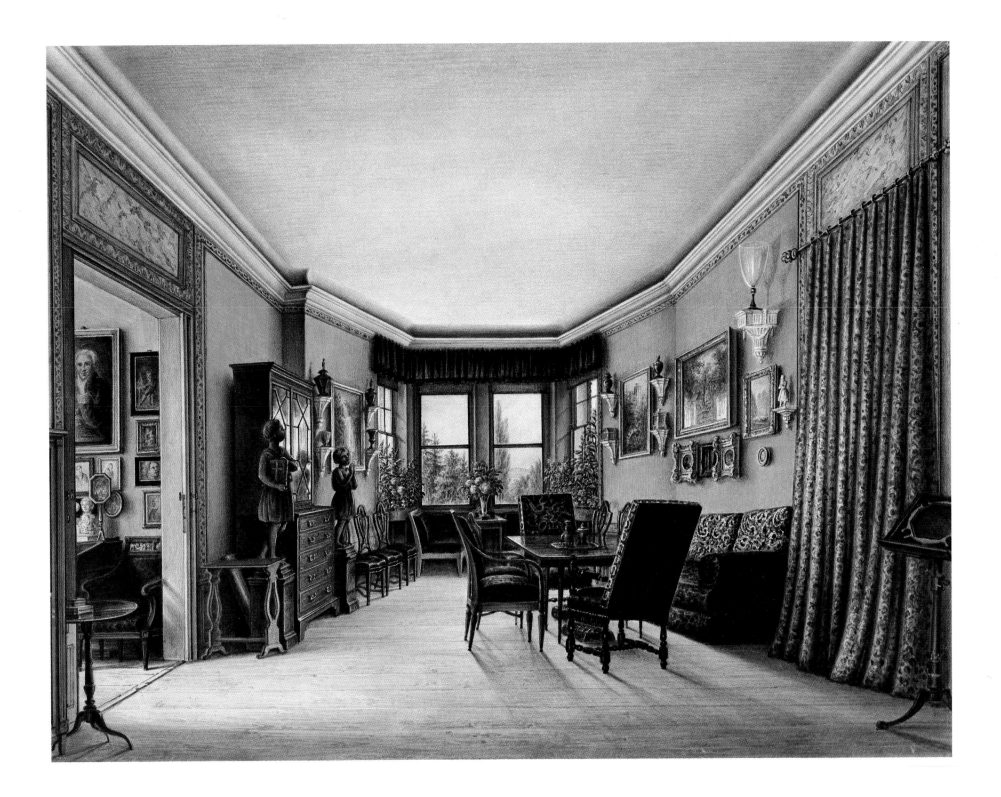

24. *A View of the Oranjezaal, Huis ten Bosch, c. 1850*

TIELEMAN CATO BRUINING (1801-77)

Watercolor and pen over graphite, gum arabic glazing, 17¼ x 17¼ in. (43.8 x 43.8 cm)

The present view is one of a set of four large watercolors showing the whole of the Oranjezaal (Orange Hall) of the Huis ten Bosch (House in the Wood) outside The Hague. It is probably part of a group commissioned from Bruining by Queen Sophia (1818-77), first wife of William III of the Netherlands, to record the interior of their summer residence, the Huis ten Bosch, a seventeenth-century moated palace at the eastern end of a wooded park. The palace was built by Jan van Campen and Pieter Post between 1645 and 1652 for Amalia von Solms, wife of Prince Frederik Hendrik of Orange. The octagonal, forty-nine-foot-high Orange Hall is its showpiece. Celebrating the Triumph of Frederik Hendrik, it was decorated for the widowed Princess Amalia between 1648 and 1653, as a monument to her husband's exploits. The scheme was devised by the humanist Constantin Huygens with the help of van Campen. The room is a mosaic of paintings covering the walls and the reveals of the window bays. This view shows its south side; the other three views, to the north, east, and west, are now in The Pierpont Morgan Library.

The lower tier of the decoration is punctuated by van Campen's large arch-topped canvases of scenes of Triumphs which echo the shape of the triple windows in the bay. Above the windows a large canvas by Gerrit von Honthorst shows *The Marriage of Frederik Hendrik and Amalia von Solms*. Ancestral portraits and armorial cartouches surround the window bay, continuing the central theme. Around the room are other paintings by Honthorst, works by Everdingen, Jor-

daens (*The Triumph of Prince Frederik Hendrik*, a magnificent example with subtly transparent coloring in Jordaens' most exuberant manner), and Jan Lievens. Bruining's mid nineteenth-century view shows a different arrangement from the original, which has since been restored.

The Oranjezaal has been the subject of detailed art-historical investigation. The iconography and the individual paintings with which it is decorated are discussed by Jan van Gelder ("De schilders van de Oranjezaal," in *Nederlandsch Kunsthistorisch Jaarboek*, 1948-49, pp. 118-64), by Hanna Peter-Raupp (*Die Ikonographie des Organjezaal*, Hildesheim-New York, 1980), and by Beatrijs Brenninkmeyer-de Rooij ("Notities betreffende de Decoratie van de Oranjezaal in Huis ten Bosch," in *Oud Holland*, 1982, pp. 133-85).

The Huis ten Bosch had traditionally been used as a summer retreat, but Queen Beatrix has chosen it as her principal residence. Apart from the Oranjezaal, it contains a dining room painted in 1749 by Jacob de Wit with mythological scenes in *grisaille*, a Chinese room with eighteenth-century wallpaper, a Japanese room with embroidered hangings, and a Chinese boudoir, also with embroidered hangings.

A number of artists were recording interiors of the Dutch royal residences for Queen Sophia in the 1840s and 1850s. Nine more studies by Tieleman Cato Bruining of the principal rooms in the palace survive in the Koninklijk Huisarchief in The Hague. It is on the basis of these that the four views of the Oranjezaal are attributed to him, though P.F. Peters and H.F.C. ten Kate were also involved in the recording of Queen Sophia's interiors (see Praz, 1964, pls. 305-12).

Exhibited: Pierpont Morgan Library, New York, 1985, n. 74; Hartwick College, Oneonta, New York, 1987, no. 15.

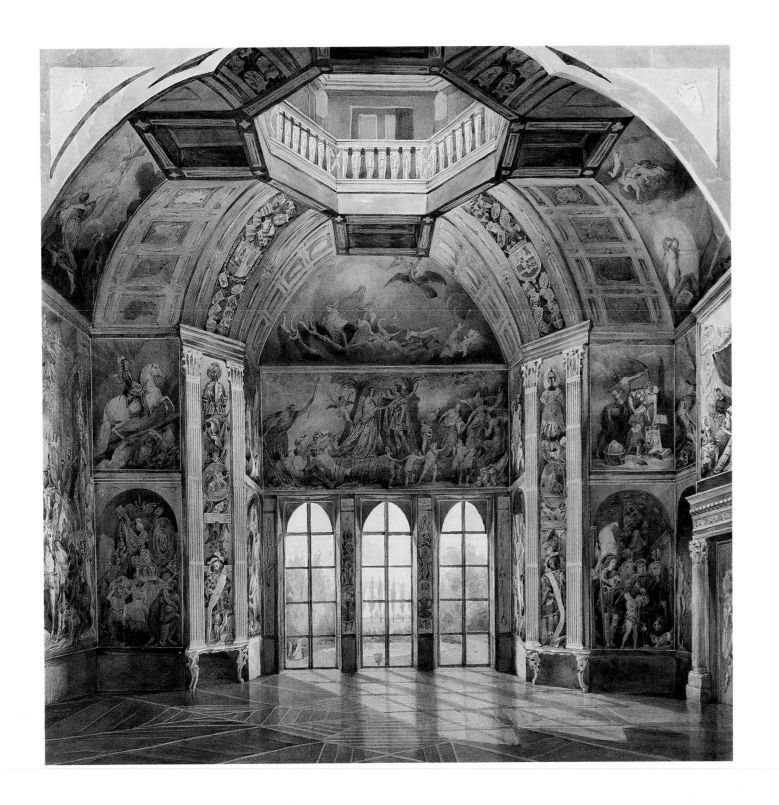

25. *The Library at Dingestow Court, c. 1850*

CHARLOTTE BOSANQUET (1790-1852)

Watercolor and pen with black ink over graphite, 6⅜ x 9⅜ in. (16.2 x 24.0 cm)
Inscribed on old labels affixed to the backboard of the original frame "Library at Dingestow as it was in the time of Samuel Bosanquet and Emily Courthope, his wife, whom he married in 1830," "The Library at Dingestow Court about 1850," and "S Beach, Framer, Monmouth"

Charlotte Bosanquet came of a large family of Huguenot origin. Eldest daughter of the banker William Bosanquet and his wife Charlotte Elizabeth Ives of Norwich, she had five brothers and three sisters. The four branches of the Bosanquets constituted a wide-flung family network, and Charlotte painted many views of the houses of her brothers and cousins. She assembled two large albums of these, one of exteriors and one of interiors, which are now at the Ashmolean Museum, Oxford. As her nephew Gustavus (d. 1933) remarked, "She drew a great deal." These drawings are a valuable record of a wide spectrum of the unpretentious and well-used rooms in the town and country houses of the English gentry. Though his London house in Harley Street is included, Dingestow Court in Monmouthshire, the house of her cousin Samuel (1800-82), does not feature in the albums, and the label of a local framemaker suggests that Samuel laid claim to this view of his library as the artist completed it.

Known to date from the seventeenth century, Dingestow Court is said to have been built in 1623 on the site of an earlier house. Alterations in the eighteenth century included the enclosing of the Jacobean front with a Georgian façade. In 1843 the house was extensively renovated by Lewis Vulliamy, who returned it to a style approximating to that of the original date or rather earlier. The library is completely lined with bookshelves and is virtually without ornaments or works of art save for a few bibelots on the table in the window. The square Corinthian columns and pilasters enclosing the shelves, the frieze with classical busts above them, the panelled overmantel, and the compartmented ceiling with plasterwork ornaments in high relief are inspired by the English Renaissance style of the period of Henry VIII. Though it would have been possible to furnish the room appropriately with Tudor-inspired pieces modelled on the illustrations in Henry Shaw's *Specimens of Ancient Furniture* (1836), the Samuel Bosanquets preferred a miscellaneous collection of comfortable Victorian chairs and sturdy tables. The scheme has been given some semblance of unity by the red-and-white striped slipcovers on the chairs and sofas. The windows are curtained in red, with heavy wooden poles and rings, but the glazed double doors in the pedimented embrasure at the end of the room, leading out into the garden, have neither curtains nor shutters.

It is interesting to see that the owners never envisaged complementing the architectural decoration of the recently completed Tudor Revival scheme with pedantically correct furnishings, but preferred a comfortable and useful room.

Exhibited: Pierpont Morgan Library, New York, 1985, no. 71; Hartwick College, Oneonta, New York, 1987, n. 3.

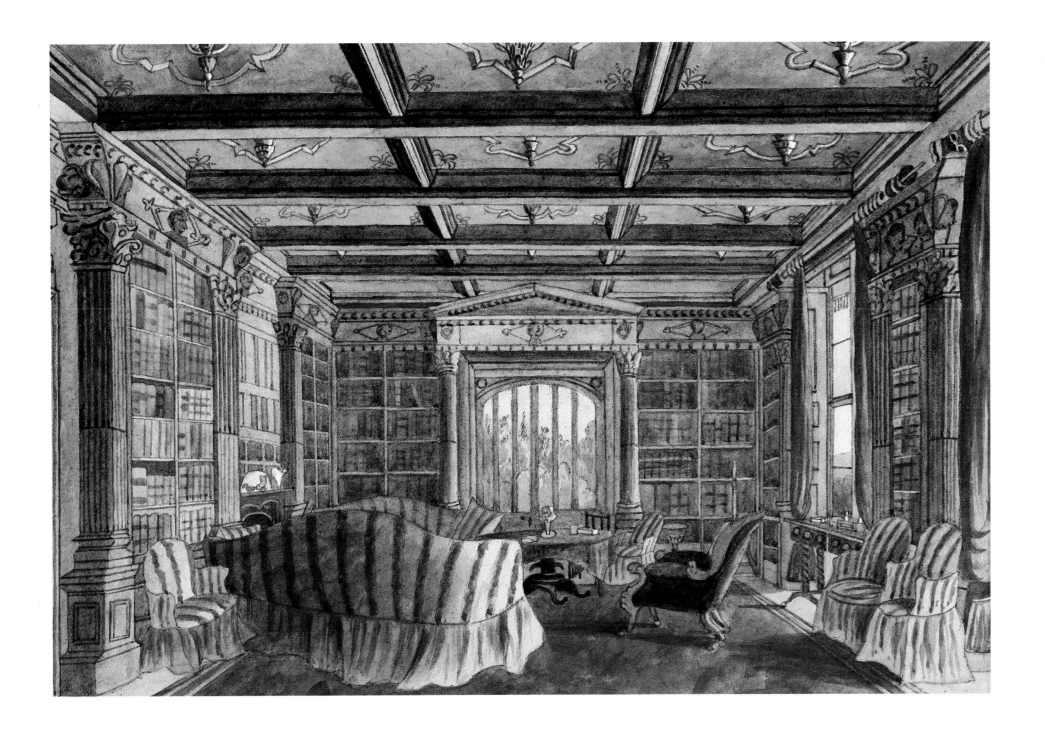

26. *An Artist's Studio, c. 1850*

JULIE BAYER (fl. 1850s)

Graphite and watercolor, 7⅜ x 11¹⁵⁄₁₆ in. (18.8 x 30.4 cm)
Signed lower right "fec. Julie Bayer," defaced inscription in
German on the reverse

It is tempting to assume that the figure shown
reading on the sofa is a self-portrait, and that this
is Julie Bayer's own studio. There is evidence of
female occupation: a pincushion and scissors
hang on the wall at the right beneath the mirror; a
miniature chest of drawers for trinkets stands
behind the small portable writing desk on the
table at the left; there is a cluster of ornaments on
the carved bracket under the portrait on the far
wall; and the sofa is elaborately *capitonné* in the
latest Parisian fashion. The hanging cuckoo clock
with a porcelain face is Swiss. The musical
instrument on the sofa is a zither.

The room is predominantly a working studio.
The small panel propped up above the canvas on
the easel is no doubt a sketch being transferred to
a larger format. Casts of what seem to be a
Medieval standing figure and an Antique bust are
stored on the disused stove, and there is another
bust on top of the shelves between the windows.
Disembodied pairs of hands hang on the wall
beyond the second window. A palette and
brushes have been set down beside an open book
on the largest table, and drawing instruments
hang on the side of the shelves, which are
covered with a protective green curtain. The
brown curtain roughly strung on a wire across
the room must have been intended to obtain
some privacy for sleeping quarters at one end.

Though far from being a romantic Bohemian garret,
this room is bleak in its absence of window curtains
or floor covering. A small iron stove has been
substituted for the original large tiled stove.

It is disappointing to find no record of Julie
Bayer's career. This interior view is handled in its
considerable complexity with professional com-
petence, and it is unlikely to be the only surviving
example of her work.

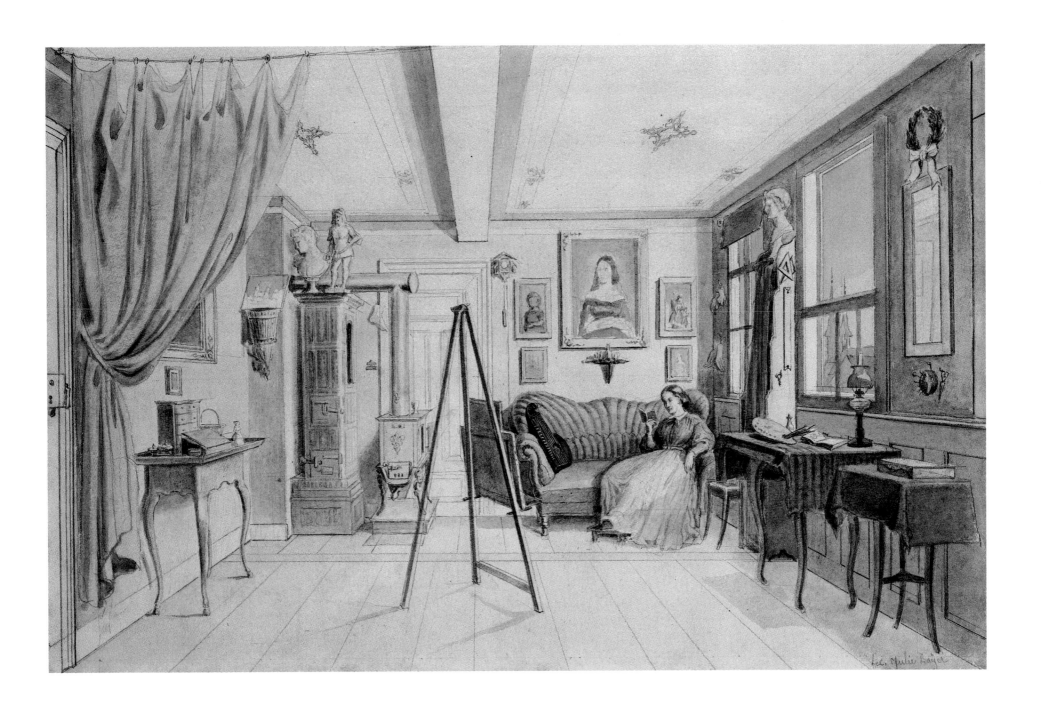

27. An Interior with a Curtained Bed Alcove

AUSTRIAN (1850s)

Watercolor and gouache with touches of gum arabic over graphite, 11⅝₁₆ x 8⅞₁₆ in. (28.7 x 21.4 cm), Whatman paper with dated watermark, possibly 1853

European town apartments frequently consisted of an enfilade of living rooms ending in a narrow boudoir with a bed behind a curtain. In this drawing the centrally placed door in the right-hand wall and the mirror opposite, which would have reflected the vista through the door, suggest that this is such a bedroom-boudoir. The bed alcove is simply contrived with a pair of curtains and a pelmet in the Moorish taste across one end of the room, not attached to the ceiling. The position of the bed to one side of the alcove suggests that there was access to a dressing room behind the spectator. Almost unknown in England except for intercommunicating state apartments in a large mansion, the *en suite* arrangement was a common feature of apartment buildings in Paris and Vienna, whether purpose-built or converted. The bedroom led directly out of the drawing room and served as an extension to it, in which company could be entertained once the bed was concealed behind the curtain. The toilet apparatus would have been in the adjoining dressing room. César Daly remarked in 1852 that "as a result of a certain ease of manners, the absence of prudishness, and the intense love of company, the modesty of fortunes and the diminutiveness of lodgings in Paris, the bedroom of the mistress of the house often serves to supplement the drawing room" (quoted in Donald J. Olsen, *The City as a Work of Art, London, Paris, Vienna,* 1986, p. 125, with an invaluable discussion of the nineteenth-century apartment building and its plan).

It has been suggested that the present drawing is

Austrian. There are still some traces of the Biedermeier style, but by the 1850s distinctively national features had all but disappeared from furniture and decoration. The Parisian apartment of the type described by Daly was much admired and imitated in Vienna. The use of one half of the bedroom for writing, sewing, and gossiping and for the display of pictures and bibelots left the adjacent room to be the formal salon valued by the Viennese bourgeoisie as a mark of gentility. That this boudoir was used to receive guests is suggested by the elegance of the decoration, with the elaborate curtain and pelmet arrangement framing the tall window, the wide-striped mauve-and-white wallpaper, and the luxurious patterned carpet covering the whole floor of the room. The walls are densely hung with pictures, and others, apparently portraits, are on the writing table and the gold-and-black lacquer cabinet in the corner. Two more are on a two-tiered easel that stands facing the light. Armchairs covered in a lattice-patterned fabric are placed round a table littered with books, boxes, sewing basket, and inkstand, which enhances the informal character of the room.

The anonymous artist of this interior has tackled with an evidently practiced dexterity the complex perspective of tall, narrow room, massed pictures on the walls, and furniture with convincingly rendered shadows. If this is an amateur work, it is by a gifted and well-taught hand.

Literature: Gere, 1989, pl. 220.
Exhibited: Pierpont Morgan Library, New York, 1985, no. 70; Hartwick College, Oneonta, New York, 1987, no. 12.

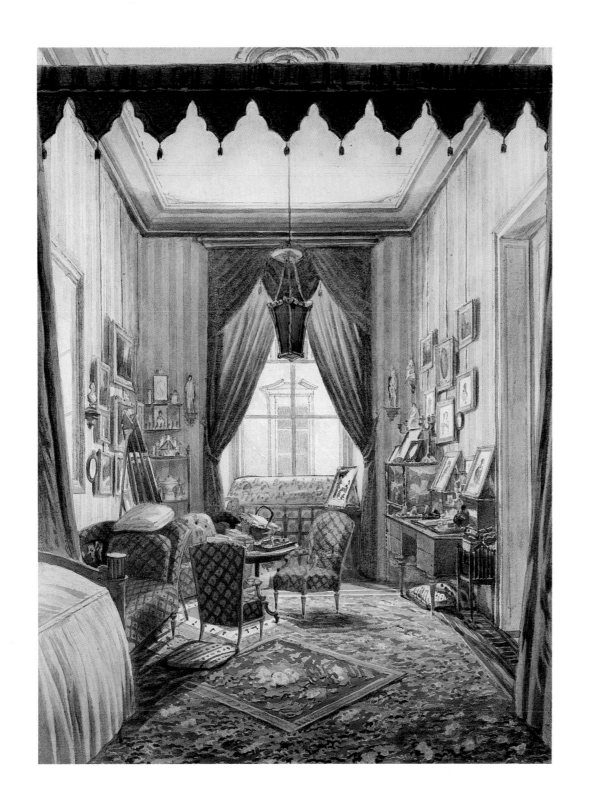

28. *The Sitting Room at 7 Owen's Row, Islington, 1855*

RICHARD PARMINTER CUFF (1819/20-76 or later)
Watercolor and grey wash over graphite, 11 x 13½ in. (27.9 x 34.3 cm)
Signed, dated, and inscribed lower left "R P Cuff, London 7 Owen's row, Goswell road, Augt 1855," on the reverse a study of the head of a young woman inscribed "R P Cuff anno 1855"

Owen's Row was developed in 1773 by Thomas Rawstone, an Islington bricklayer, and runs between St. John Street and Goswell Road. A bombing raid in 1940 destroyed all but four of the fifteen houses in the Row.

Readers of Charles Dickens' *Pickwick Papers* (chap. XII) will remember that "Mr Pickwick's apartments in Goswell Street, although on a limited scale, were not only of a very neat and comfortable description, but perfectly adapted for the residence of a man of his genius and observation. His sitting-room was the first floor front, his bed-room the second floor front; and thus whether he were sitting at his desk in the parlour, or standing before the dressing-glass in his dormitory, he had an equal opportunity of contemplating human nature in all the numerous phases it exhibits, in that not more populous, than popular thoroughfare."

In Owen's Row, Parminter Cuff has drawn an almost Dickensian scene. The room and its formal arrangement are of an earlier era. There is hardly a piece of furniture or an ornament less than thirty years old; the drop-leaf pedestal table, the chairs, the sewing table with its pleated silk well, the flowered needlework hearth rug, the japanned hand-screens for shielding the face from the fire visible at each end of the mantelshelf, and the little ornaments all date from the first two decades of the nineteenth century. Only the engravings in their gold frames have been added later.

Mr. Pickwick's sitting room, as depicted by his illustrator, Hablot K. Browne ("Phiz"), suggests a room very much like this one in Owen's Row, even to the elegant eighteenth-century marble fireplace and the striped and flowered wallpaper. The restricted nature of Mr. Pickwick's quarters must have obliged him to eat in the sitting room, and the same is plainly true of the Owen's Row room, in which the heavy damask crumbcloth is still spread over the patterned carpet in readiness for the next meal, when the table will be lifted onto it and the carefully arranged books removed. Mr. Pickwick's room overlooked the street, providing him with diversion very much to his taste, but the ample window seen here has a view of trees, and the artlessly arranged vase of flowers on the sewing table adds a rural touch.

The Owen's Row house belonged to John Peacock, minister of the Spencer Place Baptist Chapel, and his wife Deborah. The 1851 census reveals that they were respectively seventy-one and sixty-four, so the plain Regency furniture must date from their early married life. Richard Parminter Cuff, architect and engraver then aged thirty-one, and his brother William, a bookseller aged twenty-nine, shared lodgings in the house. The brothers were born in Wellington in Somerset. The ghostly female figure in the drawing suggests that by 1855 one of them had married. There is a study on the reverse for the head of a young woman, possibly the subject of the unfinished portrait, wearing a hat decorated with a fern-leaf.

A companion drawing of the other half of this room shows that William conducted his book-dealing business on the premises (fig. 6). Books fill every available shelf, and a wire hook suspended by the fireplace and stuffed with documents, presumably bills and receipts, suggests a busy commercial operation. A young woman is shown seated at a table with her folding writing desk, attending to correspondence and bills. Perhaps this is a finished portrait of the ghostly figure in the sitting room. By 1860 Parminter Cuff had moved from Owen's Row and was living in nearby Holford Street.

Parminter Cuff exhibited at the Royal Academy in London from 1860 to 1876. He was one of the illustrators commissioned by John Ruskin to work on the second edition of *The Stones of Venice*, replacing the original plates made by Ruskin himself, which had become worn. Minutely supervised by Ruskin, to whom he gave satisfaction — he was referred to as "the good Mr Cuff" — he brilliantly transferred the drawings to the printed page. In his interior views, however, his style and technique, particularly in rendering the effects of light, show the influence of William Henry Hunt.

Exhibited: William Drummond, London, 1976; Hazlitt, Gooden & Fox, London, 1981, no. 28; Pierpont Morgan Library, New York, 1985, no. 73.

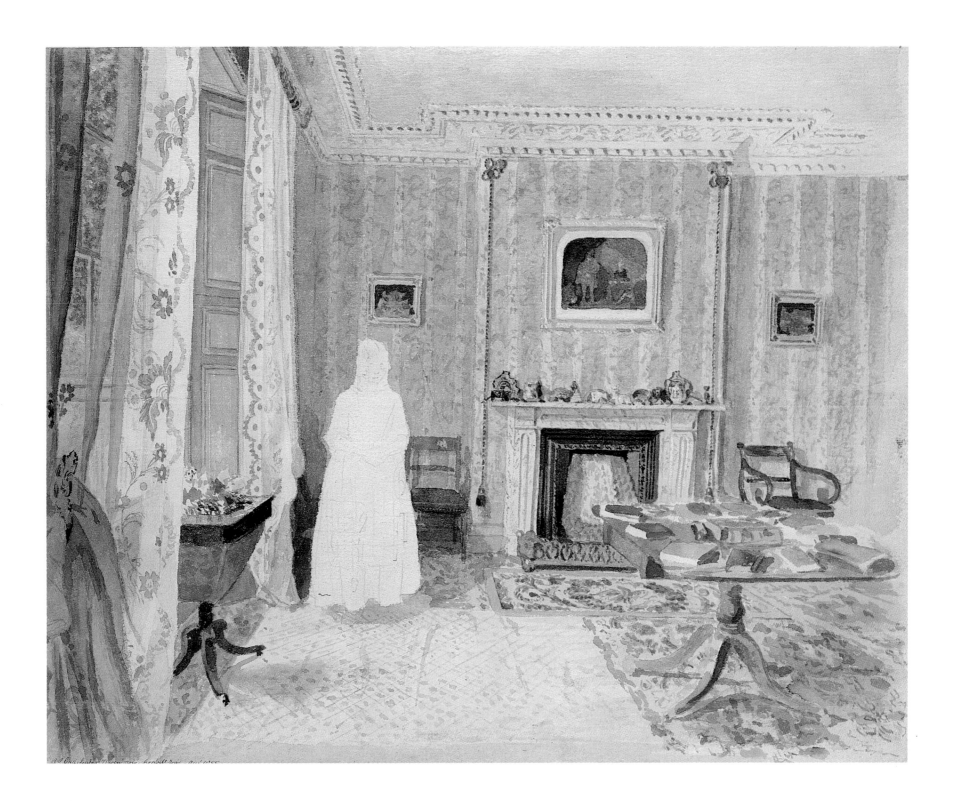

29. *A Salon, Probably in Stuttgart, c. 1850*

CASPAR OBACH (1807-65)

Watercolor over graphite, with accents of gold paint, 9¾ x 14¹⁵⁄₁₆ in. (24.8 x 36.4 cm)
Signed lower right "C. Obach"

This irregularly shaped room with its old-fashioned casement windows and eighteenth-century panelled skirting has been brought up-to-date by means of a carefully coordinated scheme of decoration. An arrangement of curving plain and gilt wooden pelmets edged with long blue fringes and hung with lace curtains and inner muslin blinds occupies the whole of the right-hand wall and ingeniously unites the window openings of different sizes. The two armchairs in the blue-upholstered suite of furniture are trimmed with the same blue fringing as the pelmets and the tasselled tiebacks; the upholstered seats of the stools in the bay window match the tablecloth. Just visible in the bay, which is flanked by a handsome pair of foliage plants in green wrought-iron plant stands, is a flower-filled wooden jardinière which forms part of the suite of Rococo Revival furniture. The expanse of polished parquet is unbroken but for a patterned square rug, probably of needlework, under the table. The plain buff walls are finished below the ceiling molding and above the baseboards with a band of olive green outlined in gold.

To judge from the costume of the man on the sofa, this view cannot be much earlier than the 1850s. The room is surprisingly uncluttered for that date, though there is more than a suggestion of splendor in the heavy marble chimneypiece, the overmantel mirror, the fine French gilt-bronze clock under a glass dome, and four-branch candelabra and six-branch central chandelier in gilt and patinated bronze.

On the walls are carefully arranged groups of monochrome portraits. Some may be engravings, but it is tempting to suppose that the oval frames arranged in a circle above the settee and possibly some of the other frames may contain portrait photographs, which at this period were still a prized novelty. The circular object hanging between the windows is an aneroid barometer.

Caspar Obach was one of the artists chosen in the 1850s by Crown Princess Olga, wife of Crown Prince Karl of Württemberg, to record the interiors of their Renaissance-style Villa Berg, built by Christian Friedrich Leins, between 1843 and 1853. Faced with the intricate carved and molded decoration of the Villa Berg library Obach achieved the same clarity and precision as in this much more modest room (cf. Thornton, 1984, pl. 385). Obach, who was primarily a landscape painter, was born in Zurich, where he was a pupil of Fuseli, but in 1825 he settled in Stuttgart, where he was to stay for the rest of his life.

Literature: Rudolf Pressler and Robin Straub, *Biedermeier Möbel*, Munich, 1986 (Galerie Peter Griebert, Grunwald bei München, Germany).

30. *A Moorish Smoking Room, 1856*

EMMANUEL COULANGE-LAUTREC (fl. 1856-after 1877)

Watercolor and gouache, 11½ x 9½ in. (29.3 x 24.1 cm)
Signed and dated lower left "E de Coulange inv. 1856," inscribed on the reverse "E. Decoulange / 1856 / superbe aquarelle / infinie de détails / Salon en 1856 / coll. Zola"

Before the middle of the nineteenth century, prejudice against smoking indoors was widespread and enjoyment of the habit involved smoking either out of doors or up the chimney. Queen Victoria hated smoking and banned it long after the example set by soldiers returning from the Crimea — who learned the habit from the Russians — had been followed throughout society. Sir Frederick Ponsonby (*Recollections of Three Reigns*, 1951, p. 17) described the arrangements which the Queen had made when faced with the problem of a son-in-law who smoked: "It was not so bad as if he drank, but still it was a distinct blemish on his otherwise impeccable character. The Queen, however, decided to be broadminded and actually to give him a room where he could indulge in this habit. A small room was found near the servants' quarters which could only be reached by crossing the open kitchen courtyard, and in this bare room was placed a wooden chair and table. She looked upon this room as a sort of opium-den."

In contrast, the specially designed smoking room in well-appointed houses from the 1850s onwards was a place of exotic luxury, like this Moorish-style kiosk. It is a square room with canted corners occupied by arch-topped niches, rising to a coved and panelled ceiling at the center of which is an open arcade to provide ventilation. A chandelier of four oil lamps shaded with glass globes hangs from a carved and gilded boss. The room is patterned all over with gilded Moresques

in red, green, and yellow, and the rich effect is intensified by the reflections in the five mirrored panels set into the fireplace wall. Though our view of the room is through a curtained proscenium, as if we were facing a theater stage, it is clear from the reflected image that the decoration is carried right round the walls. Tall Moorish-style porcelain vases occupy the shelf in each niche above small, double, built-in banquettes with striped upholstery. A Moorish-style table stands at the center of the room, and the *garniture de cheminée* consists of a clock flanked by pairs of Alhambra-style perfume flasks and tazzas.

The Moorish or Arab kiosk was thought particularly appropriate for the smoking room, and many designs survive. This example is relatively early in date, though some ten years before, in 1847, Alexandre Dumas had installed an intricately carved Turkish room in his Renaissance-style Château de Monte-Cristo. By this time there were publications to inspire these exotic interiors; Owen Jones' *Plans, Details and Sections of the Alhambra* had been issued in parts from 1836 to 1845, and more significantly for a French patron the *Description de l'Arménie, la Perse et la Méso-potamie* by Charles Texier had appeared in 1845. Coulange-Lautrec made another drawing of a Moorish smoking room in 1863 (Hazlitt, Gooden & Fox, *Interiors*, 1981, no. 80), and the celebrated Parisian decorator Alexandre Prignot produced Moorish schemes in the 1870s (see fig. 12). César Daly included in his *Décorations intérieures peintes* of 1877 a Moorish smoking room from the Château Crêtes in Switzerland, by the architect J.-B. Laval and the decorative painter Denuelle (*L'Architecture privée au XIXe siècle*, third series, 1877). King Ludwig II of Bavaria, that great connoisseur of the exotic, had two Moorish kiosks, both of Parisian manufacture, at Linderhof, his miniature Versailles in the mountains.

By 1897 Edith Wharton and Ogden Codman had noticed the demise of this particular form of exoticism: "The smoking-room proper, with its *mise en scène* of Turkish divans, narghilehs, brass coffee-trays, and other Oriental properties is no longer considered a necessity in a modern house; and the room which would formerly have been used for this special purpose now comes rather under the head of the master's lounging-room or den" (*The Decoration of Houses*, 1897, reprinted 1978, p. 151).

Emmanuel de Coulange, or Coulange-Lautrec, was born in Nîmes. He studied at Marseilles and returned there in 1877 as a professor at the École des Beaux-Arts. He exhibited at the Salon from 1856, while also working as an illustrator for the deluxe publications of a firm in Saint-Germain-des-Prés in Paris.

31. *A Sitting Room with a Writing Table, 1867*

WILHELM AMANDUS BEER (1837-1907)

Watercolor and gouache with accents of gold paint over graphite, 10½ x 13½ in. (26.7 x 34.3 cm)
Signed and dated lower right "W.A. Beer. fec. 1867 im März"

Though this unpretentious room does not look self-consciously contrived, the furniture is in the latest style, and considerable pains were evidently taken over the details of the decoration. At an angle to the window for the best light is a desk in the newly-fashionable revived Rococo style, partnered by a table with elegant cabriole legs of the same type. The round center table with a rust-colored plush cloth, its wide patterned border almost brushing the floor, is characteristic of the 1860s. The patent folding chair against the wall behind the table is similar to examples pioneered in the United States in the 1860s by the German immigrant chairmaker George Hunzinger (1835-98). Much of Hunzinger's furniture was produced at his birthplace in Tuttlingen, a German city near the Swiss border. The chair is covered in a striped material from North Africa, then much in vogue for upholstery and hangings. On the other side of the fireplace is an armchair upholstered in cut velvet with a double row of contrasting piping and finished with a thick fringe. A heavy ebonized cabinet with ormolu mounts and scrolling gilded ornament between the windows is matched by a black-and-gold folding screen at the far left. The ornate fireplace set across the corner of the room is surmounted by an angled étagère in the same Rococo style as the desk and table; on it is displayed a variety of precious ornaments, including a fine clock of ormolu and rock crystal with an urn-shaped finial. The curving shelves are edged with crimson silk fringe secured by a gold fillet.

The most conspicuous object in the room is the carved fire screen inset with an embroidered panel of a white horse in parade trappings on a background of brilliant green. The boldly patterned carpet and the scattered ornaments show evidence of Oriental inclinations. On the walls are mainly engravings after contemporary paintings, including Paul Delaroche's popular *Death of a Christian Martyr* (Louvre, Paris; reduced version in the Walters Art Gallery, Baltimore); it hangs over an inconspicuous jib door in the center of the wall, so cleverly incorporated into the wall-covering and the panelled dado as to be almost invisible. As a sign of decorative sophistication, a fabric matching the curtains has been used to cover the walls and the upper part of the jib door, including the surface of the lock. The edges of the fabric under the ceiling molding and above the dado are finished with a gold fillet in the eighteenth-century manner.

It is evident that the room, though not particularly large, has been the object of considerable expense. The fashionable French taste of the furnishings provides no evidence as to the whereabouts of the house; lavish expenditure outstrips time-lag in the spread of decorative fashion. The movements of the artist may provide some clue. Beer was born in Frankfurt am Main and studied there at the Städelsches Institut under the celebrated professor of history painting Edward Steinle. After some time in Antwerp and Paris he went to Russia, where he travelled extensively and became fascinated by the folk traditions. Russian peasant life grew to be his favorite subject matter, to such an extent that he was known as "Russian Beer." He returned to Frankfurt in 1870, and from 1897 until his death he taught at the Städelsches Institut. He worked mainly in oils but executed some painstakingly accurate watercolors like the present example. It is tempting to suggest that this room was in Russia, where he found his greatest inspiration.

32. *A Salon in Vienna, 1872*

FRANZ ALT (1821-1906)

Watercolor and gouache, 8¾ x 12⅝ in. (22.2 x 32.0 cm)
Signed and dated lower left "Franz Alt 1872"

This view shows a formal salon, probably in Vienna, with a carefully coordinated scheme of decoration, a collection of paintings in heavy gold frames on the walls (including a watercolor of a popular subject, the Scaliger tomb in Verona), and two drawings on a double easel by the window. In the adjoining room portraits are massed above a writing desk. In both rooms the walls are pale in contrast to the rich blue of the upholstery and curtains. The painted ceiling is delicately tinted in keeping with the cream wallpaper patterned in grey with swags and flowers.

Even if the artist had not dated this watercolor it would be evident that the rooms had been decorated and furnished in the 1870s. The taste for black-and-gold Japanese lacquer and black-ground *"famille noire"* porcelain vases is characteristic of the period. On the round table in the near window is a circular panel of Chinese embroidered silk bordered with a crocheted fringe in deep blue and cherry red. What may be a pair to it is on the table in the center of the farther conversation group. On the nearer square table is a paisley-bordered cloth, also of Oriental embroidered silk. In the center of the table is a brocade-pattern covered cup mounted in gilt-metal. On the gilded Rococo Revival pedestal table by the door is a miniature version of Falconet's equestrian statue of Peter the Great, which stands on a huge granite rock by the Admiralty building in St. Petersburg. The Louis XV-style white-and-gold console table between the windows supports a pair of many-branched candelabra whose lights would have been reflected and enhanced by the tall mirror. Like the central chandelier and the three-branched girandoles flanking the mirror, which may have come from the French Baccarat factory, they are of Louis XV inspiration. A taste for the French eighteenth century is a further mark of the 1870s; the three-tiered whatnots with cabriole legs, supporting respectively a pair of vases and a black-and-gold lacquer canister, are inspired by a Louis XVI *table à café*.

The suite of spoon-back easy chairs, side chairs with cabriole legs, and sofas is upholstered in blue velvet, with a central band of floral needlepoint embroidery and with contrasting piping and fringed edging that pick up the colors of the flowers as well as the velvet. In the 1870s this upholstery treatment replaced the ubiquitous buttoning of the Second Empire. The theme of the upholstery is repeated in the heavy portière and the window pelmets. The season must be summer, as sunlight floods into the room and the only curtains are of filmy patterned lace. The floral motifs in the upholstery panels are echoed in the repeating lozenges patterning the carpet that covers the floor from wall to wall and continues into the room beyond. The lacy black-and-gold Gothic frame of the firescreen in front of the bombé ceramic stove is earlier in taste, but this intricate carving remained popular in Austria and Germany until well into the 1880s.

Unexpected in this formal and opulently appointed salon are the mass-produced bentwood chairs with cane seats, one of the earliest designs, (about 1855) manufactured by the Viennese firm of Thonet. In 1869 the patent restraining the copying of this model ran out and other firms seized the opportunity to fill the demand for these popular, portable chairs. Their inclusion suggests that the room is arranged for some entertainment for which even the extensive suite of upholstered furniture was insufficient.

Franz Alt was the son of the painter Jacob Alt and brother of Rudolf von Alt, the celebrated architectural and topographical draughtsman. He was born and trained in Vienna and was based there throughout his career, but he travelled all over central and southern Europe painting landscapes as well as architectural and interior views.

Literature: Gere, 1989, pl. 55.
Exhibited: Hazlitt, Gooden & Fox, London, 1981, no. 86.

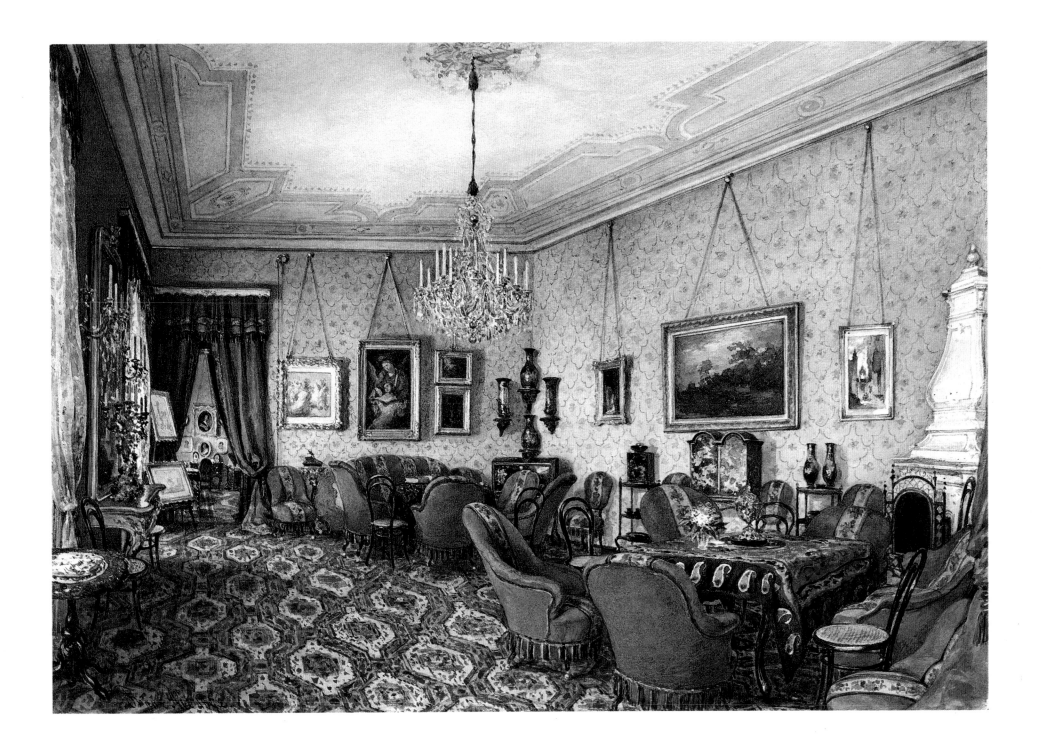

An Elizabethan Room at Lyme Hall, Cheshire, 1844 and 1872

JOSEPH NASH (1808-78)

Watercolor and gouache over graphite, with gum arabic, 13⅛ x 19⅟₁₆ in. (33.3 x 48.4 cm)
Signed and dated lower right "J Nash 1872"

This is a repetition of pl. I, entitled "Bay Window, Lyme Hall Cheshire," in the fourth series of Joseph Nash's popular and widely influential *Mansions of England in the Olden Times* (1839-49). In 1844 Nash exhibited a watercolor of the same title at the Society of Painters in Watercolours (no. 15), probably the version that was to serve for his publication. During the remaining thirty years of his membership of the Society he exhibited a great many of the interiors that had featured in the *Mansions*, with repetitions year after year of the most popular subjects. However, this late version of the room at Lyme Hall was not exhibited, and may have been done at the request of one of Nash's patrons.

In the 1870s, the increased interest in "Olde English" architecture would have made this painting even more relevant to contemporary taste than it had been in the 1840s. The room contains many of the elements that characterized the style: the carved panelling and heavily molded plasterwork on walls and ceiling, the overmantel with its armorial cartouche, the deep window embrasure reached through a pointed and panelled arch, and the bay window densely set with panes of armorial stained and painted glass. Elizabethan carved oak chairs were being copied by several firms, and there could be no difficulty in recreating an interior in this fashionable idiom.

The subjects covered in the four volumes of Nash's *Mansions* can be broadly described as Tudor and Elizabethan — "an era most prolific of splendour and originality of style, stimulated by the advance of national prosperity and greatness, and when the arts may be said in this country to have first begun to flourish." Nash has been somewhat disingenuous in suppressing the fact that the chief glories of Lyme are the later saloon with its gilded ceiling and Grinling Gibbons carvings and the Palladian remodelling by Giacomo Leoni; but he is at pains to justify his depiction of one of only two surviving sixteenth-century rooms in view of the "extraordinarily rich" ornamentation. The Tudor house was built by Sir Piers Legh, and successive generations of the family extended it in the eighteenth and nineteenth centuries. When Nash made his drawing of Lyme in 1844, the architect Lewis Wyatt had already added his Victorian version of Tudor to the house.

The local town, Disley, has now crept up to the boundaries of the park, but in the 1840s the house was still lived in by the Legh family, who had been in possession of the estate since the fourteenth century, and the park remained romantically untamed: "It stands," wrote Nash, "in an extensive park, which partakes much of the wild character of the neighbouring wood.... The park of Lyme is celebrated for its wild cattle, which have been kept here from time immemorial. There are also here preserved a noble breed of dogs, known by the name of Lyme Mastiffs."

Joseph Nash was a pupil of Augustus Charles Pugin, with whom he collaborated in his early career on, for example, *Paris and its Environs* (1829). He had been educated as an architect, but abandoned this in favor of a career as an illustrator and architectural draughtsman. His early exhibits at the Society of Painters in Watercolours were mainly illustrations to Shakespeare and to contemporary poetry and novels. During the work on *Mansions* he was also preparing his *Windsor Castle Sketches* (1848); the chromolithographed plates of both publications reproduce with extraordinary fidelity his meticulous watercolor style.

Exhibited: Hartwick College, Oneonta, New York, 1987, no. 7.

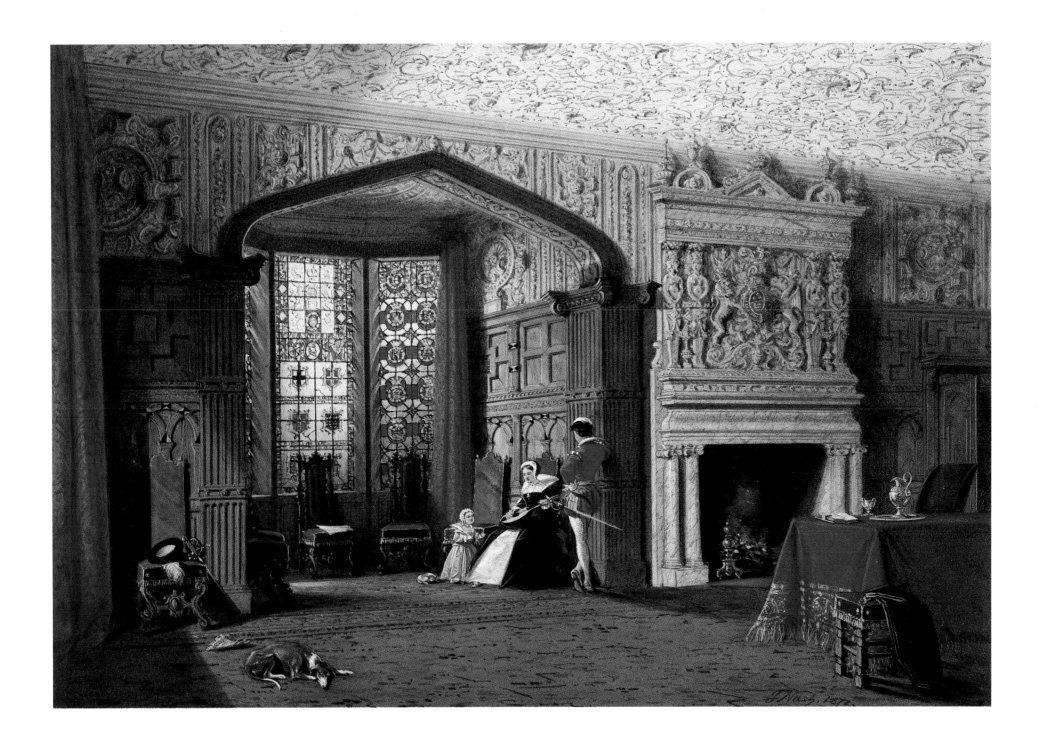

34. *Sir Lawrence Alma-Tadema's Library in Townshend House, London, 1884*

Anna Alma-Tadema (1867/68-1943)

Pen and ink and watercolor, 13 x 17¾ in. (33.0 x 45.0 cm)
Signed and dated lower left "Anna Alma Tadema 19/11/84"

Of the much-admired artists' houses in late nineteenth-century London, only the Gothic Revivalist architect William Burges' fanciful Tower House in Kensington was more conspicuously described and illustrated than Alma-Tadema's Townshend House near Regent's Park. In 1869 the Dutch-born Alma-Tadema came to England, where he was to establish a phenomenally successful career as a painter of genre subjects of ancient Roman life. In the following year he acquired the large Italianate house opposite the North Gate of the park which he immediately set about transforming into a Pompeian villa. But on October 2, 1874, four tons of gunpowder exploded in a barge on the nearby Regent's Canal; and, as *The Times* moralized, "the artist who has revived for us Pompeii in all its glory has a mournful opportunity of studying an image of Pompeii in its desolation."

The owner had to move out for a year while the house was rebuilt, but he seized the opportunity to create an even more sumptuous interior. Comparison of illustrations of the house before the explosion with later descriptions by Mrs. Haweis (in *Beautiful Houses; Being a Description of Certain Well-Known Artistic Houses*, 1882) and Moncure Conway (*Travels in South Kensington*, 1882) and an illustrated article in *The Magazine of Art* (1882) shows the extent of the transformation. It is true that Alma-Tadema's painting room was decorated in the "Pompeian" style and that it sometimes served as a setting for his scenes of Roman life, but in the rest of the house there was no striving for chilly archeological correctness:

the decoration is a good example of the eclectic interior, owing as much, or more, to Japan and seventeenth-century Holland as to ancient Rome. Where possible, arched openings replaced conventional doorways, and Mrs. Haweis noted "the Dutch fondness for nooks and crannies, little rooms opening into other little rooms, with unexpected glimpses of further rooms in effective sequence." What is probably an instance of this predilection can be seen in the present drawing: the massive wall enclosing the fireplace must originally have been on the exterior of the house, the room beyond being added later. Another room was entirely panelled with the remains of a collection of fourteen seventeenth-century Dutch cabinets, which had been salvaged from the explosion.

In *The Magazine of Art* the library, on the ground floor leading out of the hall on the right-hand side, is described as "Gothic," but the furniture of the room is practical rather than self-consciously revivalist — indeed, the bentwood chair behind the writing table is positively utilitarian. The fur-covered couch under the window and the bronze chandelier, with its blue candles echoing the color of the architrave and panels of the door, were both designed by Alma-Tadema himself. The floor is covered with Japanese tatami matting, used elsewhere in the house for dadoes; the dado here is covered with a fabric that looks like batik — a resist-dyed cotton from Southeast Asia, especially the Dutch East Indies. Mrs. Haweis describes another dado in the house as being of dark brown batiste, a very fine cambric that would have been entirely unsuitable for the purpose, but this may have been due to a mishearing of the word batik. On the panels flanking the window are a pair of framed and glazed drawings representing obelisks hung with coats of arms, the uppermost one on the left panel surmounted by a crown. These seem to be

German. The shape and color and what can be seen of the decoration of the object suspended from the ceiling of the room to the left suggest that it may be a Japanese parasol or a large, flattened paper lantern, but its purpose is mysterious.

This drawing has in the past been misidentified as a view of the Gold Room, a room on the first floor of the house of which Anna Alma-Tadema exhibited a painting at the Royal Academy in 1885 (fig. 13; Gere, 1989, pl. 27). Her father's pupil, Anna was described as thirteen in the 1881 census, so that she must have executed this remarkably competent interior when she was only sixteen or seventeen. Her two views in Townshend House may have been executed as records or souvenirs, since it was in 1885 that Alma-Tadema and his family moved to the house formerly owned by James Tissot in Grove End Road, in another part of St. John's Wood, to realize his ambition to build an ancient Roman villa that had been frustrated by lack of space in his previous house.

Literature: Jeremy Cooper, *Victorian and Edwardian Furniture and Interiors*, 1987, pl. 34.

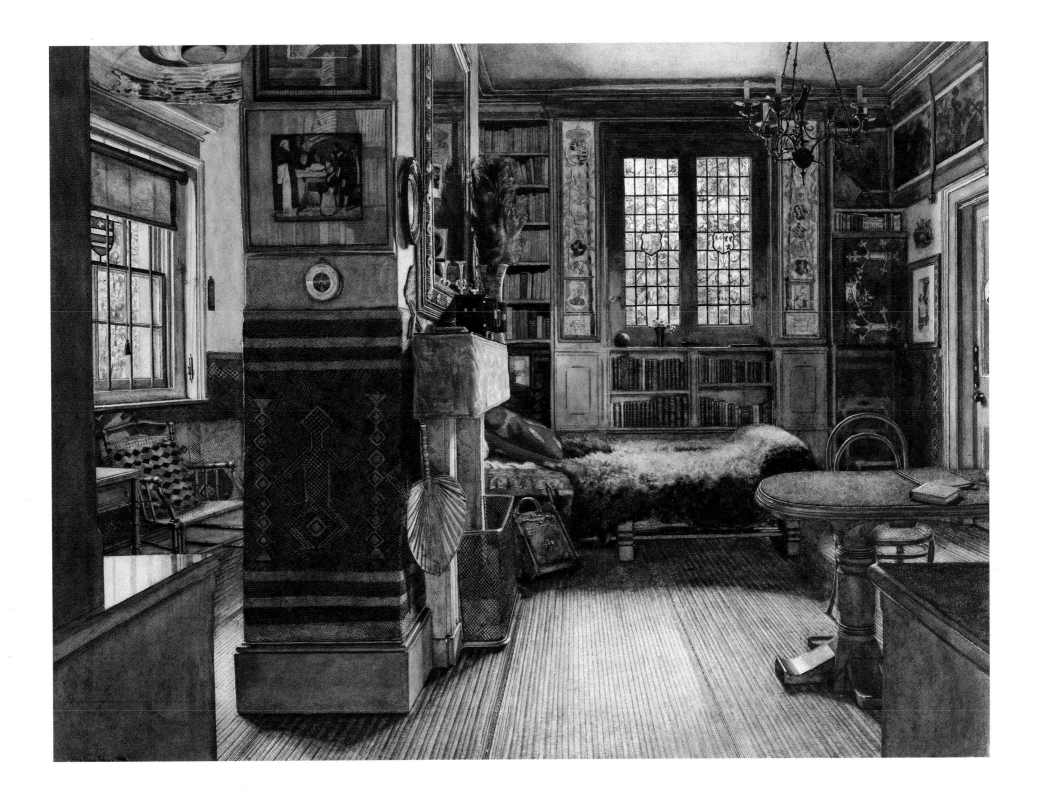

35. *The Bedroom of Czarina Maria Alexandrovna at Gatchina*

ALEXANDER BENOIS (1870-1960)

Watercolor and gouache, with pencil and red chalk, slightly heightened with white, 12$\frac{7}{16}$ x 16$\frac{3}{4}$ in. (32.1 x 42.5 cm) Signed and inscribed lower right "Alexander Benois, Chambre de l'Imperatrice Marie Alexandrovna a Gatchina," labels on the old frame inscribed "Dobuzinski" and "Mme Vera Narischkina, 8 rue Eugène Delacroix, Paris"

Without the artist's inscription, it would be difficult to identify the location of this opulently appointed bedroom. The suite of highly polished mahogany furniture in the revived Rococo style could be French, German, or English. The new taste for the Rococo originated in France at the time of the Bourbon Restoration and was already established in England in the 1820s. Intricately carved frames and close buttoning of the *capitonné* upholstery reached a peak of elaboration in Second Empire Paris, but the fashion had spread rapidly all over Europe and to America through German immigrants like John Henry Belter, who developed a mass furniture trade that flourished in the second half of the nineteenth century. Despite an imperial policy that throughout the nineteenth century promoted the nationalist Pan-Slavonic movement, focusing architectural inspiration on traditional Russian ornament and forms, Russian palaces continued to be furnished in the latest European taste (see Anna Voronchina, *Views of the Hermitage and Winter Palace*, 1983). A companion drawing to this view of Maria Alexandrovna's bedroom, of the study of Czar Alexander II, has a similarly international flavor (see Gere, 1989, pl. 276). The two rooms were left unchanged after the death of Alexander II in 1881.

Alexander Benois was brought up within the imperial entourage, as his father was employed as an architect to the court, living and working at Peterhof and later at Pavlovsk. As a small child at Pavlovsk, Benois had conceived a passionate interest in the mad Czar Paul I, whose favorite palace, Gatchina, is the setting for this drawing. The Czarina, born Princess Marie of Hesse-Darmstadt, married the future Alexander II in 1840 and died after a long period of ill-health in 1880. Only six weeks after her death Alexander married his longstanding mistress, Princess Ekaterina Dolgorukova, by whom he had already had three children. He was assassinated a year later in 1881. To record the most private rooms of the Czar and Czarina was not for Benois simply an act of dispassionate observation. Though his career was spent mainly as a stage designer, his art-historical researches encompassed studies of the imperial palaces Tsarskoe Selo and Peterhof in the eighteenth century, and he dedicated to his wife a series of albums containing watercolors of St. Petersburg, Peterhof, Pavlovsk, Tsarskoe Selo, and Gatchina. This drawing belonged at one time to Benois' friend the artist Mstislav Dobujinsky, fellow contributor to the magazine *Mir Iskusstva (World of Art)*, started by Sergei Diaghilev in 1898.

Literature: Gere, 1989, pl. 275.
Exhibited: Exposition d'art russe ancien et moderne, Palais des Beaux-Arts, Brussels, 1928, no. 42; Pierpont Morgan Library, New York, 1985, no. 76; Hartwick College, Oneonta, New York, 1987, no. 28.

36. *The Drawing Room at Brabourne Vicarage, 1893*

M.F. PEARCE (?) (fl. 1890s)

Watercolor over graphite, 7 x 10 in. (17.4 x 15.4 cm)
Inscribed on the reverse "The drawing room, Brabourne Vicarage, February - 1893" and "M.F.P."

In this vicarage room, artistic taste has been achieved at no great cost. A basket chair, an embroidered bamboo screen, a black-and-gold Oxford frame entwined with ivy (barely visible at the right-hand edge of the painting), a large philodendron in a terracotta pot on the floor, and a palm in a blue lusterware pot on the table beyond the grand piano contribute to the effect without too much financial outlay. The Aesthetic interior in England reconciled two very different sources: on one hand the art of Japan, and on the other the revival of interest in "Queen Anne" architecture and furniture. Here the "Aesthetic" look is achieved by brilliant yellow paint on the woodwork and figured gold-and-brown silks for upholstery and curtains to give an impression of Oriental richness. Chairs of the type retailed by Shoolbred or Gillow with bobbin-turned woodwork give a "Queen Anne" touch.

The tradition of the artistic vicarage dates from the 1840s, when "Reformed Gothic" — appreciated only by the avant-garde taste of the time — was adopted as the most appropriate style for ecclesiastical buildings. Leading architects like Pugin, Street, and Waterhouse were responsible for the design of vicarages and often for the furniture as well. Pugin suggested that some of his most advanced and uncompromisingly plain furniture designs should be made at a price affordable by "poor vicars." The often inconveniently dark Gothic type of vicarage was later adapted to the revived vernacular manner to which the Aesthetic style of interior was perfectly suited.

The Kentish village of Brabourne in the last century was little more than a street of cottages with an inn at one end and the church at the other, a pleasant hamlet at the foot of the Downs, on the route of the Pilgrims' Way. Sir Gilbert Scott, celebrated and prolific exponent of the Gothic Revival style, restored the church discreetly, without destroying a unique palimpsest of earlier periods. A rare survival, the Norman window complete with Norman glass was retained, as was a striking seventeenth-century altar table. A "heart-reliquary" reputedly once held the heart of John of Balliol, founder of the Oxford college, and the memorial brasses are particularly fine. In the nineteenth century the brasses were discovered hidden in the roof-space at the vicarage, where they must have been concealed to escape the attentions of Cromwell's desecrators in the seventeenth century, so the house must be of that date or earlier. The little that can be seen in this drawing of the architecture of the vicarage suggests an unpretentious early Kentish house with exposed beams with additions made in the early nineteenth century.

Two interiors of Brabourne Vicarage survive, both competent but obviously amateur works; the other (fig. 11) shows a corner of the library, which was also, as far as can be seen from the restricted view of the room, decorated in the "Aesthetic" taste, with pale grey walls, ebonized furniture, and watercolors in wide white mounts above a dado rail. The library watercolor is inscribed with the initials "R.C.P." This artist and the "M.F.P." who signed the present drawing may have been members of the family — possibly daughters — of the Rev. John Thomas Pearce, who was Vicar of Brabourne in the 1890s.

Exhibited: Hartwick College, Oneonta, New York, 1987, no. 8.

The Wittgenstein Interiors
and the Hofburg Album

The Wittgenstein Family Album gives an unrivalled insight into the peripatetic nature of life in a nineteenth-century princely family: how the great caravan of Prince and Princess, children, nurses, tutors, servants, pets, furniture, personal treasures, toys, and trunks full of clothes moved from house to house, from country to country, in a seasonal round that took them all over Europe — even to the Isle of Wight — and to the brink of Asia. The watercolors span approximately a decade, from 1834 to 1843.

Intact albums are rare. The Wittelsbach Album and the Hesse Album remain in the possession of those families, and Queen Victoria's drawings are all still in the Royal Library at Windsor, but the fascinating Sagan Album was sold at auction in 1989 (Sotheby's, Monaco, March 4, 1989) and is now dispersed.

One of the few surviving examples is Johann Stephan Decker's 1826 album of interiors occupied by Emperor Franz I at the Hofburg in Vienna, now in the Metropolitan Museum of Art (see fig. 7). In contrast to the variety of houses and artists included in the Wittgenstein Album, it shows a suite of rooms from a single palace all painted at the same time. Decker's technique, with its almost surreal clarity, provides a detailed record of the works of art and furnishings in the formal and rather characterless rooms.

A room at the Hofburg done in a manner reminiscent of Malmaison (fig. 14) is decorated with gold-bordered draperies in the Empire style devised by Percier and Fontaine, and subsequently much imitated. The armorial carpet looks French and may possibly be from the Savonnerie manufactory, where carpets designed by Percier and Fontaine were woven for the imperial palaces. Napoleon presented a Savonnerie carpet to the King of Saxony in 1809; however, the part of the armorial device visible here relates to the Swedish royal house. The distinctive Savonnerie style was influential throughout Europe, and echoes can be seen in other carpet manufactories throughout the nineteenth century.

The drawing room (fig. 15) and state bedroom (fig. 16) at the Hofburg adjoin one another and are decorated *en suite*, predominantly in green and ivory. The Neoclassical design of the green-and-gold Brussels or Wilton fitted carpet dates from the end of the eighteenth century. The large octagons enclosing rosettes and smaller squares in a geometric pattern imitate a Roman mosaic floor. The bedroom, hung with fine paintings including three of Canaletto's Venetian views, is furnished as a sitting room, and provides a link between the eighteenth-century state bedroom and the bedroom-boudoir found in the apartments of the nineteenth-century bourgeoisie (cf. no. 27). The dining room (fig. 17) is simply

Fig. 14. Johann Stephan Decker. A Room in the Malmaison Style in the Hofburg, from the Hofburg Album.

furnished for family use with a round table and French-style chairs upholstered in green. It has a parquet floor — more practical than a carpet — laid in a diagonal pattern of diamonds and squares. The diners are shielded from the heat of the cylindrical stove by a red folding screen. Set into the back wall is a large Gobelins tapestry with a red border. The windows, in deep panelled reveals, are uncurtained.

Shown on the pages that follow are all but two of the interior views that survived in the Wittgenstein Family Album into the present century. When they were published by Mario Praz in 1964, the Wittgenstein Album had long since been raided for gifts and mementos to friends and relatives, probably, as he suggested, in prerevolutionary Russia. Praz speculated that the missing examples might one day come to light in the Soviet Union. Imperial inventory labels on the old mount of the drawing of the Pavlino conservatory (no. 12) link it with Princess Alexandra of the royal house of Greece, who in 1889 married Grand Duke Paul, brother of Czar Alexander III. Perhaps this is one of the errant drawings, a gift to a member of the imperial family.

The drawings show the Wittgenstein houses in all seasons. Pavlino is seen in high summer: in the space of four years the Viennese painter Sotira depicted in minutest detail five of the elegant rooms there, as well as the small salon in the Rasumovsky house and the flamboyant Gothic Revival salon in the Bariatinsky-Sergeevskaya

house. Winter saw the family in Rome or Naples or at Potsdam; in April they moved to their house in Berlin; to Paris in May; near Geneva or at Werki in August; then in November to Kamenka in the Ukraine, once the roads were frozen sufficiently hard to take heavy vehicles.

With variations and permutations this represents the seasonal round of the princely families on the Continent until the Great War and the Revolution in Russia had turned the old social order upside down. It would be a mistake to deduce too much from the inscriptions accompanying these drawings. It may have been more convenient for the artist to work in the absence of the family, and some of the dates are inaccurately transcribed from the drawings; but the essential picture is there, of a family with vast estates visiting their properties at the best times of the year.

The names of the people and their houses read like a roll call of European — principally Russian — history. Ludwig Adolf Friedrich, Prince of Sayn-Wittgenstein-Berleberg (1799-1866), was aide-de-camp to Czar Nicholas I; his grandfather had served as a field marshal under Catherine II, and his father, Prince Ludwig Adolf Peter (1769-1843), was a field marshal in the service of Alexander I, acquitting himself with distinction in the 1812 campaign against Napoleon. The French historian Custine (1854, p. 475), claimed that it was Wittgenstein who devised the strategy of luring Napoleon far into Russia and thus fatally overextending his lines of communication.

Wittgenstein led one of the detachments that harassed Napoleon as he retreated from Moscow, engaging the column of French troops outside Smolensk as they struggled to reach Prussia, but his part in the defeat of Napoleon was suppressed after he fell from favor at the time of the Russo-Turkish War of 1828-29. The Czar had ill-advisedly altered the plan of campaign that the older and more cautious Wittgenstein had devised, and the Russians suffered a humiliating defeat. The family had, however, been granted extensive properties in Russia, including three villages in the neighborhood of St. Petersburg and Kamenka in the Ukraine. Werki, near Vilna in Russian Poland (now Vilnius, Lithuania), was acquired through marriage to a Radziwill heiress.

In 1828, Ludwig Adolf Friedrich, Prince Wittgenstein, married Stephanie Radziwill, daughter of Prince Dominik Radziwill, head of the ancient Polish noble family. Dominik's cousin was Prince Anton Radziwill, who in the late eighteenth century had married Princess Louisa of Prussia in spite of opposition from her family because he had insufficient quarterings for this royal match. The couple had an equivocal position in society, and Princess Louisa never took her husband's name, but their children were brought up with the children of the Prussian royal house. Prince Anton was an important patron of the arts. He frequently received the young Frédéric Chopin at Antonin, the remarkable country house outside Poznan designed for him by Karl Friedrich Schinkel, which remained throughout the

nineteenth century the center of Radziwill family life.

Prince Clary (*A European Past*, 1978, p. 18) explains how the Wittgenstein marriage came about: "The head of the family in [Prince Anton's] day was his cousin Dominik, the owner of immense estates in Poland. In my family it used to be said that if people talked about vast estates in Bohemia they meant thousands of acres, but in Poland they meant hundreds of thousands. Dominik had joined the Polish Legion which served under Napoleon and was killed in battle as a colonel at Hanau in 1813, Napoleon's last engagement on German soil. After the partition of Poland he became a *de jure* Russian subject. The Emperor of Russia thought it improper that he should have fought under Napoleon, against his own country, and his entire property was sequestrated. Naturally, the family tried to save this vast fortune and, even during the Congress of Vienna, every possible string was pulled. Anton's marriage to the niece of the King of Prussia proved extremely useful. Dominik had an illegitimate son, who did not enter into consideration, but also a legitimate daughter, Stephanie, the heir to the non-entailed property. Alexander recognised her title to the inheritance on condition she married a Russian. In 1828 she married Prince Ludwig Sayn-Wittgenstein, son of the Russian Field-Marshal of the same name."

Though Prince Wittgenstein was a member of the old Westphalian nobility, by virtue of his

Fig. 15. Johann Stephan Decker. A Drawing Room in the Hofburg, from the Hofburg Album.

Fig. 16. Johann Stephan Decker. A Bedroom in the Hofburg, from the Hofburg Album.

family's three generations of Russian imperial service he could claim to be technically a Russian. After his father's death in 1843 he returned to Berlin and took his place in the upper house of the government. Stephanie Radziwill died in 1832, and the son of their marriage, who was heir to the Wittgenstein titles in the Carlsburg-Ludwigsburg line, lived at Werki when he succeeded his father in 1866.

In 1834 Prince Wittgenstein took as his second wife Princess Leonilla Bariatinsky (1816-1918), of a family still powerful at the Russian court in spite of the part played by Prince Theodore Bariatinsky in the murder of Peter III, insane husband of Catherine the Great, which had resulted in his exile by Catherine's son. Leonilla's grandfather, Prince Ivan (1740-1811), was quite a different character: suave of manner and extraordinarily handsome until an advanced age, he had served as ambassador in Stockholm and in Paris. Her father, Prince Ivan Ivanovich Bariatinsky (1772-1825), served at court before becoming counsellor at the embassy in London. In 1807 he had married as his first wife Frances Dutton, daughter of the first Lord Sherborn, but she died after giving birth to a son in the following year. Leonilla's mother was Maria Feodorovna Bariatinsky, the subject of one of Bertel Thorwaldsen's most beautiful full-length portraits, sculpted in Rome in 1818.

The Bariatinsky alliance brought huge properties in the Ukraine and Crimea. Ivanovski, a vast estate in the district of Kursk, came to the Wittgensteins through the marriage of Ludwig's younger brother Nicholas to Leonilla's near contemporary Carolyne Elizabeth d'Ivanovska. Of legendary wealth, she inherited the great estate of Woronince, near Kiev, with thirty thousand serfs.

Like the Radziwill connection, these Russian-Polish alliances were advantageous for the relatively impoverished Wittgenstein family; but the Wittgenstein-Ivanovska marriage, forced upon the sixteen-year-old Carolyne, did not prosper, and after only three or four years the couple separated. In 1847, Carolyne went to live in Weimar with Franz Liszt, taking her daughter with her but sacrificing her claim on Woronince.

Prince Aleksy Rasumovsky was one of the favorites of Czarina Elizabeth, predecessor of Catherine the Great. It was said that they had married in secret; certainly he was given a splendid palace in St. Petersburg. His nephew Andrey Kyrilovich (1752-1836) was Beethoven's patron, the Count Rasumovsky of the Rasumovsky Quartets. He was ambassador successively at Naples, Stockholm, and Vienna, and he represented Russia at the Congress of Vienna in 1814. A friend of Haydn and Mozart as well as Beethoven, he was celebrated for the concerts held at his house in Moscow and for the collection of pictures in his gallery.

The Rasumovsky small salon shown in one of the drawings (no. W16) may have been in any one of

several houses: in Vienna; in the Moscow house (John Parkinson was "exceedingly struck with the splendour of Count Razomofsky's house" — see *A Tour of Russia, Siberia and the Crimea, 1792-1794,* ed. William Collier, 1971, p. 99); in Mme. Rasumovsky's elegant little house in St. Petersburg (Lady Londonderry was shown round it by her hostess in 1836 and remarked, "we admired her bedroom, dressing room, bath, etc. extremely" — *Russian Journal of Lady Londonderry, 1836-1837,* 1973, p. 113); or in a house in the Ukraine (Count Kyril Rasumovsky, brother of Aleksy and father to Andrey, was the last independant Hetmann or chief of the Ukraine).

During the period when these interiors were painted, the Wittgensteins owned Kamenka, the Davydov family estate 250 kilometers south of Kiev in the Ukraine. Kamenka had come to the Davydovs by inheritance from Catherine's favorite, Grigory Alexandrovich Potemkin, who had allegedly stage-managed the construction of ghost villages that greeted her along the route of her triumphant tour of the Ukraine in 1787. The young Alexander Pushkin (1799-1837) visited Kamenka in 1820-21, during his exile in the Caucasus. He was in love with Aglaya, the French wife of Alexander Davydov, and while there he wrote *The Prisoner of the Caucasus.* He was also witness to the secret meetings of the Union of Welfare, of which Vassily Davydov was a member, which plotted to overthrow Czar Nicholas I in favor of his brother Constantine. The estate was forfeited by the Davydovs after the failure of

the Decembrist uprising in 1825, when those conspirators who were not executed were exiled to Siberia.

At his accession in 1855, Alexander II declared an amnesty for the Decembrists, many of whom had died in exile. Kamenka returned to the Davydov family, and it again enjoyed a position of cultural importance when Lev Davydov, son of the Decembrist, married Tchaikovsky's sister Alexandra in 1860. Tchaikovsky spent his summers at Kamenka, and it was the nearest thing to home for him until well into his career: "I long for summer in Kamenka as for the promised land, and there I hope to find rest and peace, and to forget all my troubles." It was at Kamenka that Tchaikovsky was introduced to the work of Gogol and Pushkin and learned the appreciation of Russian culture that was to play such an important part in his work. Kamenka in the last years of the century and up until the Revolution is recorded and depicted in the memoirs of Mariamna Davydov (*On the Estate: Memoirs of Russia before the Revolution*, ed. Olga Davydov Dax, 1986).

Kamenka was a large eighteenth-century house overlooking a lake, stuccoed in white, with a green roof, a central pediment supported on columns, and great curving wings in the form of open colonnades. The nearby village that went with the property consisted of a single street with an elegant domed and colonnaded eighteenth-century church and a row of single-story wooden

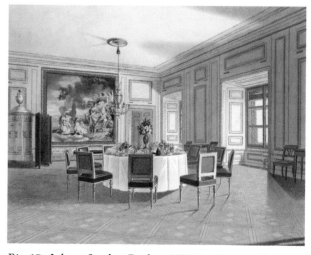

Fig. 17. Johann Stephan Decker. A Dining Room in the Hofburg, from the Hofburg Album.

peasant huts. The Marquis de Custine (1854, p. 239) took a rather sanctimonious attitude towards these charming wooden buildings: "... they display signs of wealth, and even a sort of rustic elegance, which is very pleasing. The neat wooden houses form the line of a single street. They are painted, and their roofs are loaded with ornaments which might be considered rather ostentatious, if a comparison were made between the exterior luxury and the internal lack of conveniences and cleanliness in these architectural toys. One regrets to see a taste for superfluities among a people not yet acquainted with necessaries; besides, on examining them more closely, the habitations are discovered to be ill built." Both house and village were typical of the noble and princely estates to be found all over Russia.

The eighteenth-century Pavlino, the house most often represented in the album and perhaps the most loved, resembled Kamenka in being white, green-roofed, pedimented, and flanked by curving colonnaded wings, as well as in overlooking a lake, but it was smaller and better proportioned, very much like the imperial palace of Pavlovsk before its enlargement and the enclosing of the colonnades. The name Pavlino may even reflect a connection with Maria Feodorovna's perfect palace. The earliest views of Pavlino are of the sitting room (no. W1) and the winter garden (no. W2) and date from 1834, the year of the Wittgensteins' marriage. On the table in the living room is shown prominently a single pineapple on a dish, which in certain seafaring cultures was a symbol

of hospitality. It is difficult to tell whether these interiors were ever meant to be "read" for private meanings. Théophile Gautier makes the point that the Russians, with their savage climate, greatly prized exotic fruit, much of it grown in the hothouses that were such a feature of the palaces, and that huge arrangements of grapes, pineapples, pears, and oranges were always offered for dessert. When Lady Londonderry visited the villa of Prince Serge Golitsin outside Moscow in 1836 she was shown around a pinery, a peach house, and an orangery (*Russian Journal*, 1973, p. 72).

The thoroughgoing Gothic of the Bariatinsky-Sergeevskaya house reflects imperial enthusiasm for this English-inspired taste. In 1826 the "English" Cottage retreat in the Alexandria Park behind Peterhof was built for the rare hours of relaxation of the imperial family in "the new Gothic style so much in vogue in England." Custine obtained permission to go round the interior, and reported on it for his history of Russia (1854, p. 71): "It is, as I have said, quite an English residence, surrounded with flowers, shaded with trees, and built in the style of the prettiest places that may be seen near London, about Twickenham, on the borders of the Thames."

The Bariatinsky and Pavlino Gothic rooms (nos. W13, W15) are more consistent in their adherence to their chosen style than the English Cottage in Alexandria Park, which is furnished with a miscellaneous collection of furniture and

treasured works of art in addition to the ornamental Gothic pieces. There is some truth in the claim that the cottage was a family retreat rather than a decorative showcase. The ornamental style of the early Gothic Revival remained popular in Russia and Germany, where the more severe English "reformed" manner never caught on. Pavlino no doubt acquired its Gothic rooms in response to fashion, but in most of these interior views, like those in other Continental houses of the period, conventional Neoclassical or plain Biedermeier furniture supplemented by comfortable upholstered chairs and couches is preferred.

In the noble painted salon of the Palazzo Caramanico in Naples (no. W22), the magnificent suite of Egyptianizing Neoclassical furniture with stiff, unyielding striped cushions has been pushed against the walls to make room for upholstered sofas and reclining chairs in flower-patterned and velvet covers and the convenient, lightweight, and still popular "Chiavari" chairs, made at Chiavari on the Ligurian coast east of Genoa from the early nineteenth century. These comfortable pieces accompanied the family to the Villa Dackenhausen, on the Bay of Naples at Castellammare, to furnish the elegant but bare rooms of their summer retreat (Praz, 1964, figs. 11, 12).

The German residences of the Wittgenstein family included a Russian-style wooden house in the Alexandrovska colony in Potsdam, situated next to the barracks to the north of the town and the park of Sanssouci. The two-story houses were built in 1826 by Friedrich Wilhelm III for the band of Russian musicians at that time attached to the First Regiment of Guards. A chapel was added in 1829. The appearance of these houses is deceptive, for the interior depicted in the album (no. W7), with its enfilade of rooms glimpsed through the open door, is on a grander scale than the quaint wooden exteriors suggest.

In Paris in 1837 the family were in the Hôtel Lobau on the corner of the rue de Bourbon and the quai d'Orsay (nos. W10, W11), the house of Maréchal Lobau, who had commanded one of Napoleon's five battalions at Waterloo. The house with its extensive garden on the entrance front was next to the Chambre des Députés and near the Prussian embassy, the magnificent Hôtel Beauharnais in the rue de Lille.

We know that the Maréchal was in the habit of renting a portion of his house, as it was offered to Lady Blessington when she was in Paris in 1828 (see Countess of Blessington, *The Idler in France*, 1841, p. 72). The Maréchal was indignant when the Blessingtons did not take the apartment because it was too small for them. Lady Blessington noted (p. 90): "In England, a person of the Maréchal's rank who had a house to let would not show it *in propria persona*, but would delegate this task, as also the terms and negotiations, to some agent; thus avoiding all personal interference, and, consequently any chance of offence:

but if people *will* feel angry without any just cause, it cannot be helped; and so Monsieur le Maréchal must recover his serenity and acquire a temper more in analogy with his name; for, though a brave and distinguished officer, as well as a good man, which he is said to be, he certainly is *not Bon comme un mouton*, which is his cognomen."

The Blessingtons finally settled on a house belonging to Maréchal Ney, just round the corner in the rue de Bourbon. For those interested in Parisian interior decoration in the nineteenth century, Lady Blessington describes each of the rooms in great detail (see pp. 97-108, 114-17, 119-22).

Apropos of her Parisian house-hunting Lady Blessington remarked (p. 72): "I highly approve the mode at Paris of letting unfurnished houses, or apartments, with mirrors and decorations, as well as all fixtures (with us, in England, always charged separately), free of any extra expense. The good taste evinced in the ornaments is in general remarkable, and far superior to what is to be met with in England; where if one engages a new house lately papered or painted, one is compelled to recolour the rooms before they can be occupied, owing to the gaudy and ill-assorted patterns originally selected."

The Wittgenstein family also spent some months in Paris in 1843 in what must have been an almost constant state of upheaval, moving bag and baggage and much of their furniture to and fro from a magnificent hôtel in the place Vendôme (nos. W24, W25) to a plain Italianate house, the Castel de Madrid, in the Bois de Boulogne (nos. W26, W27). Lady Blessington provides the explanation (p. 109) of how this might be achieved: "To my surprise and pleasure, I find that a usage exists at Paris which I have nowhere else met with, namely that of letting out rich and fine furniture by the quarter, half or whole year, in any quantity required for even the largest establishment, and on the shortest notice. I feared that we should be compelled to buy furniture, or else put up with an inferior sort, little imagining that the most costly can be procured on hire, and even a large mansion made ready for the reception of a family in forty-eight hours. This is really like Aladdin's lamp, and is a usage that merits being adopted in all capitals." For the Hôtel Ney she was able to secure "five beautiful buhl cabinets" (p. 116), no doubt like the three cabinets in Princess Wittgenstein's boudoir (no. W24).

In July the Wittgensteins' third child, Louis, was born, and sometime during these months Franz Xaver Winterhalter portrayed Leonilla reclining on a terrace with the seashore in the background (National Portrait Gallery, London, *Franz Xaver Winterhalter*, 1988, no. 20). She was painted as an odalisque, in white satin with a wide silk sash, recalling, it was said, the Russo-Turkish character of the Wittgenstein estate in the Crimea. The completed portrait can be seen, hanging at the

back of the salon in the Castel de Madrid, in the watercolor by François-Étienne Villeret (no. W26); it is now in the J. Paul Getty Museum at Malibu.

These Parisian rooms are the latest in the Wittgenstein Album, which records a decade of princely domestic arrangements. Perhaps the most fascinating, because the most distant from our own western experience, are the Russian rooms. The paintings bring vividly to life the Russian travel diaries of the Wilmots or Lady Londonderry or Théophile Gautier. Gautier is the best and most detailed guide to the mid nineteenth-century Russian interior, noting oddities and Russian peculiarities with a gimlet eye. We read with amused incredulity of a suite of furniture made out of stuffed bears — the sofa contrived from a giant polar bear and little brown bears made into tabourets or small tables — but the truth of his account is confirmed when we notice one of these very tabourets pushed inconspicuously to one side under a writing table in the Princess' sitting room at Pavlino (no. W15).

The bedroom at Kamenka (no. W12) is in the Russian style as described by Gautier; which reminds us of the Oriental side of the Russian inheritance. It is Turkish in character, with the sleeping arrangements consisting of a simple divan or mattress behind a screen. When Grand Duke Nicholas (later Czar Nicholas I) visited England in 1816, Baron Stockmar (quoted by James Lees-Milne in *The Bachelor Duke*, 1991, p.

31) met him at Claremont, a royal residence where Princess Charlotte was then living. He noticed with astonishment "that when it was time for bed, a leathern sack was filled in the stable with hay for the Grand-Duke by his servants, on which he always sleeps. Our English friends thought this very affected."

In one important respect the domestic arrangements at Pavlino departed from the Russian style: the bathroom of the Princess (no. W4) is of Parisian opulence, the walls and even the tub draped with pink hangings. The Russian bathroom, even in the imperial palaces, was usually a steamroom or *hammam*, and the estate villages were sometimes provided with a communal bathhouse, a facility unknown in remote localities in western Europe. A rare survival, the Russian-Turkish baths on East 10th Street in lower Manhattan, reaffirms this national preference.

The profusion of flowers in Russian houses was always remarked by visitors. These lavish arrangements recall the royal flower gardens in eighteenth-century France, which seemed to bloom by magic. In Mme. de Pompadour's garden it is said that a thousand plants were replaced each day, and much the same amount of labor was needed to maintain the screens and trellis arrangements that can be seen in these rooms. Each of these houses is provided with a fine concert piano, a reminder of the Radziwill connection with Chopin and an indication of continuing musical patronage.

Other features are conspicuous, notably the provision of the latest lighting equipment; picture lights like the *puissants réflecteurs* described by Gautier can be seen in the new salon at Pavlino (no. W14). There is evidence of great enthusiasm for picture collecting. The enormous history painting installed at Pavlino by 1838, showing Anne Boleyn taking leave of the infant Princess Elizabeth, is a conspicuous piece of patronage. In the Bariatinsky house (no. W13) we note a painting of the Villa of Maecenas at Tivoli by François-Marius Granet, flanking the door leading into the columned hall. On the other side of the door is what appears to be another Granet, one of the many versions of his popular painting of the *Choir of the Capuchin Church in Rome*, of which one was acquired in 1821 for the Hermitage in St. Petersburg.

Gautier names Horace Vernet, Théodore Gudin, and the Belgian Baron Leys as history painters popular with Russian collectors. The military subject in the saloon at Pavlino (no. W5) may well be a Vernet, possibly from his stay in Russia in 1836 when he was engaged, at the invitation of the Czar, in painting a series of great battle pieces. The album drawings show many portraits, some possibly by such Russian painters as the fashionable Briulov, whom Gautier singles out as the choice of patriotic Russian patrons. Some of the drawings and miniatures, perhaps of family members, reappear in a succession of rooms; even the large *Seaport* by Joseph Vernet was transported from Pavlino, where it hung with the *Anne Boleyn* in the new salon, all the way to Werki in Poland (no. W19), just as later the tiny Italian primitive in its Gothic frame was moved from one Parisian home to another.

There are no interior views after 1843. Of Prince Ludwig's six children, three were born during the decade covered by the album. One of these was Antoinette, whose marriage in 1857 to Don Mario Chigi-Albani, Prince of Campagnano, brought the succession of the drawings to Italy. Prince Ludwig's fourth child, Alexander, was born in 1847. Prince Ludwig died in Cannes in 1866; he was long survived by Leonilla, who lived through the Great War and the Russian Revolution, dying in 1918 aged 102 years old.

W1. *A Sitting Room at Pavlino, 1834*

CARL (KARL IVANOVICH) KOLLMAN (1786-1846)

Watercolor, 6⅞ x 10⅝ in. (17.4 x 26.9 cm)
Signed and dated lower right "C Kollman 1834," inscribed
on the old mount "Kollman / Pawlino / 1834"

This modest sitting room at Pavlino, depicted in the year of the Wittgensteins' marriage, contains a magnificently gilded, white-covered Empire sofa, a fine pianoforte, and a miscellaneous collection of chairs including a white-painted Neoclassical armchair of about 1820, a library chair upholstered in black leather, a simple wood armchair with loose yellow cushions, and a Russian mahogany side chair. The furnishings are completed by two tables covered with embroidered cloths and by a profusion of flowering plants in pots. On the left-hand table, framed portraits stand on the deep blue velvet cloth with a gold key-patterned border; there are also glass vases, a feather fly-whisk, and a blotter with a Gothic-style silver cover. The pineapple set out on a dish on the round table shows that the estate had a heated greenhouse for the cultivation of exotic fruit. All kinds of fruit were grown under glass in Russia — strawberries and peaches as well as tropical fruits — to compensate for the deprivations of the severe winters.

The room is far from elaborate in decoration or fittings, though an attempt has been made to give it a fashionable air with French-style draped pelmets, curtains trimmed in black silk fringe, and printed floral borders edging the sky-blue walls and the doorframe. Instead of the intricate patterned parquet commonly found in grand Russian houses of this date, the floor is of wide planks without any covering, not even a hearth rug.

Kollman's interior views are handled with a naive

charm suited to this plainly appointed room and the winter garden (no. W2). Starting in the following year, the skillful Viennese painter Sotira was commissioned to record the more elaborately appointed rooms in the Wittgenstein houses, which were beyond the scope of Kollman's relatively modest attainments.

Little is known of the many minor artists who embraced view-painting during the half-century when it was in great demand. Kollman may be identified with Karl Ivanovich Kol'man, a landscape painter, draughtsman, and illustrator. The details of his career are rather scanty. Though he is usually described as Russian, he was in fact born in Augsburg and studied in Munich before settling in St. Petersburg, where he died.

Literature: Praz, 1964, pl. 285.

Carl (Karl Ivanovich) Kollman (1786-1846)

Watercolor, 7 x 10 in. (17.8 x 25.5 cm)
Signed and dated lower left "C. Kollman 1834," inscribed on the old mount "Kollman / La Salle des Fleurs à Pavlino / Juin 1834"

The terraced and pedimented front of the Neo-classical house at Pavlino was flanked by open colonnades in the form of curving wings. One wing was glassed in entirely and the other partly so, to make a range of winter gardens or conservatories. This view shows the end section of one wing, to which a sloping glass roof has been added. Both views of the Pavlino winter garden (cf. no. 12) show the planking of the colonnade ceiling, which would have restricted light and heat too much for the cultivation of exotics. In the glass-roofed end section the vegetation is denser and more vigorous. Ornamental winter gardens attached to houses were not generally used for the propagation of plants; these were forced in pots in a purely functional glass house and brought to the winter garden at the peak of their flowering to make up formal arrangements of the type seen here. As the flowers faded they were replaced with pots kept always in readiness. The temperature could not have been controlled in the Pavlino winter garden, as one side of the colonnade was not glassed in at the front. This summer view through the open colonnade shows the park in front of the house, sloping down to a distant stretch of water on which we see a steamboat.

The tiled floor leads towards a carpeted wooden pergola furnished with *chinoiserie* cane seats and ornamented with white marble sculptures. Groups of pots filled with hydrangeas and climbing roses are massed at the base of each column of the colonnade, and the pergola, constructed of bamboo canes and flanked by stone plinths supporting ferns in stone vases, is covered with delicate climbers — white jasmine or plumbago — with more pink roses in pots at the base. The reflected sunlight on the floor and ceiling of the winter garden and the shafts of light illuminating the glass-roofed annex are skillfully painted.

W3. *The Little Salon at Pavlino, 1835*

SOTIRA (fl. 1830s)

Watercolor heightened with white, 5¾ x 8⅞ in. (14.7 x 22.5 cm)

Signed and dated lower left "Sotira / 835," inscribed on the old mount "Sotira / Le Petit Salon à Pawlino / Juillet 1835"

This room is on the ground floor of Pavlino, leading to the winter garden in the right-hand wing. There is only a glimpse of the plant-filled winter garden with its Chinese lanterns and flowers, since the curve of the colonnade interrupts the vista. The furniture in the room is Gothic Revival, a fashion inspired, as the Marquis de Custine remarked, by the English Gothic style, but it is given a Continental flavor by the curving banquette with red velvet upholstery on the far wall, a piece reminiscent of designs by Karl Friedrich Schinkel for the Berlin royal palaces. In the 1830s Schinkel was designing furniture in the Gothic taste for Schloss Babelsberg at Potsdam, the romantically castellated summer residence of Prince Friedrich Wilhelm of Prussia, of which Queen Victoria remarked that it was "a Gothic *bijou*, full of furniture." There are many touches to suggest that Schinkel inspired the decoration of the present room.

Before the grate is a screen with three pointed-arch panels of painted glass showing figures in Medieval costume. The tall lamp on the table has a Gothic architectural stem and a shade formed of diamond-shaped panels of vividly colored glass. There are two other lamps, both in the Gothic taste, a generous provision of light typical of Russian rooms. The suite of Gothic furniture mixed with the evidences of Classical enthusiasm displayed around the room — notably the urn on a plinth between the windows — is characteristic of Schinkel's eclectic inspiration. The ornaments seem also to have been chosen regardless of the

Gothic scheme: a *Mercury* after Giambologna, the two black cast-iron vases on tall pedestals, a number of gilt-porcelain vases and a tea equipage, the Russian gilt and patinated bronze chandelier, and the contemporary portraits all contribute to the impression of a personal selection.

The decoration of the room is certainly not self-conscious; on the mantelshelf, sitting perkily at the extreme edge nearest the spectator, is a tumbler mannikin with nodding head, an undignified companion for the gold-and-black clock under a glass dome. The Gothic style of the furniture and lamps has not been extended to the walls, which are papered with stripes in two tones of green finished with an unusual border in a red-and-green checker pattern. Flowering plants are discreetly placed in the window embrasures behind the delicate draped muslin curtains.

This is one of the earliest of a series of drawings made for the Wittgenstein Album by the mysterious Viennese artist Sotira, about whom almost nothing is known — not even his full name. It is strange that the details of the career of such a supremely talented practitioner of this genre should be so hard to recover. The eight drawings included here were all made in Russia in the brief span of four years (1835-38) and remain the best documentary evidence of his activities.

Literature: Praz, 1964, pl. 284.

W4. *The Princess' Bathroom at Pavlino, 1835*

SOTIRA (fl. 1830s)

Watercolor, 5⅝ x 8⅞ in. (14.2 x 22.4 cm)
Inscribed on the old mount "Sotira / Le Bain de la Princesse / Pawlino / Juillet 1835"

This luxurious bathroom would have attracted attention even in Paris; in Russia, where the usual bathing arrangements, including those in the imperial palaces, consisted of a steam room and shower, it must have been remarkable. In the alcove, behind a screen of climbing plants, intricate pink silk drapery ruched, swagged, and edged with silvery white fringing and tassels extends even to the sides of the bathtub, which is fed from a fountain of yellow marble supporting two pots of hydrangeas and a white marble version of the Medici *Venus*. This drapery, arranged over curved gilt cornice poles and caught up with cloak pins, is real; but the rest of the room is lined with an illusionistic paper simulating panels of stretched fabric below fringed pelmets, with triangular draperies terminating in ornamental tassels suspended from the pelmets and with white pilasters separating the panels. Such drapery papers, inspired by Napoleon's campaign tents, were popular in France under the First Empire and were widely exported during the early nineteenth century. Block-printed by such firms as Dufour and Zuber, they were expensive to produce and were not manufactured outside France.

For the sake of privacy the lower two-thirds of the bathroom windows have been blocked out with fabric-covered screens, over one of which hangs a mirror in a heavy ornamental frame. It seems likely that the decorative elements of this French-inspired scheme would have been obtained from Paris, while the severely plain but elegant toilet table, side chair, and divan with large square cushions upholstered in pink velvet are probably Russian.

This is one of three views of Pavlino painted by Sotira in 1835. The scheme may have been newly completed, a circumstance that was often the occasion for commissioning watercolors of interiors.

Literature: Praz, 1964, pl. 9.

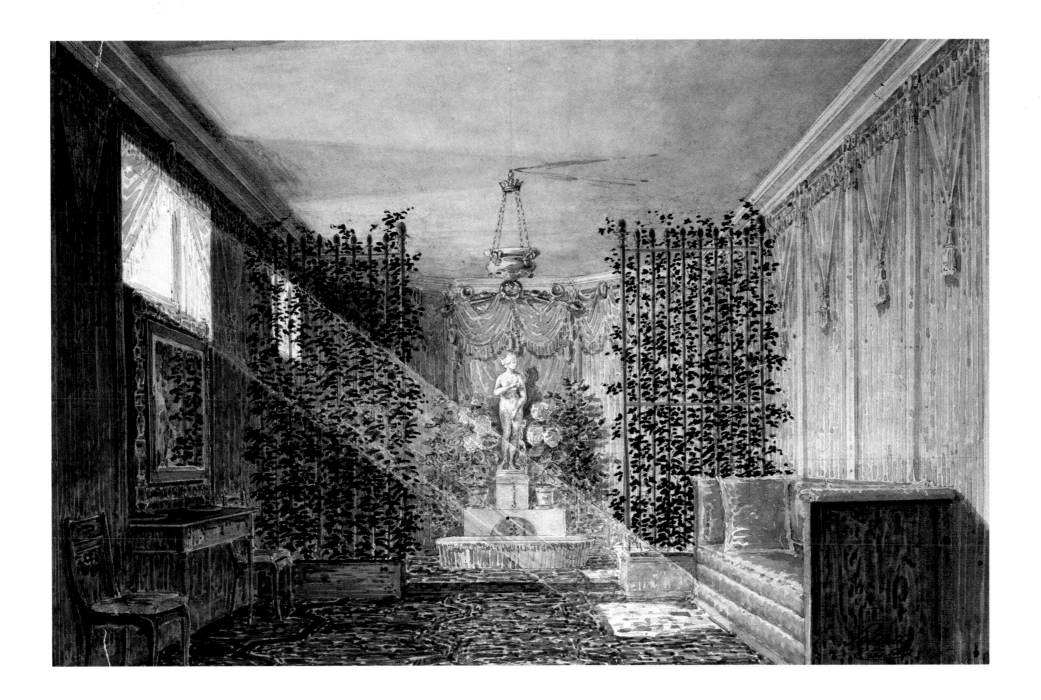

W5. *The Saloon at Pavlino, 1835*

SOTIRA (fl. 1830s)

Watercolor and gouache, 11⅛ x 16¼ in. (28.3 x 41.2 cm)
Signed and dated lower left "Sotira/835," inscribed on the
old mount "Sotira / Pawlino"

This large saloon with its fine suite of early
nineteenth-century Russian furniture arranged in
careful symmetry around the walls is the most
formal of the recorded Pavlino rooms. It is given
over to the display of paintings, sculpture, and
porcelain and is decorated in the most sumptuous
Russian Neoclassical style, with vivid green walls,
a heavily gilded cornice, and an elaborately deco-
rated ceiling. The painted ceiling decoration
consists of simulated antique reliefs in gold on a
green ground, four pairs of stylized figures in
black, and, in the corners, painted terracotta
athéniennes — Greek vases on stands with a
billow of grey smoke rising from each one. At the
far end of the room is an open fireplace — a
common feature at Pavlino — flanked by gilt
Egyptian herms on panels of lapis lazuli and
surmounted by an overmantel mirror rising to
the cornice. The *chinoiserie* fire screen is prob-
ably of painted glass. On the mantelshelf is a
massive French ormolu clock under a glass
dome; its base, in the form of a classical frieze,
supports figures taken from the central group in
The Oath of the Horatii by Jacques-Louis David,
exhibited in 1785. A similar clock formed part of
the furnishings of the new wing at the Munich
Residenz, decorated and furnished for Ludwig I
of Bavaria by Leo von Klenze. The twenty-five
candles visible in the great central chandelier are
supplemented by standard double-wicked oil
lamps fed from a reservoir in the form of a
Roman lamp.

On the right of the fireplace, a screen of flowers
in pots gives some measure of privacy to the sofa.

Visitors were fascinated by such flower arrange-
ments: "The residences of several Russians of
taste are distinguished by a peculiar ornament,"
wrote the Marquis de Custine (1854, p. 149), "a
little artificial garden in a corner of the drawing-
room.... In this little verdant boudoir are placed a
table and a few chairs: the lady of the house is
generally seated there, and there is room for two
or three others, for whom it forms a retreat,
which, if not very secret, is secluded enough to
please the imagination." A large Bokhara-pattern
rug almost completely covers the floor.

The walls of the room are densely lined with
paintings. A taste for landscapes is evident, but
the choice is eclectic, the collection being given
uniformity by the device of framing the works in
variants of a simple gold molding with a deep
hollow. The painting to the right of the fireplace
shows a family group, a mother in some national
costume, possibly Italian, with two small chil-
dren; at this date (1835) the subjects could only
be Stephanie Radziwill, Prince Wittgenstein's
first wife, and the two children of that marriage.
On a pedestal in the center of the room is a
statue, in the manner of Lorenzo Bartolini, of a
kneeling child praying. On pedestals in the
window are reduced replicas of well-known
groups by Giambologna, *The Rape of the Sabines*
and *Florence Subduing Pisa*. Their protective
glass domes suggest that they are of some fragile
material — alabaster or ceramic. Such models
were bought in Florence, as popular souvenirs of
the tour of Europe that was still regarded as an
essential culmination of the education of a culti-
vated gentleman.

Literature: Praz, 1964, pl. 294.

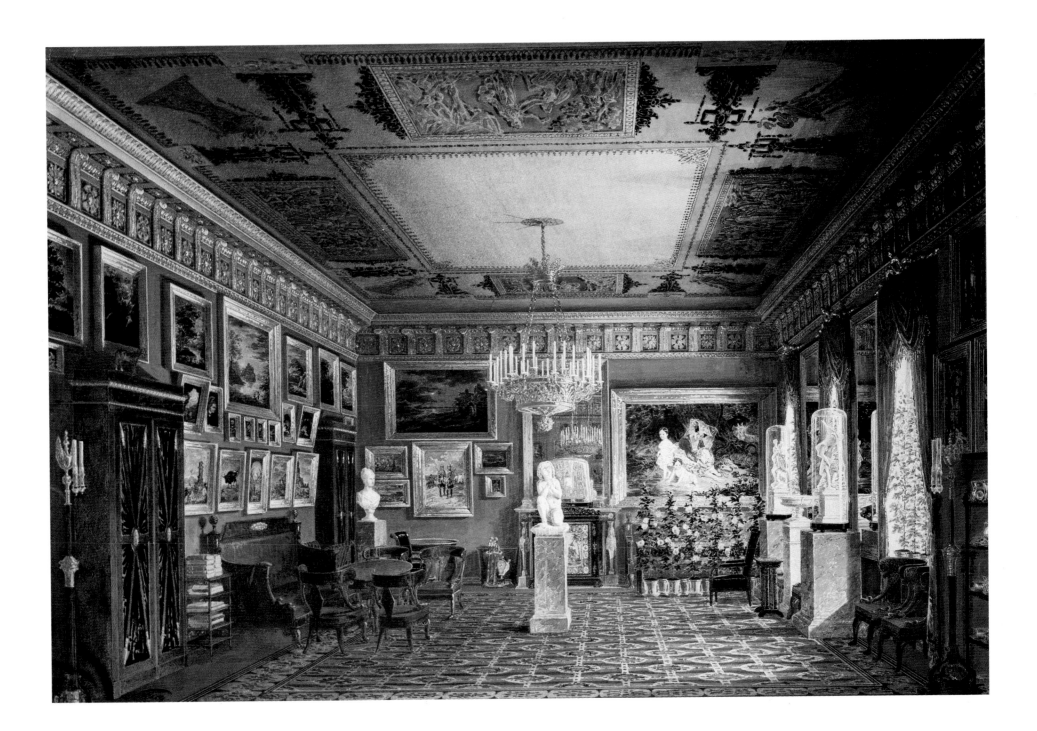

W6. *A Bedroom in the Wittgensteins' Berlin House, 1836*

EDUARD GAERTNER (1801-77)

Watercolor and gouache, 7¾ x 10⅜ in. (18.7 x 26.3 cm)
Signed lower right "E. Gaertner," inscribed on the old mount "Gaertner. / La Chambre à coucher à Berlin / Avril 1836"

On March 5, 1837, Lady Londonderry (1973, p. 152) set down her first impressions of Berlin: "a beautiful capital, so clean and regularly built, wide streets, fine large stone buildings, etc. and the perfect symmetry of the whole is very striking. Not a house can be built without permission and according to the general plan. There is a very clever architect and they have good stone." The "clever architect" was Karl Friedrich Schinkel, by then so well known throughout Europe that it was unnecessary to give his name. His hand can clearly be seen in the decoration and furnishing of this bedroom. The black-upholstered armchairs are of his design, combining — with characteristic economy of effort — elements from two different models: the back and arms from a chair in his book of furniture designs of 1835-37, and the legs from one designed for the boudoir of Princess Augusta in the Prinz Albrecht Palais. The whole scheme of this bedroom is likely to have been devised by him. It was Schinkel's practice to oversee every detail, deciding the colors and supplying carpets, curtains, and picture frames. The unusual wastepaper basket in the form of an Etruscan urn is a characteristic touch. There is evidence of Russian influence in the troughs of climbing plants that screen from view the high bed, with its pile of feather pillows; the scrolled feet supporting the troughs would also have performed the useful function of providing slots for the carrying-poles that enabled the screens to be removed easily, an ingenious device that may well be due to Schinkel himself.

The large doll lolling in the chair beside the writing desk is probably a dressmaker's mannequin. Many of the surviving dolls from the eighteenth and early nineteenth centuries were made to demonstrate the latest fashions, not as playthings. The handsome, elaborately dressed child's toy with realistically modelled features, limbs of wax or china, and eyes that opened and closed was not introduced until later in the nineteenth century. On seeing the diversity of costume in St. Petersburg, Martha Wilmot (1934, p. 26) noted, "I have heard people of curiosity regret that during a long life they had not collected specimens of the fashion of every year by dressing a Doll as every flash of fashion flitted by."

Prince Wilhelm of Sayn-Wittgenstein-Hohenstein, the Great Chamberlain to the Prussian court and thus the minister responsible for decisions relating to development in the capital, was a kinsman of Prince Ludwig Adolf. We need look no further for a connection with Schinkel, but Prince Ludwig Adolf would already have known of the architect's gifts from his first wife's family, the Radziwills, who were among Schinkel's most important early patrons. Schinkel went on in 1837 to design for the Wittgensteins Schloss Werki at Vilna (see no. W19), together with other decorative schemes and furnishing. The amount of his work that is identifiable in the Wittgenstein Album documents his role in the history of nineteenth-century taste.

Eduard Gaertner's views for the Wittgenstein Album were completed when he could still find time for private commissions, before he embarked in the 1840s on more than a decade of recording the state rooms in the Berlin Schloss and private rooms there and in the other royal palaces (see nos. 20, 21).

Literature: Praz, 1964, pl. 20.

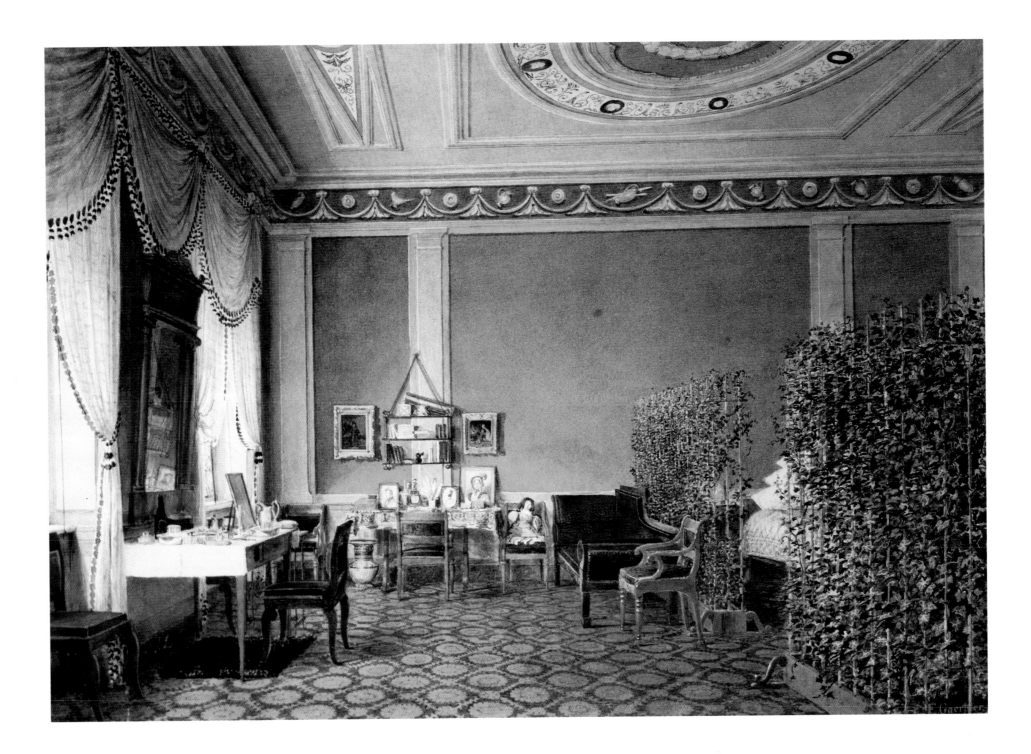

W7. *A Room in a House at Potsdam, 1836*

EDUARD GAERTNER (1801-77)

Watercolor, 7 x 9¹⁵⁄₁₆ in. (17.8 x 25.2 cm)
Signed and dated lower right "E. Gaertner 1836," inscribed
on the old mount "Potsdam 1836"

An exterior view formerly in the Wittgenstein Album, inscribed on the old mount "Maison Russe dans la colonie près de Potsdam," shows one of the wooden houses in the traditional Russian style built in the Alexandrovska Park in 1826 for the Russian bandsmen then attached to a regiment of the Prussian guards. That the present drawing may be an interior in the same house is suggested by the musical motifs decorating the coffered ceiling. The room is furnished with English-style pieces then much admired in Germany — side chairs in the Regency taste and the nesting quartetto tables popularized through the publication of Sheraton's *Drawing Book* in a German translation in 1794 — and a heavier Biedermeier sofa and pyramidal display cabinet with ram's-head ornaments (for a similar model dated "c. 1815" see Ferdinand Luthmer and Robert Schmidt, *Empire - und Biedermeiermöbel aus Schlossern und Bürgerhausen*, 1922, pl. 82b). At the right, a profusion of flowering plants forms a column of greenery in a special container; built around a central pillar dividing at the top into four scrolls from which hang glass vases and culminating in a winged Victory balanced on a crystal globe, this decorative device is inspired by Russian floral arrangements, which were, by the 1830s, becoming fashionable in Germany. The Wittgensteins would have been in advance of German fashion, for they had always filled their Russian houses with lavishly planted containers, making centerpieces or screens of foliage and flowers.

The immense two-tiered chandelier with rings of candleholders closely hung with long crystal pendents visible in the room beyond the door suggests a formal salon or ballroom, whereas the figure seated on the banquette and spinning in the company of two children gives the nearer room the domestic air of a boudoir or family sitting room.

Eduard Gaertner was one of the most accomplished practitioners of the genre of interior view-painting. In the 1840s and 1850s he made a series of watercolors recording in the finest detail the state rooms in the Berlin Schloss (see no. 20) and in the palaces of other members of the royal family (no. 21). In 1836 he had only recently completed his panorama of Berlin for King Friedrich Wilhelm III of Prussia (now at Schloss Charlottenburg, Berlin) and was about to embark on the first of several visits to Russia (1837-39), where he painted a panorama of Moscow for Nicholas I (a version of which is also at Charlottenburg).

Literature: Praz, 1964, pl. 289.

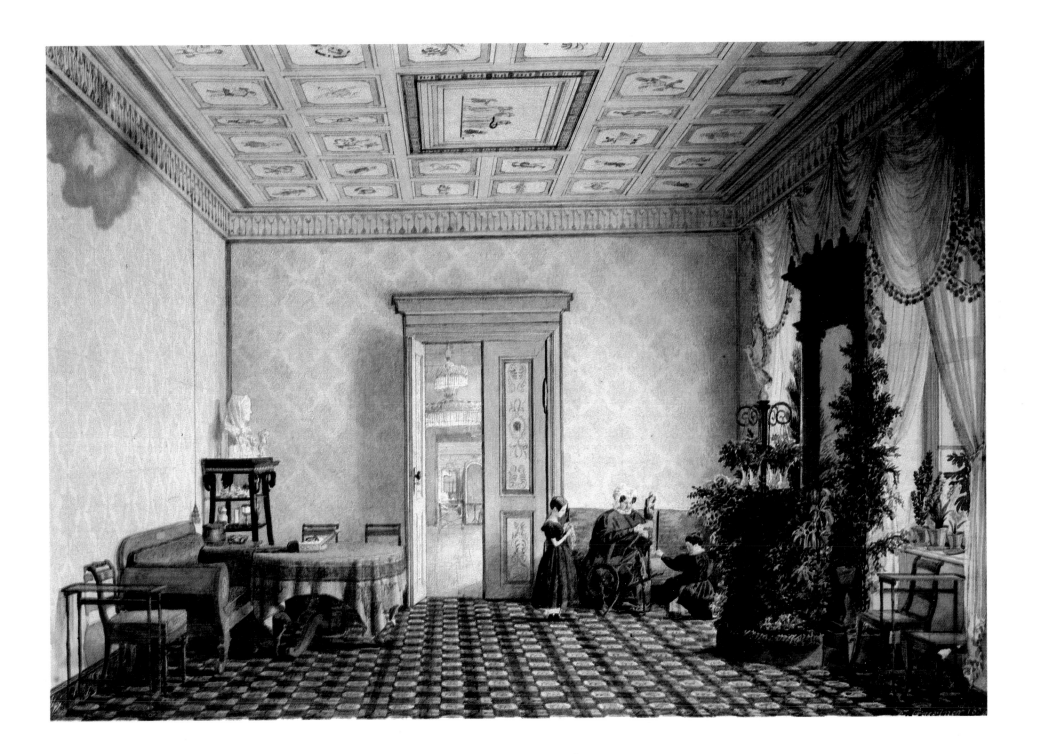

W8. *The Columned Salon at Ivanovski*

Russian (1830s)

Watercolor and gouache, 10¾ x 14¼ in. (27.4 x 36.1 cm)
Inscribed on the old mount "Iwanowski"

The Wittgenstein connection with Ivanovski was through Prince Wittgenstein's younger brother Nicholas, who in 1837 married Carolyne, daughter of Peter d'Ivanovski, a member of the landed Polish nobility. The great Neoclassical house on a vast estate in the province of Kursk belonged to Carolyne's uncle, Dionizy Ivanovski; his land agent, Jan Paderewski, an impoverished member of a noble family, was father of the celebrated pianist Ignacy Paderewski, who was born in 1860 in a manor house on the estate and in 1919 became the first President of the Polish Republic.

The focal point of this large room is a Venetian window giving onto a conservatory or winter garden, the two being linked by an ornamental trellis in the window openings. In front of the window is a tiered arrangement of plants surrounding a white marble figure of a kneeling nymph, and other classical figures decorate the winter garden itself.

Through the double-columned screen dividing the room — a device inspired by Robert Adam — two members of the family can be seen playing billiards while a small child vigorously wielding a toy whip pulls a pair of horses on wheels. The simple, white-covered banquettes and side chairs suggest that the season is summer. They hardly begin to furnish this lofty almond-green room, with its ceiling of gilded plasterwork inset with brilliant sky-blue floral medallions and finished with a border of cornucopias. Sunlight streams onto the polished parquet floor, which is bare of carpet or rugs. Just visible through the columns is a window dressed with a fashionable French-inspired arrangement of draped muslin curtains over cornice poles in the form of crossed spears.

Neither the present drawing nor that of the Ivanovski library (no. W9) is signed; while this one is the work of a competent, probably professional hand, the other is clearly done by an amateur. Exceptionally, neither is dated on the original album page, but the costumes of the billiards-playing figures and the style of such furniture as there is suggest the same decade, 1830-40, as the rest of the album. The decoration of the room is earlier, and probably dates from the late eighteenth century when the house was completed.

Literature: Praz, 1964, pl. 5.

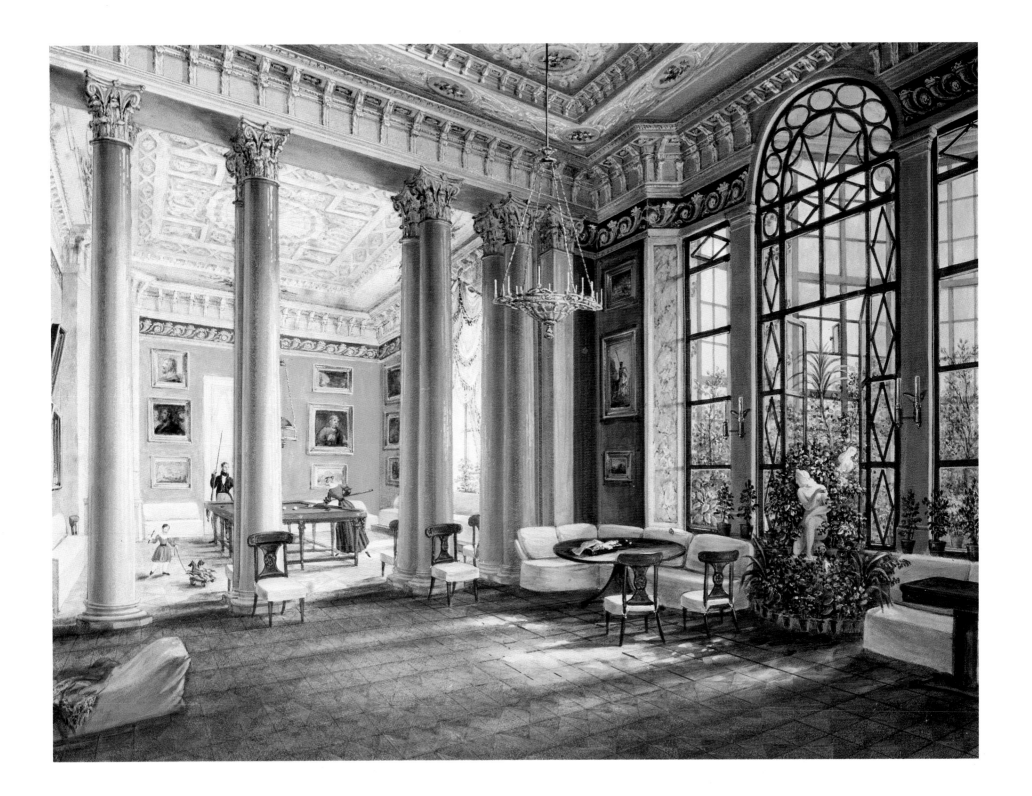

W9. *The Library at Ivanovski*

RUSSIAN (1830s)

Watercolor, 7½ x 11½ in. (18.5 x 28.6 cm)
Inscribed on the old mount "Biblioteca di Iwanowski"

A totally functional library is rarely depicted. By the late 1830s the library was often used as an informal sitting room, but the one in this drawing is old-fashioned in being entirely devoted to books. The walls are lined with glass-fronted shelves almost to the cornice, leaving room for a single row of landscape paintings on the right above the bookcases. These must have been almost invisible from below and are further obscured by the conventional library busts in plaster or white marble that stand in front of them. In the wall at the left the space above the bookcases is pierced by a row of lunette windows which cut into the cornice and form a kind of clerestory. On the end wall are more landscape paintings, hung round the door without any attempt at a formal arrangement. In the center of the room is a round table covered by a red cloth, with a stiff upright settee and two chairs drawn up to it, probably for consulting books rather than for relaxation or conversation. Beyond the table is a large folio press for the storage of maps or prints; on it are a tall lamp with a white glass shade and a group of scientific instruments including globe, telescope, and orrery.

In the far corner is an open fireplace, an unusual feature in a Russian house, in which the rooms were usually heated by large porcelain stoves. More landscape paintings and a drop-front secré-taire surmounted by a bust can be seen in the room beyond, in which the walls are a deep blue like the carpet entirely covering the floor of the library. Supplementing the lamp on the folio press are a hanging lamp and a three-branch Argand lamp on a tripod in the window, which

would have shed a powerful light. As Lady Londonderry remarked (*Russian Journal*, p. 98), "The lighting in this country is very brilliant," a theme she returned to more than once.

On the floor in front of the lampstand is an unexpected feature, a model house presumably made of painted cardboard or thin wood, set on a tray that rests in turn on another tray with a model of a garden. The care lavished on the plants and *chinoiserie* features of the garden suggests that this is more than a simple child's toy. The house is a single-story structure like the wooden dachas in the Russian countryside owned by most well-to-do families. The Wittgensteins had one at Zausze (see no. W18), a simple, low-built, but nonetheless elegant house with a columned and pedimented entrance. Other views from the album show the family in residence (cf. Praz, 1964, pls. 14, 15) enjoying the wooded, flower-filled garden. The model may be a project for elaborate pleasure grounds of the same kind.

Every convenience was provided for the users of this library. Carolyne d'Ivanovska, niece of its owner, married unsuitably and unwillingly to the incorrigibly frivolous Nicholas Wittgenstein, was well-read and intensely serious-minded. Dionizy Ivanovski's wife was a writer and Polish patriot, and it was her over-enthusiastic campaigning during the Polish uprising in 1848-49 that obliged the family to leave their home in Poland and live in exile at Ivanovski.

Literature: Praz, 1964, pl. 286.

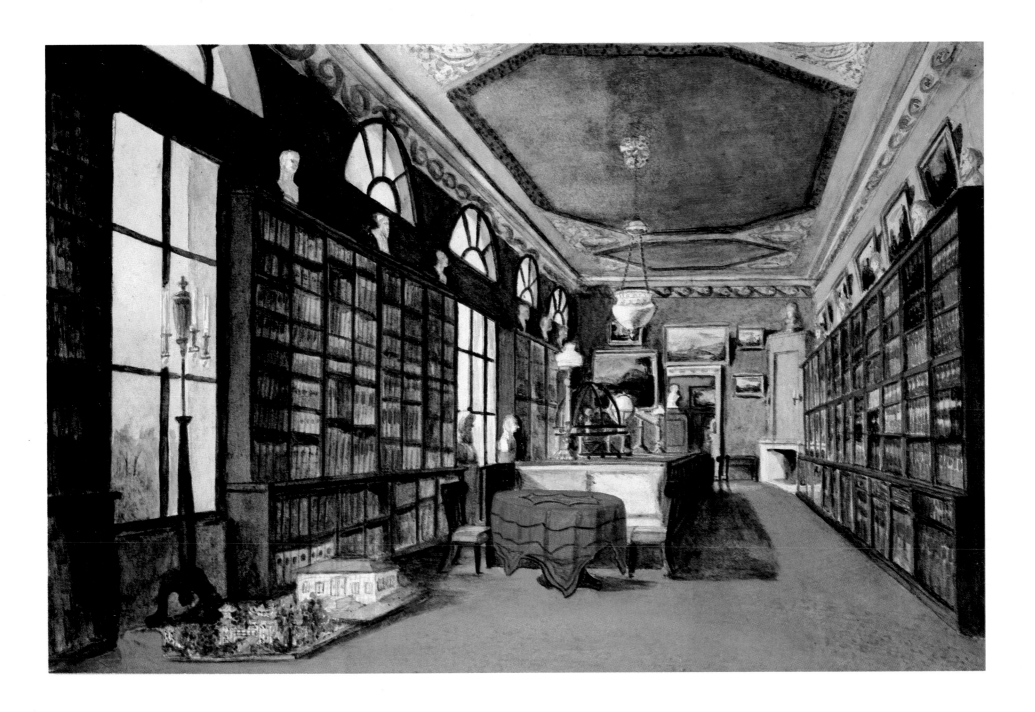

W10. *A Room in the Hôtel Lobau, Paris, 1837*

FRANÇOIS-ÉTIENNE VILLERET (1800-66)

Watercolor and gouache, 8⅞ x 11⁹⁄₁₆ in. (20.0 x 29.3 cm)
Signed and dated lower right "Villeret 1837," inscribed on the old mount "Villeret / Salon de l'Hôtel Lobau à Paris / Mai 1837"

Georges Mouton, Comte de Lobau, was made marshal of France in 1831 at the time of the French campaign in Algeria. He died in 1838. A view of the Hôtel Lobau formerly in the Wittgenstein Album shows a large, plain eighteenth-century house with a garden in front, on the quai d'Orsay immediately to the east of the Palais-Bourbon (Chambre des Députés). It was demolished to make way for the opening of the boulevard Saint-Germain.

The Countess of Blessington, seeking an apartment in Paris in 1828, was offered the Hôtel Lobau (*The Idler in France*, 1841, p. 72): "The house of the Marechal Lobeau [*sic*], forming the corner of the Rue de Bourbon, is the one I prefer of all those I have yet seen," she reported.

The painted doors and imposing overmantel mirror must be part of the original scheme, which would have been in white and gold, but the blue velvet walls and curtains dominate the room with overpowering effect. It is unusual to find a room completely hung with fabric in a plain color relieved only by a patterned border in the same color; in the 1830s there was a fashion for tenting or draping the walls and ceiling of small rooms in a patterned fabric that also served for curtains, but this was not considered appropriate for large rooms.

The draperies hanging from shaped gilt cornice poles above the windows at the right, which give onto shallow iron balconies, are repeated on the opposite wall for what appear to be blind windows, in front of one of which is hung a large painting — possibly the Vernet harbor scene from the New Salon at Pavlino (see no. W14). A suite of Neoclassical furniture consisting of four consoles between the windows, a sofa, and two armchairs is ranged formally round the walls, and is no doubt a survivor of the original scheme. The two circular tables have been deprived of their Empire elegance in favor of bourgeois comfort by being swathed in patterned cloths, and the stiff, square upholstered chairs are supplemented with more comfortable spoon-backed easy chairs upholstered in blue and a leather-covered reclining chair. The jardinière filled with plants in the central window seems to be contemporary with the later easy chairs. The large rug is patterned with a formal Empire-style design.

To the conventional Empire *garniture de cheminée* of an ormolu clock under a glass cover and a pair of gilt and patinated bronze candelabra has been added a pair of white porcelain statuettes of the celebrated ballet dancers Marie Taglioni and Fanny Elssler. Such figures of the rival dancers, principal ballerinas at the Paris Opera in the 1830s, were probably based on popular souvenir prints; Praz (1964, pl. 261) notes that prints of the same two dancers striking the same poses hang in a Russian house in P.A. Fedotov's painting *An Aristocrat's Breakfast* (Tretyakov Gallery, Moscow).

Hanging from the center of the ceiling is a chandelier consisting of a "waterfall" of crystal drops and a ring of ormolu candleholders. A feature of the formal salons in the album is that they are lit only by candles, in contrast with the profusion of oil lamps in studies and living rooms. Supplementing the chandelier and the pair of two-branched candelabra on the mantelpiece, each console bears a five-branched version of the winged Victory candelabrum designed by Percier and Fontaine and made by Thomire for Malmaison (see fig. 1).

François-Étienne Villeret exhibited at the Paris Salon from 1831 to 1850 and made his reputation with church interiors in the Romantic taste of the time. He was an accomplished architectural painter and made watercolor views of Parisian buildings and a number of minutely detailed interiors, of which this is a characteristic example.

Literature: Praz, 1964, pl. 288.

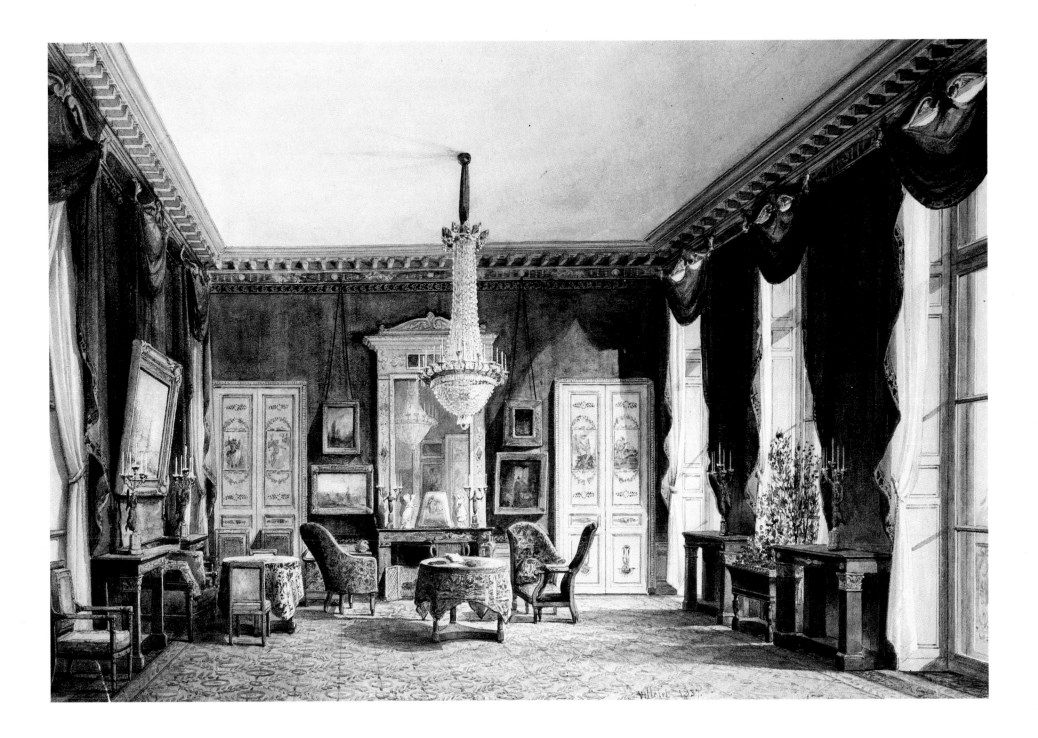

W11. *A Boudoir in the Hôtel Lobau, Paris, 1837*

RUSSIAN (?)

Watercolor, 6⁵⁄₁₆ x 10⁵⁄₁₆ in. (16.0 x 26.2 cm)
Inscribed on the old mount "Boudoir de la Princesse dans la maison du Maréchal Lobau à Paris / Mai 1837"

This low-ceilinged room must have been on the west side of the mezzanine floor of the Hôtel Lobau (see no. W10), assuming that the building visible beyond a parapet through the left-hand window is the side wall of the portico of the Chambre des Députés. The part of the house that could be rented from Maréchal Lobau was not very large, according to Lady Blessington (p. 89): "We have been compelled to abandon the project of taking the Marechal Lobeau's house, or at least that portion of it which he wishes to dispose of, for we found it impossible to lodge so large an establishment as ours in it."

The garish pattern of the carpet strikes a discordant note in the elegant white-and-gold panelled room, with its flat pilasters enclosing mirrors that surround the fireplace on three sides; to the left of the fireplace is a jib door covered in white leather, edged with brass-headed nails, to match the wall panel on the other side. A mirrored wall of this kind seems to have been fashionable in Paris in the 1820s and 1830s. Lady Blessington, who was in Paris from 1828 to 1830, noted (p. 104) that in the principal bedroom of Maréchal Ney's adjoining house in the rue de Bourbon: "One side of the room is panelled with mirrors, divided by pilasters with silver capitals; and on the opposite side, on which is the chimney, similar panels occupy the same space." The resemblance between this description and the present drawing is so striking it seems reasonable to assume that the same decorator was responsible for both houses.

Flowering plants in pots stand on the mantel-piece, on the writing table, and on the English-style nesting tables to either side of the latter. Flowers and plants in pots were a conspicuous feature of the rooms inhabited by the Wittgenstein family in Russia and at Potsdam. Propped up on the writing table is an album with an armorial binding in red morocco. The simple furnishings are completed by a pair of mahogany armchairs upholstered in blue-and-white striped silk, a plain mahogany étagère, and unlined white curtains hanging from brass rods.

The drawing is not signed or inscribed and seems to be by an amateur hand, possibly the "Princesse M.B." who painted the view of the bathroom at Marina (no. W17).

Literature: Praz, 1964, pl. 287.

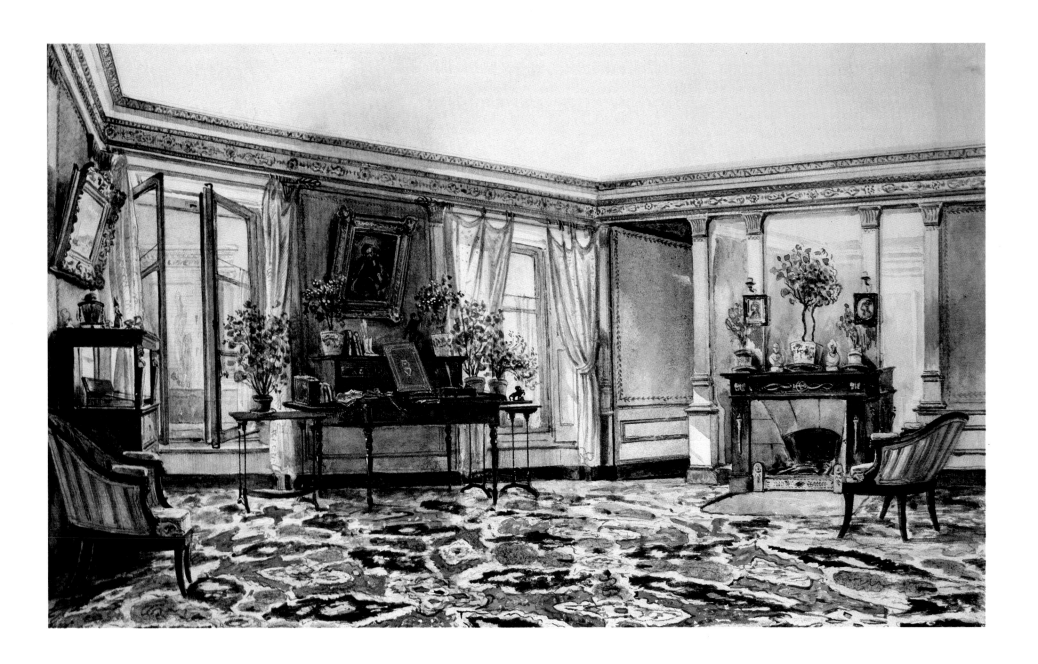

W12. *A Bed and Dressing Room at Kamenka, 1837*

HAASE (fl. 1830s)

Watercolor and gouache, 6½ x 11¾ in. (16.4 x 29.6 cm)
Inscribed on the mount "Haase. / Chambre à coucher et cabinet à Kamenka. / Novembre 1837"

This view of a bedroom at Kamenka illustrates the peculiar sleeping arrangements in Russia that so surprised travellers from the West. Théophile Gautier (*Voyage en Russie*, 1884, p. 130) remarked how in this respect the nineteenth-century Russians recalled their Oriental antecedents: "Les Russes sont d'origine orientale, et même, dans les classes élevées, ils ne tiennent pas aux douceurs de coucher." He noted that a screen (as here) concealed a low camp bed or divan; bedclothes were dispensed with, and many Russians slept simply wrapped in a cloak: "ils dorment où ils se trouvent, un peu partout, comme les Turcs, souvent dans leurs pelisses."

Martha Wilmot (1934, p. 24) describes her arrival in St. Petersburg in 1803 at the palatial house on the Neva belonging to Mme. Poliansky, who "received me with excessive politeness and introduced me to *my own establishment* in this house which consists of a very elegant dressing room furnish'd with red leather sophas, chairs, Tables &c, ... a large looking Glass before which stands a pier table furnish'd with splendid Gilt China cups and saucers 'wisely kept for shew', a little clock *à la française*, ... My Bed is literally a Sopha; and what surprised me a little, a single Quilt was all the covering provided, so that the Blankets I brought with me from old England stood me in good stead."

The dressing table in the Kamenka bedroom is equipped with a toilet set of silver and silver-gilt, not "wisely kept for shew" but obviously in use.

Miss Wilmot's remark is explained by the fact that traditionally in Russia the toilet set was part of the bride's dowry and was of the most luxurious material that her family could afford. It was placed on display at the wedding celebrations for the guests to see, and was the subject of much speculation and comment as to the financial standing of the family.

A touch of French Neoclassical taste is provided by the spearhead cresting and elegantly striped and pleated blue panels of the screen that extends the width of the room save for openings at each end, with the space beyond divided to form two compartments; the tops of the spearheads running along the central dividing screen are just visible. A maidservant usually slept in the same room as her mistress. Martha Wilmot continues: "*Madm* Poliansky would insist that I should feel more comfortable with her *femme de Chambre* in the room, so I yielded for once; and to give you an idea of matters, she brought two pillows which she plac'd on a second sopha, took off her Gown and without more ado or even attempting to cover her head which was bare, she stretch'd on the sopha, and, at my request fell into a profound slumber." Miss Wilmot would surely have welcomed the degree of privacy afforded by the division behind the screen. The suite of Russian Biedermeier furniture is upholstered to match the screen. In addition to the dressing table there is a table equipped for writing placed at an angle to the window to get the maximum light.

Praz's reproduction (1964, pl. 290) of the view of the elaborately decorated ground-floor salon at Kamenka with its frieze of flowers on a gold ground, then still in the Wittgenstein Album, gives an idea of the formal grandeur of this great Neoclassical house. Praz attributes that drawing to "Haase," and the old mount of the Kamenka bedroom is inscribed with the name of this as yet unidentified artist; another of the Kamenka views is signed with the same name in Cyrillic characters, so the assumption must be that he was Russian.

Literature: Praz, 1964, pl. 19.

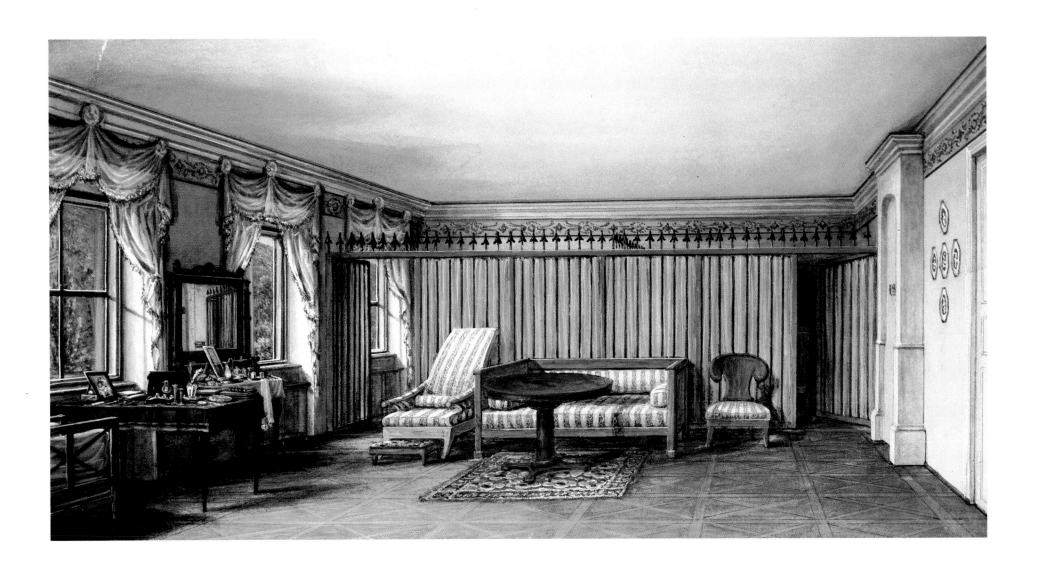

W13. *A Gothic Room in the Bariatinsky-Sergeevs-kaya House, 1837*

SOTIRA (fl. 1830s)

Watercolor and gouache, 12⅞ x 11¾ in. (32.8 x 29.9 cm)
Signed and dated lower right "Sotira, 837," inscribed on the
old mount "Sotira / Maison Bariatinsky Sergieiewskaia"

The adjoining Neoclassical salon with a statue of
Diana the Huntress on a pedestal in the center,
seen through the open double doors, suggests that
this Gothic room is an addition to an eighteenth-
century palace. The taste for the Gothic in Russia
received imperial approval with the construction
in 1826-29 of the English Cottage in the Alexan-
dria Park at Peterhof, designed by Adam Mene-
laus. The Gothic architectural elements are
heavier in the Bariatinsky-Sergeevskaya house
than at the English Cottage, where the tracery is
carried out in shallow stuccowork and the win-
dows are conventional casements. The Bariatin-
sky room has a lofty vaulted ceiling with tracery in
relief and Gothic-style windows with panes of
painted glass. The carpet, fitted up to the
threshold of the room beyond, and the maroon
wallcovering figured in black are in keeping with
the somber scheme, which is relieved only by the
vivid blue upholstery.

By 1837 the Gothic style was widely admired, and
furniture of the type used for this room was being
made in Britain, Germany, Austria, and to a lesser
extent France. The variety of furniture types in
Russian Gothic interiors — in the two rooms at
Pavlino (nos. W3, W15) and in the Bariatinsky
house, as well as at the English Cottage, all
possibly inspired by illustrated periodicals like
Ackermann's *Repository of Arts* — suggests
manufacture in Russia itself. The furniture for
the imperial English Cottage is attributed to the
workshop of Peter Gambs, son of the celebrated
cabinetmaker Heinrich Gambs, who produced

the furniture designed by Voronikhin for Pav-
lovsk (see Chenevière, 1989, pp. 232-33). Other
furniture workshops must have followed suit as
the taste spread beyond the imperial circle.

The two paintings on the end wall seem to be
works by François-Marius Granet (1775-1849),
who was much admired in Russia at this date. To
the left of the open doors is a view of a flight of
steps in the so-called Villa of Maecenas at Tivoli,
and to the right is a version of his *Choir of the
Capuchin Church in Rome*, both dark, vaulted
scenes suitable to the prevailing style of the room.
The contrast with the white-pilastered, drapery-
hung salon beyond, where a duet is being played
at the grand piano and children are pulling a little
green cart as the bright sunlight slants across the
parquet floor, could hardly be more pronounced.

Literature: Praz, 1964, pl. 298.

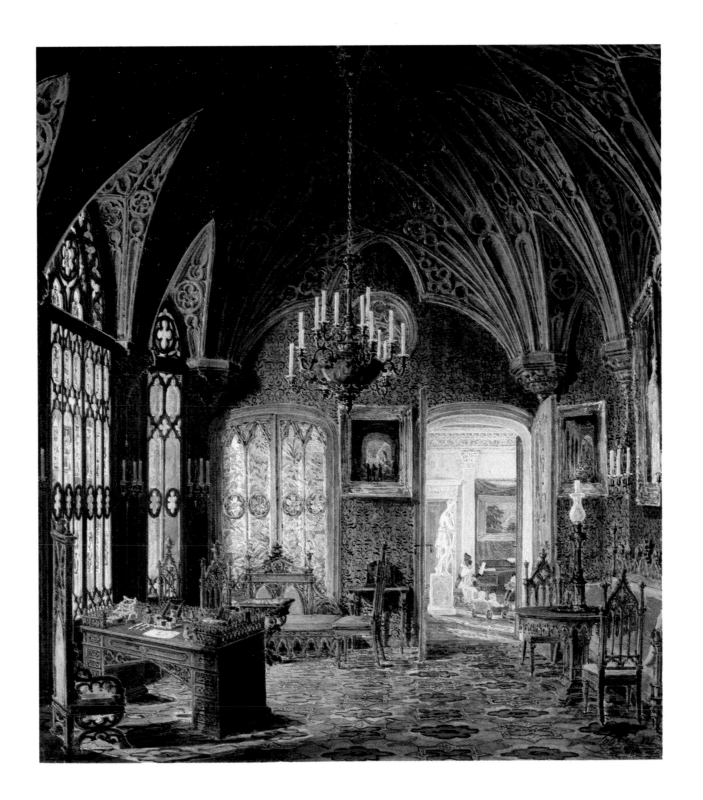

W14. *The New Salon at Pavlino, 1838*

SOTIRA (fl. 1830s)

Watercolor, 11⅜ x 16½ in. (28.7 x 42.0 cm)
Inscribed on the old mount "Sotira / Le Nouveau Salon à Pawlino / Août 1838"

The "New" Salon may have been needed to accommodate the two very large paintings that dominate it. They were evidently much treasured, since they are individually lit with the *puissants réflecteurs* noted by Gautier on his visit to Russia. The vast canvas on the end wall clearly represents *Anne Boleyn Condemned to Death, Taking Leave of the Infant Princess Elizabeth*, a favored French academic subject which seems at first sight to be by Paul Delaroche (1797-1856), whose subject matter included historical episodes from the sixteenth and seventeenth centuries showing the English in an unedifying light. The subject of Anne Boleyn in the Tower was much in the public mind in the 1830s, thanks to Donizetti's opera *Anna Bolena*, first performed in Paris in 1831. It was treated by more than one exhibitor at the Paris Salon in the years immediately following that production, notably by Henri Decaisne, whose *Adieux d'Anne de Boleyn à sa fille Élisabeth* had a considerable critical success in 1833. The central group in this work is tantalizingly close to the composition of the Pavlino painting, but Decaisne would hardly have repeated this subject so soon and on such a large scale. It should be possible to trace this major historical work, but Dr. Jon Whiteley has found nothing that corresponds exactly in his exhaustive records of the Salon exhibits of the period, and no such subject is listed in Delaroche's known work.

The large harbor scene on the left-hand wall might be one of the variants of this romantic Claudian subject popular with patrons of the eighteenth-century landscape painter Claude-Joseph Vernet (1714-89). The sculpture of the boy kneeling in prayer, depicted three years earlier in the Saloon (no. W5), has become the centerpiece of the New Salon, its pedestal encircled with pots of flowering plants echoing the banks of flowers around the room. A lamplit conversational group sits at the left, and another circle of chairs for talk or other pastimes is arranged round a table on the right. In pattern and material these chairs resemble the armchair, possibly of steel and ormolu, by the writing table in the room in the Kishkovsky dacha (no. 14), and they probably come from the same source. Otherwise much of the furniture is of the English type, notably the two nesting tables on the left. The decoration of the room is almost monochrome, with damask-patterned walls, plain ceiling, and wood floor subordinate to the display of paintings.

Sotira has risen triumphantly to the challenge of suggesting the harsh quality of the strange flaring picture lights. Views of lamplit interiors are rarer than daylit ones, since the deep shadows involve the loss of too much of the very detail for which these scenes were prized. It is interesting to see how brilliantly the *réflecteurs* could illuminate a room.

Literature: Praz, 1964, pl. 293.

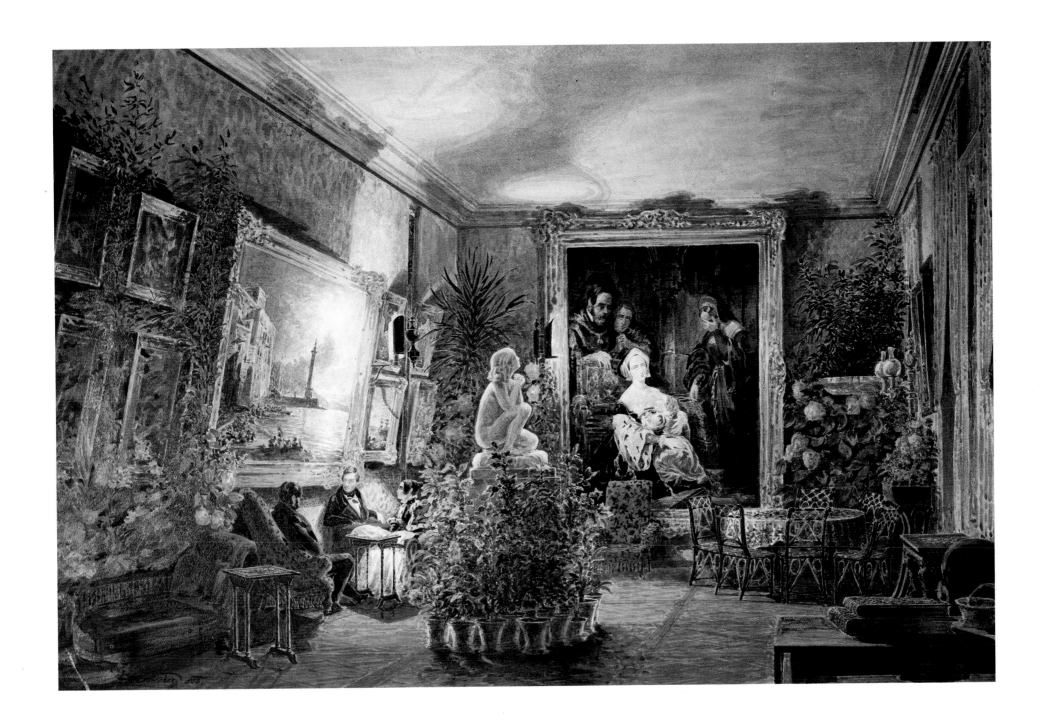

W15. *The Princess' Sitting Room at Pavlino, 1838*

SOTIRA (fl. 1830s)

Watercolor, 10¾ x 16⅛ in. (27.4 x 41.0 cm)
Signed and dated lower right "Sotira 838," inscribed on the old mount "Sotira / Le Cabinet de la Princesse à Pawlino / Août 1838"

Evidently pleased with the Gothic-style Little Salon (see no. W3), the Princess has added further Gothic decoration at Pavlino. That this is more ambitious than the earlier scheme is shown by the fact that the two portraits from the Little Salon have been moved here and given a central position over the divan. Even the chairs with their blue upholstery appear to be new, though they have pierced tracery backs with a central quatrefoil similar to those of the armchairs in the Little Salon window bay. In the latter room there is a mixture of styles, but here there are no inconsistencies to mar the Romantic Gothic effect. The large glass-fronted bookcase with its cresting of pinnacles and pointed arches, the heavy lectern supporting a painting (reminiscent of great Gothic abbey lecterns at, for example, Melk), the candelabra (one with a shade of eight transparencies, no doubt of Gothic scenes, another shaded by a pair of lithophanes of translucent porcelain), the plant stand at the end of the room, and the tables are all ornamented with intricate Gothic carving. Even the striped blue wallpaper has a Gothic border. For once there is no sign of Schinkel's influence; this scheme looks entirely Russian, like the vaulted Gothic fantasy in the Bariatinsky-Sergeevskaya house (no. W13).

Under the writing table is a bearskin with its back stuffed into a hump to make a tabouret of the kind described by Théophile Gautier in his *Voyage en Russie* (p. 131). The floor of wide planking is otherwise almost bare but for a long rug patterned with a regular geometric repeat in broad stripes.

The windows are dressed with their summer muslins draped over gilt poles in a double swag, caught up at the center with a cloak pin fixed high up in the ceiling molding. On a white painted stand in the far window on the left-hand wall is a group of scent bottles in blue and ruby glass, probably Bohemian. On the shelf running round the chimney breast opposite is a row of figures in military uniform. Hanging at the side of the fire screen is a face shield decorated with a bouquet of flowers.

In this watercolor Sotira has displayed to its full his skill in catching the glittering and dancing effect of sunlight flooding through windows onto different surfaces. Two views of Pavlino — this sunlit scene and the lamplit New Salon (no. W14) both done in August of 1838 — show at its most sophisticated his ability to suggest the different effects of light.

Literature: Praz, 1964, pl. 292.

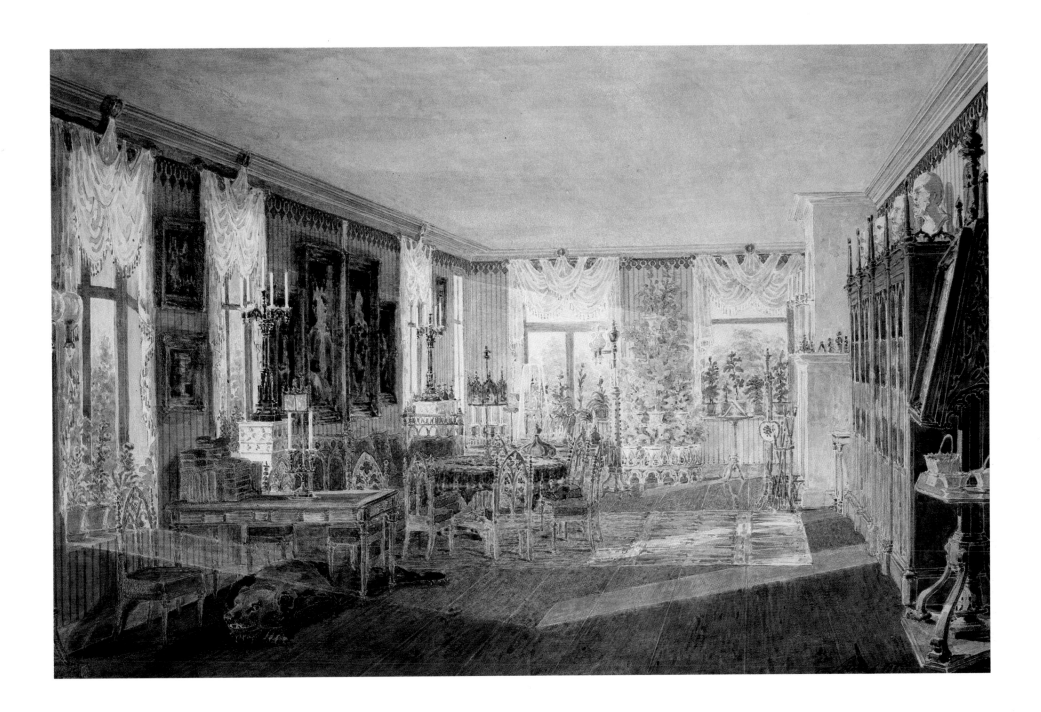

W16. *The Little Salon in the Rasumovsky House, 1838*

Sotira (fl. 1830s)

Watercolor and gouache, 7⅜ x 10¾ in. (18.9 x 27.2 cm)
Signed and dated lower left "Sotira 838," inscribed on the old mount "Sotira / Petit Salon dans la maison Razoumowski / Avril 1835"

This small pearly-white space forms an anteroom to the larger blue salon or music room beyond. It is dominated by a black-and-gold cabinet containing a collection of casts from the Antique, including the Pompeian tripod with sphinx supports that was often used as a model for the bases of small tables or lampstands, particularly by Schinkel for his iron furniture. One of the horse-tamers from the Quirinal fountain in Rome is visible on the lower shelf in the left-hand half of the cabinet; they were among the most popular of the reduced copies of monuments in plaster or alabaster that were bought as souvenirs of travel in Italy. A row of four massive busts, possibly also of plaster, are on the top of the cabinet, and a shallow two-handled vase on a square base is in front of the mirror between the windows. The windows are hung with a continuous drapery of muslin over a cornice pole stretching across the whole wall; the pelmet is caught up in a double swag by a cloak pin mounted above the cornice over the mirror. The chairs with their red squabs are clearly Russian.

The decoration of the room is austere. Its white-ness is hardly relieved by the pale pink-and-buff geometric decoration of the ceiling and the Classical cornice and frieze, the latter sharply modelled in relief and delicately picked out in white on a pink background bordered with gold-edged green lines.

This interior is less highly finished than Sotira's other drawings in the Wittgenstein Album. The ruled underdrawing shows in the panelling, and a frame is sketched but not completed above the three pictures to the right of the door. It is the last of the drawings by Sotira in the album, and its final touches may for some reason not have been completed.

Literature: Praz, 1964, pl. 283.

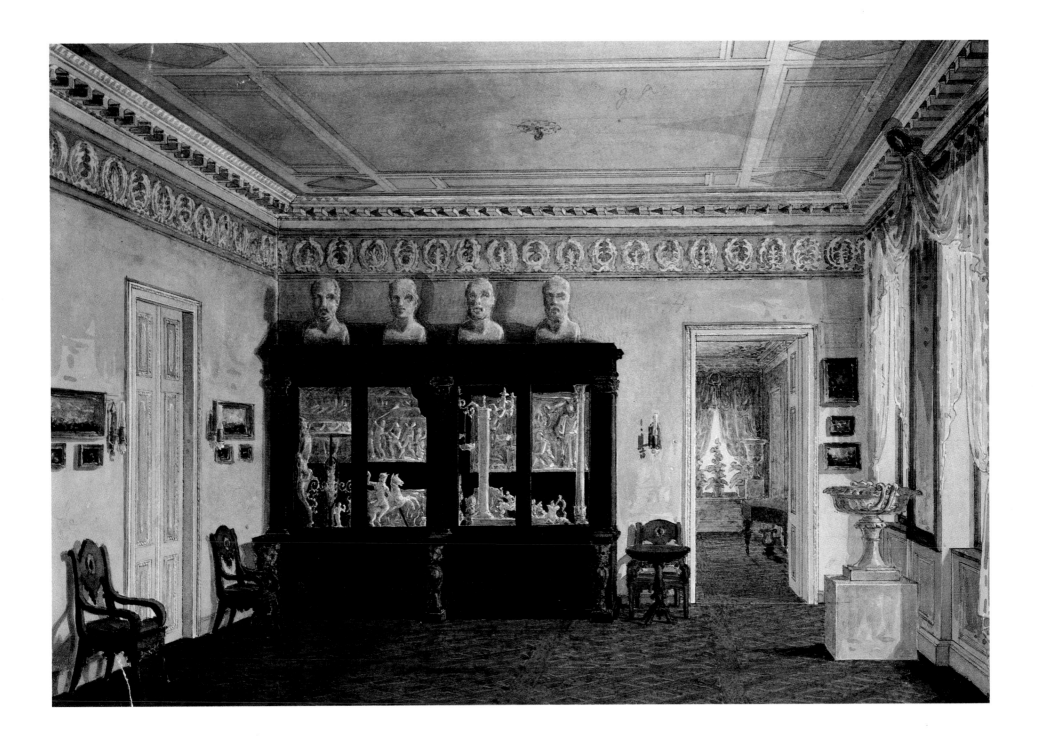

W17. *The Bathroom at Marina, 1839*

PRINCESS "M.B." (BARIATINSKY?) (fl. 1830s)

Watercolor, 7⅝ x 10⅝ in. (19.3 x 27.0 cm)
Inscribed on the old mount "La Princesse M.B. / Chambre de Bain, et Chambre à coucher à Marina / Janvier 1839"

The inscription gives no indication of the whereabouts of "Marina." No place simply of that name is recorded. In Italian, the term can mean seacoast or seashore and is found in conjunction with many placenames, as in Marina di Pisa. The Wittgensteins did have a seaside house, the Villa Dackenhausen, which had been built in 1836 on a cliff above the sea at the resort town of Castellammare di Stabia, southeast of Naples. Marina Grande is the name of the port on the nearby island of Capri where visitors disembarked. If the bathroom and adjoining bedroom shown here are in a house on Capri, the Wittgensteins would have been among the very early foreign residents, arriving when the island was still without an adequate water supply, let alone any other more rarified amenities of a civilized existence.

Though not furnished with the overwhelming luxury of the fabric-hung bathroom at Pavlino (no. W4), this room in the form of a domed octagon with alternate long and short sides is at least provided with a marble bath. The four long sides consist of arched recesses, one being taken up entirely by a full-length window, the two others visible in this view having bas-reliefs — either real or feigned — of marine subjects in the lunettes. Lady Blessington marvelled at the Princess Partano's marble bathroom at Casino (*The Idler in Italy*, 1839, p. 254), but such luxuries were not uncommon in Italy. The marble bathroom in the Pitti Palace in Florence is an eight-sided vault with a white bath and bas-reliefs in the lunettes as here, but it is more ornately decorated with sculptures and colored inlays.

The bathroom at Marina has a fitted carpet patterned in squares and floral motifs and an open fireplace with a large plain overmantel mirror. There are also a fully equipped writing table as well as a white-covered chaise longue and a reclining chair with buttoned upholstery. Bathrooms are only rarely depicted, and it seems likely that this and the Pavlino bathroom were sufficiently unusual in a Russian household to merit being recorded for posterity.

The adjoining bedroom visible through the door is plainly furnished with bed and folding screen, and seems to have a conventional flat ceiling and plain rectilinear cornice.

Praz suggested that the amateur artist of this view might be a member of Princess Leonilla's family. The unidentified figures peopling a number of the other drawings in the album suggest that a large entourage of family members, children, attendants, and domestics moved from house to house in the annual round.

Literature: Praz, 1964, pl. 282.

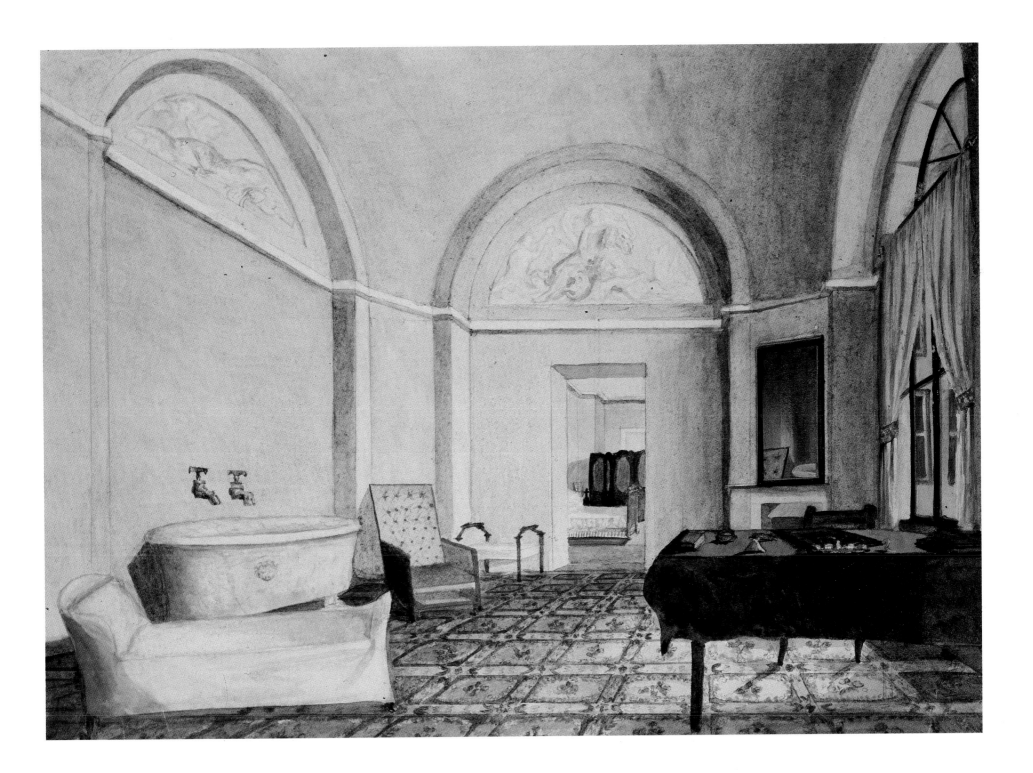

W18. *The Salon at Zausze, 1839*

RUSSIAN

Watercolor, 9⅜ x 14⅞ in. (23.6 x 37.7 cm)
Inscribed on the old mount "M.*** / Le Salon de Zausze /
Septembre 1839"

Two exterior views from the Wittgenstein Album of Zausze (possibly to be identified with Zarasay, a town on a lake north of Vilnius in modern Lithuania) show a single-story wooden country house and garden surrounded by a wooded park in which the family and their entourage play, sketch, and take alfresco meals (Praz, 1964, pls. 14, 15). Though the property is described as a farm, its surroundings were formally planted and, as this watercolor shows, the rooms were fashionably furnished and decorated. The wooden walls are covered with vertical stripes of conventionalized floral motifs in pink and white, either wallpaper or paint applied directly onto the planking; a printed paper border in the French style forms a frieze under the ceiling molding. The window frames and the panels beneath the windows are grey, and the floor is polished parquet in a pattern of diagonals within large squares. The suite of mahogany sofa, armchairs, and side chairs, upholstered in red, is Russian. The concert-sized piano may be Viennese. The muslin curtains draped from cornice poles in the form of an arrow set diagonally are in the Parisian taste — Ackermann refers to this type of arrangement as French — inspired by the designs published in the early years of the century in La Mésangère's *Meubles et Objets de Goût*. On the baize-covered writing table are a Russian atlas and a portfolio with a marbled paper cover. The profusion of floral arrangements is typically Russian.

The angle of the fender and firescreen on the right shows that there was an open fireplace across the corner of the room. The full-height panel of tiles beside the fireplace must have protruded quite some way into the room, since an armchair set beyond it is almost completely concealed; it may once have been the backing of a stove. The plush portière echoes the Oriental design of the rug. The anonymous artist, identified only by the initial "M" on the old mount (possibly the Princesse M.B. who was author of the view of the bathroom at Marina, no. W17), has rendered the textures and the glinting reflections on silk and polished wood with almost professional dexterity, but the perspective, often the downfall of the amateur, is faulty. A number of artists of very varying ability are represented in the Wittgenstein Album, but this may be the work of one of the family or a guest.

Literature: Praz, 1964, pl. 291.

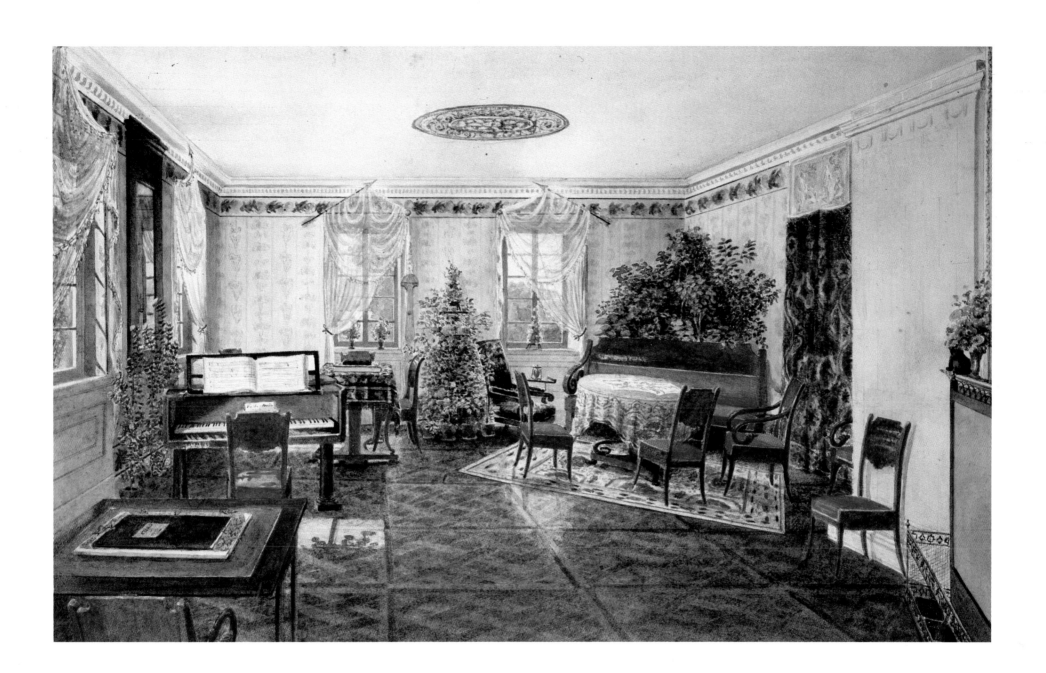

W19. *A Salon at Werki, 1840*

HAASE (fl. 1837-40)

Watercolor and gouache, 11 x 13⅜ in. (28.0 x 34.1 cm)
Inscribed on the old mount "Haase / Le Salon de Werki / Août 1840"

Werki, the estate near Vilna (Vilnius in modern Lithuania), came into the Wittgenstein family through the Prince's marriage to Stephanie Radziwill. Schloss Werki was designed by Karl Friedrich Schinkel in 1837, and can only recently have been completed when this view was painted. In 1924 Schinkel's original plans for the house were still in the Wittgenstein family at the now-ruined Schloss Sayn, east of Berndorf on the Rhine (see August Grisebach, *Carl Friedrich Schinkel*, Leipzig, 1924, p. 200). Schinkel made two watercolors of the completed Schloss, which show it to have been a large building with towers at each end of a long façade (see *Karl Friedrich Schinkel*, Berlin, 1982, nos. B.83, B.84). One of Schinkel's patrons was Prince Anton Radziwill, for whom he had designed a pavilion at Antonin in 1824, but the Wittgenstein commission for Werki came five years after the death of Princess Stephanie, when Prince Ludwig was already married to his second wife, Leonilla Bariatinsky.

There are many Schinkel touches to the furnishing of this and the adjoining blue salon. The pair of chairs with sloping arms just visible through the double doors are in the antique style designed for Crown Prince Friedrich Wilhelm. The green ottoman the edge of which can be seen just inside the door and the matching square *conversazione* upholstered in rose-pink velvet in the center of the first room were designed by Schinkel in 1832-34; another example of each survives in the State Collection at Potsdam, with the difference that the flowering plant in the square central container of the *conversazione* is

replaced by a sculptural bronze pedestal (*Karl Friedrich Schinkel*, no. 16.52). The chairs upholstered in black-and-red figured velvet, the same fabric as that used in the New Salon at Pavlino (see no. W14), show the influence of English upholstery styles and the taste for comfort that Schinkel had absorbed in England in 1826, which by the 1830s had become increasingly popular on the European mainland for informally arranged rooms. The folding screen with its pleated silk panels at the left and the carved and gilded chandelier are still in Schinkel's classical style from the 1820s. The shelves of the cabinet between the windows are laden with ornaments and curiosities, including a miniature armchair. Among the paintings is the large harbor scene probably by Claude-Joseph Vernet that was recorded by Sotira in the New Salon at Pavlino in 1838, now reframed to a design by Schinkel. The firescreen shows a lively depiction of a figure in Oriental costume restraining a rearing horse, appropriate to the Turkish character of the square central sofa and ottoman.

Schinkel's Schloss at Werki was mentioned in the 1914 edition of Baedeker's *Russia* (p. 39): "About 5 M. to the N. of Vilna (pleasant steamer trip) is the manor of *Verki*, picturesquely situated on the high right bank of the Viliya, with a garden in the English style."

Haase, the Russian artist who painted this view, was also responsible for the watercolors of Kamenka, the Wittgensteins' estate in the Ukraine (see no. W12). The details of his career have not yet come to light.

Literature: Praz, 1964, pl. 295.

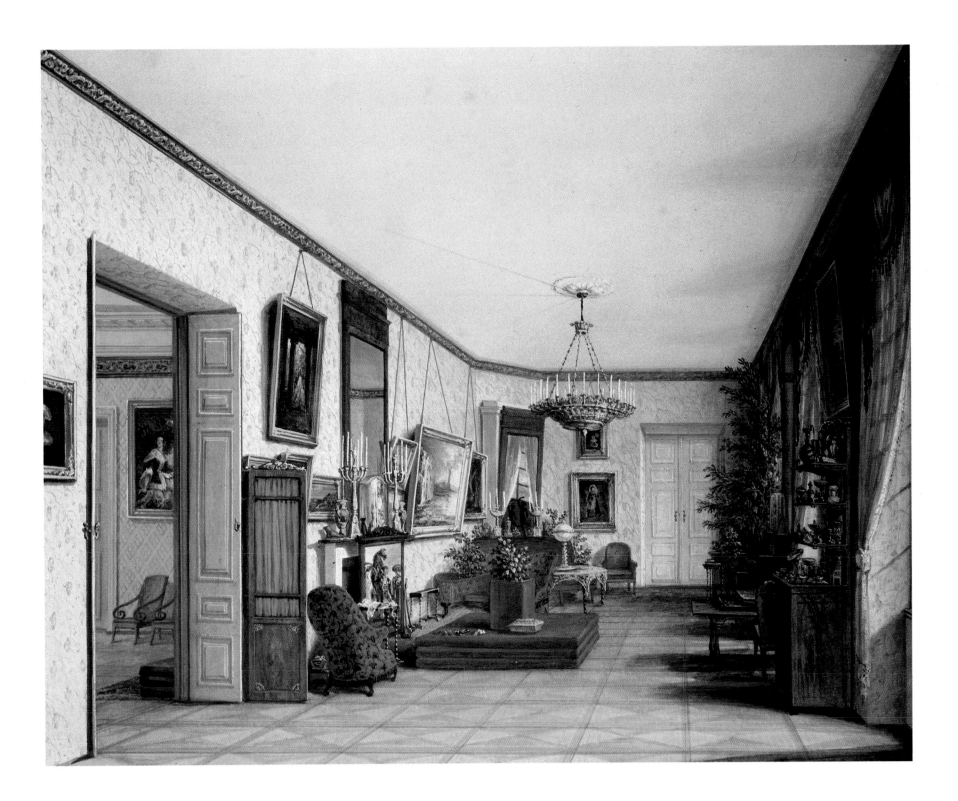

W20. *A Salon in the Wittgensteins' Berlin House, 1841*

FRIEDRICH WILHELM KLOSE (1804-63)

Watercolor and gouache, 9¼ x 11⁹⁄₁₆ in. (23.2 x 29.3 cm)
Signed lower left "F.W. Kloss," inscribed on the old mount
"Kloss / Salon à Berlin Janvier 1841"

Karl Friedrich Schinkel's hand is as apparent in the Salon as in the Bedroom of the Wittgensteins' Berlin house (cf. no. W6). Conspicuous in this blue-and-white room and in the adjoining pink boudoir are three examples of the leather-covered reclining chair originally devised about 1826 as an invalid reading chair for the ailing King Friedrich Wilhelm III of Prussia. Versions of this popular model were made for other members of the Prussian royal family (see Börsch-Supan, 1976, pl. 13). But for their presence in decorative schemes by Schinkel one might mistake them for English Regency club chairs, which were indeed his source of inspiration. In this long, narrow room, the three high windows in the right-hand wall are separated by consoles below pier glasses matched by a third on the opposite wall; these are from a design originally made for Schloss Tegel, the house outside Berlin remodelled by Schinkel for Wilhelm von Humboldt in 1824.

Across the far corner of the room is an arch-topped recess containing a tall white ceramic stove partly hidden behind a screen of climbing plants. It is a measure of the attention to detail that has been lavished on this room that the pattern of the coffering on the ceiling takes account of this; the three remaining corners are filled with triangular compartments in order to preserve the symmetry of the grid.

The rest of the furniture, the picture frames, the gilt and patinated bronze chandelier, the two-handled vase above the stove, and the whole scheme of decoration even down to the pattern of the parquet are either by Schinkel himself or directly inspired by him. By 1841, the date of this drawing, many of his designs had been published (for example by Ludwig Lohde, *Schinkel's Möbelentwurfen*, 1835-37), and Berlin workshops like those of J.C. Sewening and Karl Wanschaff were making up the furniture. The blue-and-white scheme is continued in the curtains and much of the upholstery, but the effect is not intimidatingly formal. However exalted his patron, Schinkel believed in keeping to a modest domestic scale.

Friedrich Wilhelm Klose (or Kloss) was a near contemporary of Eduard Gaertner. His training and career followed similar lines, and he too numbered among his patrons the Prussian royal family (cf. no. 23). Many of his drawings record interiors designed by Schinkel, including the Chamois Room in the Kronprinzenpalais (see Gere, 1989, pl. 223), Schinkel's first recorded royal commission, which he received in 1808 (*Karl Friedrich Schinkel*, Victoria and Albert Museum, 1991, no. 33).

Literature: Praz, 1964, pl. 296.

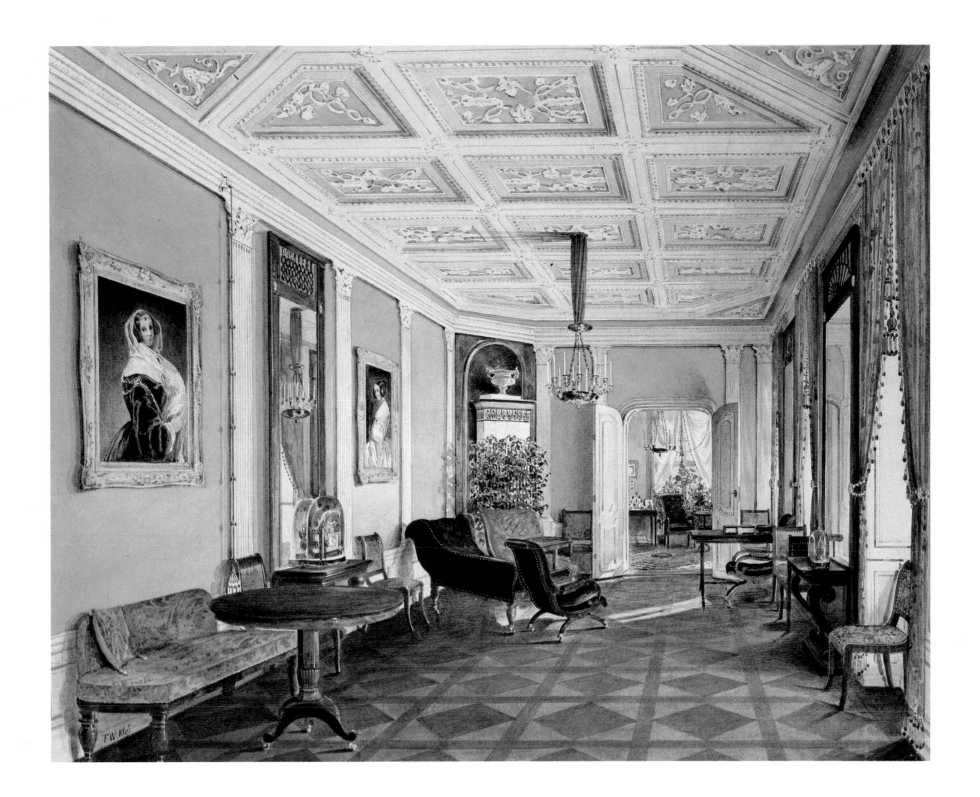

W21. *A Room in the Palazzo Parisani, Rome, 1842*

KARL ANDREEVIC BEINE (c. 1815-58)

Watercolor and gouache with pen and ink, 11 x 13¾ in. (27.9 x 34.8 cm)
Inscribed on the old mount "Beyne / Palazzo Parisani à Rome Janvier 1842"

The Palazzo Parisani was demolished in the early years of the present century. It stood near the Corso in the Piazza S. Claudio, now a characterless short street connecting the Largo Chigi with the Piazza S. Silvestro. The *salone* is clearly a magnificent example of late eighteenth-century Roman Neoclassicism. The walls, clad in yellow Siena marble or painted in trompe l'oeil, and divided by flat pilasters with white Corinthian capitals, are left almost bare, apart from an elegant mahogany-framed overmantel mirror and a clearly contemporary portrait of a man. The vignette of a mother and child in an ormolu-mounted frame on a side table to the left of the fireplace was a souvenir of Russia that later in the year was to accompany the Wittgenstein family to Castellammare and then to Paris (no. W25). In the center of the coffered ceiling with plasterwork motifs within each compartment (also possibly illusionistic) is a painting of a mythological or allegorical subject, which seems to involve a galloping horse and a reclining nude woman. Two gilt and patinated bronze chandeliers are suspended from the ceiling, and there would have been a third hung symmetrically at the near end of the room. Great care has been taken not to damage or obscure the ceiling painting.

The furnishings are not the matching suite that would have been appropriate to the austere Neoclassicism of the decoration. This miscellaneous collection of upholstered chairs and sofas, occasional tables, and the indispensable pianoforte seems to be contemporary with the drawing. The installation has an impermanent look, emphasized by the fact that the moonlit seascape is propped on an easel beside the window rather than hung on a wall. The curtains are white, probably of muslin like those contrived by Lady Blessington, whose househunting in Rome had proved a dispiriting experience (*The Idler in Italy*, 1839, p. 387). Her apartments once secured were dirty and very inadequately equipped, "But murmuring will not render things any better; so *courage*! and to-morrow I will try if, with the aid of countless yards of white muslin, for clean window curtains, innumerable table covers, with which we are always provided, to conceal the ill-polished wood; and dozens of eider-down pillows, smartly cased, to lay along the hard backs of the miserable half-stuffed sofas, I can render the three saloons habitable."

On the small round table in the foreground is a miniature version of the *Dying Gladiator* from the Capitoline Museum in Rome. Behind the winged armchair, which has beside it a pair to the round table, is a lifesize *Venus* possibly after the Antique, though the Wittgensteins were considerable patrons and may have bought it from one of the many talented sculptors working in Rome during this period.

The Russian architect Karl Andreevic Beine (or Beyne) was trained in St. Petersburg and spent his early career there, but he travelled very widely in Egypt, Palestine, Turkey, and Greece as well as western Europe. He was a talented architectural draughtsman and accomplished a considerable body of work including a great many interior views, of which this and one of the Villa Dackenhausen sitting room (Praz, 1964, pl. 11) and terrace are attractive examples.

Literature: Praz, 1964, pl. 297.

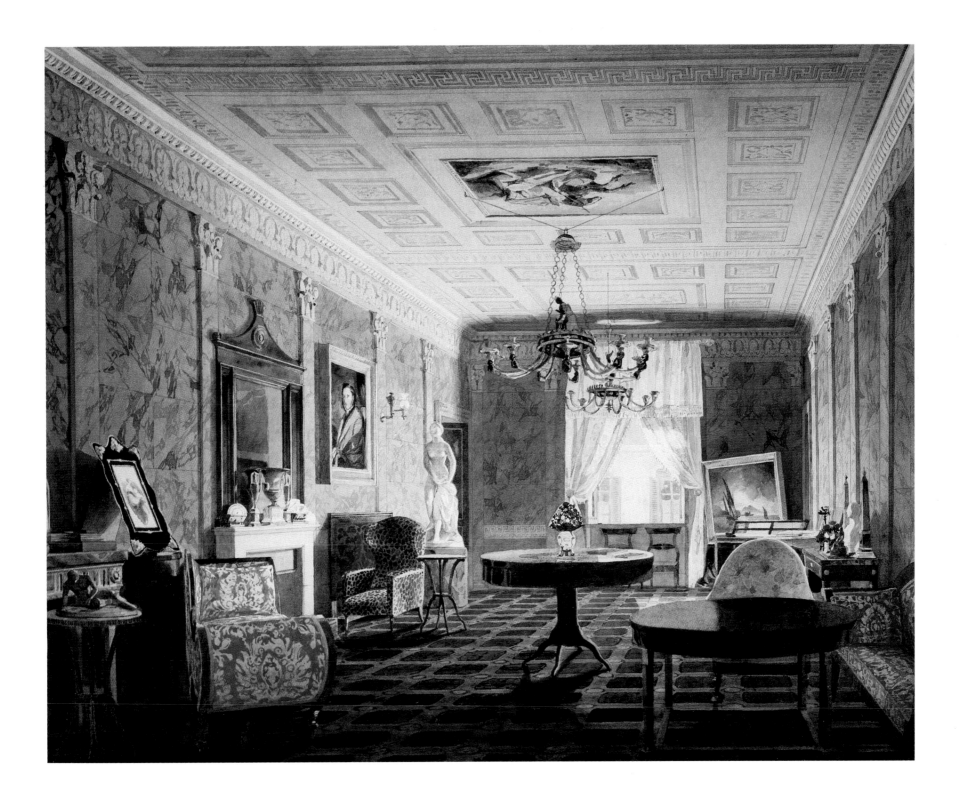

W22. *A Room in the Palazzo Caramanico, Naples, 1842*

AUGUSTO CIULI (fl. 1840s)

Watercolor and gouache, 13¼ x 17¹³/₁₆ in. (33.7 x 45.2 cm) Signed and dated lower left "Au. Ciuli 1842," inscribed on the old mount "Ciuli / Palazzo Caramanico à Naples Avril, 1842"

As Théophile Gautier's *Voyage en Russie* illuminates practical details of life in Russia, so the Countess of Blessington's experiences recorded in *The Idler in Italy* (1839, p. 245) reveal the difficulties of housekeeping in Naples. "I devoted a considerable portion of yesterday to house-hunting; and though I have seen many fine palaces, I have not met with one quite to my fancy, for all are fitted up more with a view to show than comfort." She finally settled on the Palazzo Belvedere at Vomero: "I long to take possession of it; but alas! some days must elapse before it can be made ready for our reception, for it requires so many of the comforts indispensable to an English family, that their absence could not be compensated by the painted and gilded ceilings, oriental alabaster architraves, marble floors, pictures, and statues, with which the palace is abundantly supplied. The Prince and Princess Belvedere looked surprised when I had an upholsterer to note down the different articles of furniture requisite for him to supply; as they thought the heavy, cumbrous gilt chairs and sofas, ranged in formal rows along the apartments, and the scanty furniture of the bedrooms, amply sufficient for our wants, as they had been for theirs."

The Wittgensteins might have said the same about the Palazzo Caramanico, in which they have done their best to domesticate the large *salone* with its painted ceiling and suite of white-and-gold Neoclassical couch, chairs, and consoles in the Egyptian style, "ranged in formal rows," by importing comfortable upholstered sofas and chairs, the indispensable pianoforte, and some framed portraits to stand on the side tables. The armchair in the center, upholstered in purplish-red, must have been transported from Germany, since it is a version of the one designed by Schinkel for Prince Karl of Prussia and used at Schloss Klein-Glienicke and in the tented bedroom at Schloss Charlottenhof (see *The Age of Neo-Classicism*, Arts Council of Great Britain, 1972, no. 1903, and *Karl Friedrich Schinkel*, Victoria and Albert Museum, 1991, no. 73a). Its shape derives from the club furniture so much admired by Schinkel on his English tour in 1826, particularly the chairs supplied to the Athenaeum Club by Holland & Sons and probably designed by the architect of the building, Decimus Burton.

It is not surprising to find examples of the Italian Chiavari type of lightweight portable chair in a Neapolitan *salone*, but their appearance here may also be due to Schinkel's influence. Chairs of this type had been made since the early years of the nineteenth century at Chiavari, near Genoa, and the pattern was used when Schinkel furnished Charlottenhof for Crown Prince Friedrich Wilhelm in 1826. The Prince had seen such chairs in use when visiting the royal palace in Naples in 1822 and had brought some back to Germany. Their combination of utility and elegance had wide appeal, and similar ones can be seen in views of the rooms furnished for Napoleon III and the Empress Eugénie at St. Cloud and at Fontainebleau (cf. Praz, 1964, pls. 355-61). When the Wittgenstein family went to the Villa Dackenhausen at nearby Castellammare later in the summer of 1842 they took with them the chintz-upholstered sofa, the Schinkel easy chair, and the Chiavari chairs (Praz, pl. 11). The villa had been built as recently as 1836 and may still have lacked some of the furniture needed for a large household.

The Wittgensteins imparted a Russian flavor to this room in a Neapolitan palace by the unusually generous provision of light. There are at least six pairs of wall-mounted Argand lamps, a pair of table oil lamps, and a two-branched candelabrum or table lamp, as well as a crystal chandelier hanging from the painted ceiling.

The artist Augusto Ciuli is not recorded in the standard reference works and may be a local professional. Later in the summer of 1842 Ciuli painted a view of the Villa Dackenhausen and the terrace with an awning shading a table set for an alfresco meal, but the Dackenhausen sitting room was painted by the admired Russian architect Karl Andreevic Beine, who had painted the *salone* in the Wittgensteins' Roman palazzo in the previous winter (no. W21).

Literature: Praz, 1964, pl. 12.

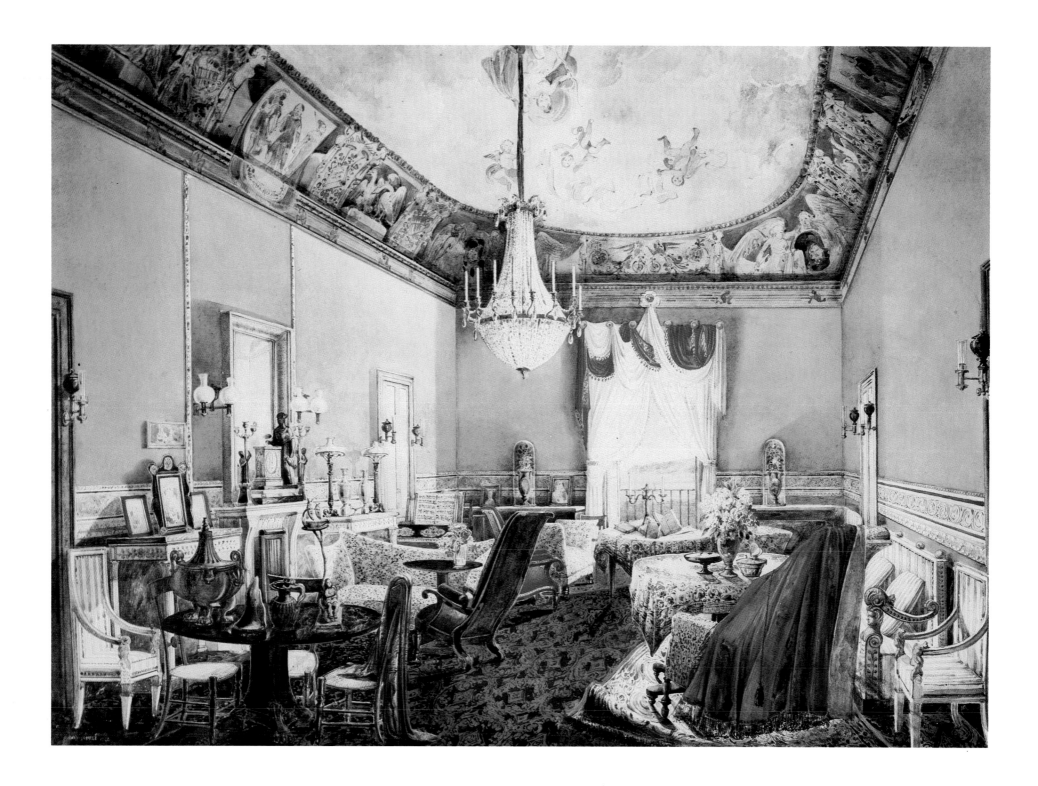

W23. *A Salon in a House near Bonn, 1842*

GERMAN

Watercolor, 8¹⁵⁄₁₆ x 12⁹⁄₁₆ in. (22.7 x 31.9 cm)
Inscribed on the old mount "Salon de la Maison près de Bonn Septembre 1842"

It is fortunate that members of the Wittgenstein family and their entourage should feature prominently in this room, where there is little in the way of remarkable furniture or decoration. In the absence of a fireplace that would have served as a focal point, the furniture is placed informally, oriented to the windows and French door through which can be glimpsed a prospect of fields and distant mountains. The three matching sofas with arms in the form of bolsters are reminiscent of the fashionable "Turkish" ottoman, but their high backs give them an unmistakably European look. Sofas of this hybrid type were made about 1825 by the Viennese designer Joseph Danhauser, and a similar model can be seen in the window embrasure of the Archduchess Sophie's boudoir in the Laxenburg Palace (*Vienna in the Age of Schubert*, Victoria and Albert Museum, 1979, pl. 10). The side chairs and the round table found here are like those in the Wittgensteins' house in Potsdam (cf. no. W7) and may have been brought to Bonn to supplement the furnishings of a inadequately equipped country house. It is unusual that there should be neither paintings nor plants to adorn this spacious room, and that the polished boards are bare of rugs or carpet. The whole arrangement has a temporary air, though a piano has once again been deemed essential. Also unusually, the piano is an upright; the handsome instruments in the Wittgensteins' other houses were grand pianos suitable for professional recitals. In the 1840s the upright piano was still something of an innovation, not having been invented until 1800; though its tone was less powerful than that of the grand piano it was judged to be no less pleasing, and the upright form was more convenient to transport.

As in many of the interiors from the album, children are present, and the man seated at a writing desk in the adjoining room — possibly Prince Wittgenstein himself — is turning to look at this scene of tranquil activity. Though the room is so sparsely furnished, the decoration, as far as it goes, is in the latest style; a nice touch is the accord between the Gothic-inspired ivy-garlanded wallpaper and the ceiling border and central rose of trailing "Gothic" foliage. The gilded and carved cornice poles, also in the Gothic taste, seem to call for something more elaborate than the plain, almost skimpy, draperies, and the temporary character of the curtains is emphasized by the way they are bunched up at the hem to hang clear of the floor.

This watercolor has the precision and careful tonality of the views by Eduard Gaertner, but it is dry and thin in application and without his distinguishing fullness of color and depth of contrast between light and shade. By 1842 Gaertner would have had a considerable influence on his fellow professionals in Germany; on the other hand the present drawing could be an amateur work executed under his guidance, though both of the watercolors by him in the album were painted in 1836, six years earlier.

Literature: Praz, 1964, pl. 299.

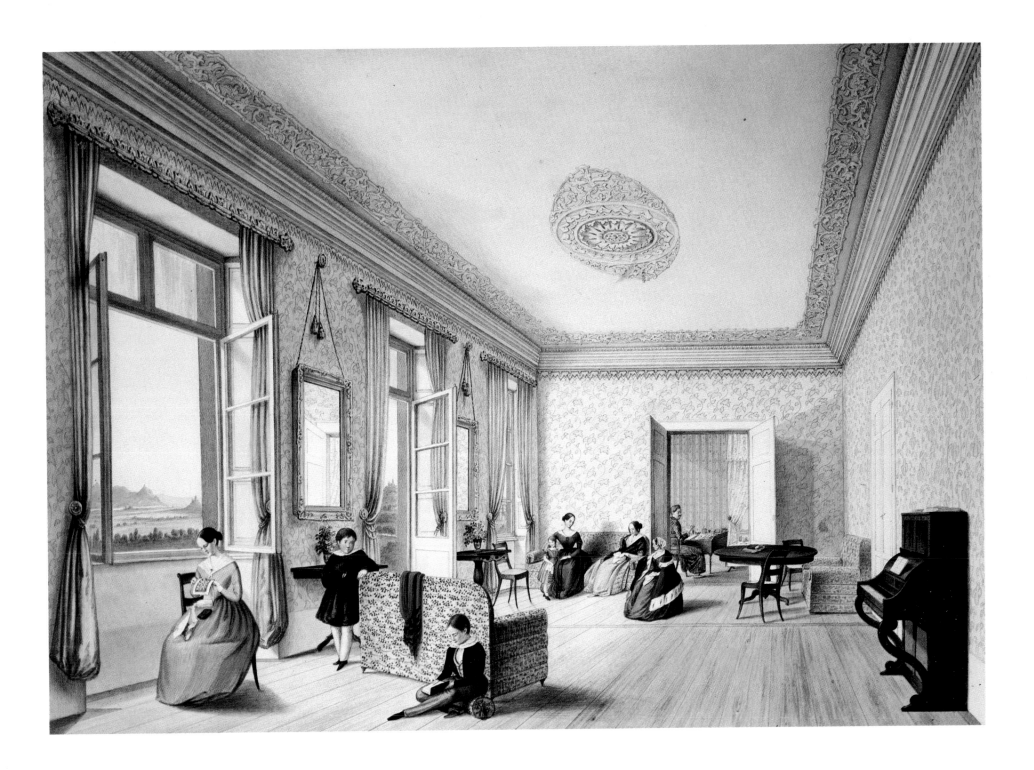

W24. *A Salon in a House in the Place Vendôme, Paris, 1843*

FRANÇOIS-ÉTIENNE VILLERET (1800-66)

Watercolor and gouache, 8⁷⁄₁₆ x 11¹⁵⁄₁₆ in. (21.5 x 30.4 cm)
Signed and dated lower left "Villeret 1843," inscribed on the old mount "Villeret / Salon à Paris — Place Vendôme — Avril 1843"

Though the façades of the place Vendôme, designed by Jules-Hardouin Mansart and his pupil Germain Boffrand, were completed in the early years of the eighteenth century, many of the houses behind them were not built until later. Unfortunately, nothing on this drawing or on the view of the place Vendôme formerly in the album enables the house occupied by the Wittgensteins in 1843 to be identified. Through the doorway can be seen the boudoir represented in no. W25.

This drawing is of interest as a record of a Neoclassical decorative scheme of about 1770. The interiors of many of the houses on the place Vendôme have been destroyed, as Georges Pillement complained (*Les Hôtels d'Auteuil au Palais-Royal*, 1952, pp. 70-71), by "cet acharnement de certains amateurs, encouragés par les propriétaires et les antiquaires qui cherchent un profit, à retirer du cadre pour lequel ils ont été créés les chefs-d'oeuvre de notre art décoratif. La place Vendôme, comme la place Royale ou la place des Victoires, devrait offrir des ensembles incomparables de l'art de nos anciens décorateurs; cependent, les unes comme les autres, elles n'offrent plus que de rares épaves dans un écrin vide."

The console table and armchairs with sphinx supports that match the figures flanking the fireplace and the plain side chairs are in the style of the furniture supplied by Jacob-Desmalter and Charles Lemarchand, probably after 1810, for the second stage of decoration at Malmaison. The candelabra in the form of winged Victories in gilt and patinated bronze are based on the popular model designed by Percier and made by Thomire, also for Malmaison (cf. fig. 1). The curtains are in an asymmetrical arrangement, another late Empire device in which one side is made of velvet or some other colored cloth and the other of white lace or muslin, sometimes finished with a patterned border as here. The only later pieces of furniture to have been added are the red-upholstered, serpentine, three-seated *indiscret* and the upright pianoforte. The *indiscret* may have been supplied by the Maison Jeanselme, founded in 1824 and one of the greatest names in mid nineteenth-century French cabinetmaking. A two-seater *confident* of the same pattern by Jeanselme was illustrated in Pasquier's *Cahier de Dessins d'Ameublement* about 1840. Jeanselme was *Fournisseur du Mobilier de la Couronne* to Louis-Philippe, specializing in seat furniture; only exceptionally did the firm supply the other furnishings of a room. Jeanselme continued to enjoy imperial favor during the Second Empire with commissions for furnishing the palaces of Fontainebleau and Compiègne and the Palais-Royal.

Literature: Praz, 1964, pl. 302.

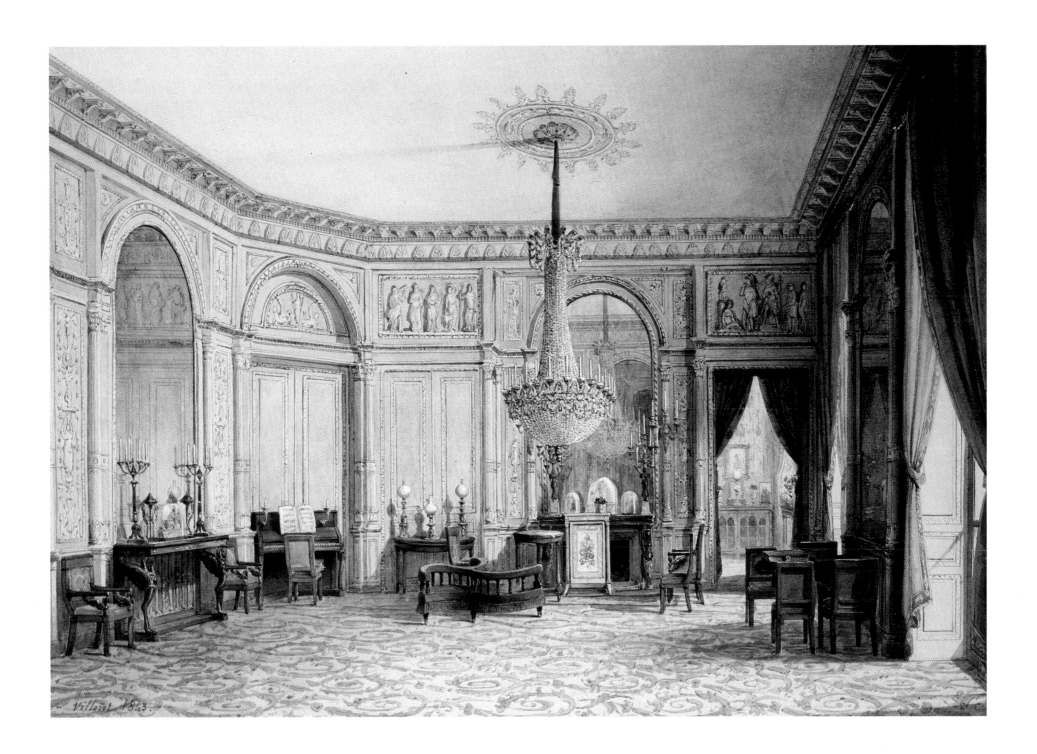

Villeret 1843

W25. *The Boudoir of Princess Wittgenstein in the Place Vendôme, Paris, 1842 or 1843*

FRANÇOIS-ÉTIENNE VILLERET (1800-66)

Watercolor and gouache, 10⅝ x 9⅝ in. (27.0 x 24.4 cm)
Signed and dated lower left "Villeret 1843," inscribed on the old mount "Villeret / Boudoir de la Princesse à Paris — Novembre 1842"

In the center on each side of this continuously draped narrow room the curtains are caught back to reveal large sheets of mirror glass, one over the writing table and the other forming an overmantel above the fireplace opposite. They give an illusion of space in an oppressively upholstered room into which the heavily draped window embrasure admits little light. The double doors at the near end of the left-hand wall, also framed by looped-back curtains, lead from the salon (no. W24). The upholstered effect is emphasized by the allover floral pattern of the carpet, which matches the fabric in color and style.

The fashion for tenting or draping boudoirs and bedrooms came in during the Empire period, inspired by Napoleon's campaign tent with its striped lining. Percier and Fontaine's tented council room at Malmaison was much copied by, among others, Karl Friedrich Schinkel, who designed a tented bedroom striped in blue and white for the palace of Charlottenhof at Potsdam. The walls of Napoleon's and Josephine's bedrooms at Malmaison were hung with draperies. These again inspired the "Malmaison" room at the Hofburg in Vienna (fig. 14), as well as Schinkel's elegant white-hung bedroom for Queen Luise of Prussia (1810) and Princess Augusta's exquisite "muslin cabinet" in the Kronprinzenpalais (1829; Thornton, 1987, pls. 252, 323). Tented and fabric-hung rooms were the fashion all over Europe in the 1820s and 1830s; Princess Wittgenstein's bathroom at Pavlino (no.

W4) and the Neoclassical salon adjoining the Gothic study in the Bariatinsky-Sergeevskaya house (no. W13) were both hung with festooned fabric. The use of flower-patterned fabric and heavy festoons finished with silk cord and tassels at the window end of the Princess' boudoir is a characteristically French development of the idea. These later rooms follow closely the schemes for boudoirs included in Le Bouteiller's *Journal de l'Industrie et des Arts utiles* (Paris, 1840; Thornton, 1987, pls. 346-47). The formal grandeur of the room in this drawing, with its red velvet upholstery, the Boulle furniture, and the works of art including a tiny painting in a carved Gothic frame, contrasts with another boudoir drawn by Villeret a few years later, in 1848, a room completely tented but hung with less heavy drapery and furnished with easy chairs upholstered in pale blue-and-white striped and floral-patterned fabric. The red velvet chairs with candy-twist turned black frames in the seventeenth-century style are like an example by Jeanselme Frères, also upholstered in red, published about 1840 in Pasquier's *Cahier de Dessins d'Ameublement*. In the 1840s the Jeanselme workshops were already making chairs in the styles of the Renaissance and the period of Louis XIV.

In the place Vendôme boudoir, the Louis XV-style ormolu-mounted writing table is matched by three massive Boulle cabinets, one with two triple-paned doors and a pair facing one another at the farther end of the room. The technique of decorating furniture with marquetry of brass and tortoiseshell perfected by André-Charles Boulle in the reign of Louis XIV remained in fashion until the Revolution. Under the Directoire and the Empire it came to seem old-fashioned and characteristic of the *ancien régime*, but the period of the Regency in England and the Restoration in France saw a revival of interest which gathered momentum through the 1830s and 1840s. The

Boulle tables, commodes, and cabinets made by nineteenth-century *ébénistes* like Louis Le Gaigneur were admired for the perfection of their craftsmanship and remained in favor for grand formal rooms until the turn of the century. François-Étienne Villeret excelled at rendering the intricacies of festooned and patterned fabric and of chiselled and inlaid ornamental furniture. This is the most accomplished of the five drawings that he made for the Wittgenstein Album.

Literature: Praz, 1964, pl. 6.

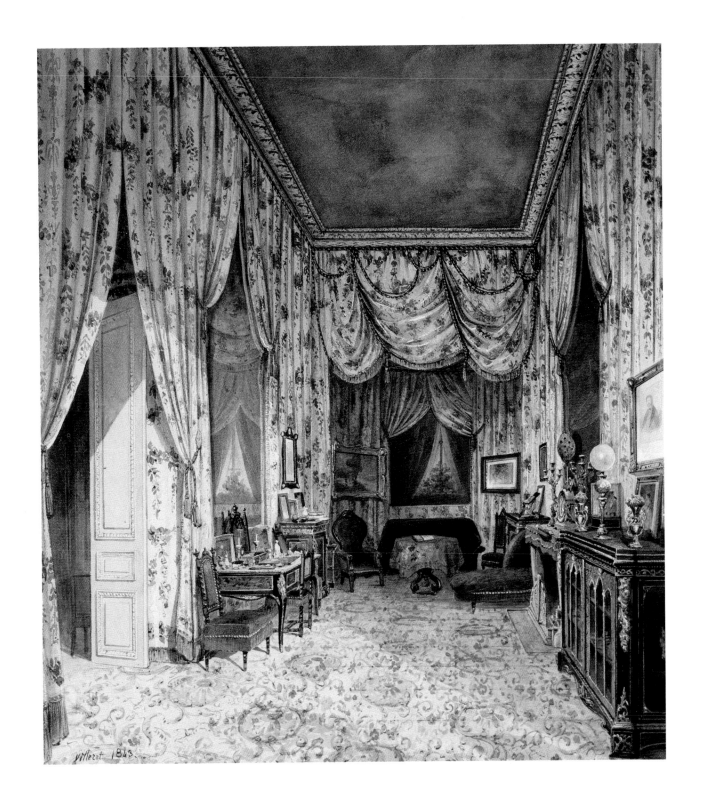

W26. *A Salon in the Castel Madrid, Paris, 1843*

FRANÇOIS-ÉTIENNE VILLERET (1800-66)

Watercolor and gouache, 8⅝ x 11¹³⁄₁₆ in. (21.8 x 30.0 cm)
Signed and dated lower left "Villeret 1843," inscribed on the
old mount "Villeret / Salon de Castel Madrid"

A view of a three-story Italianate house with green shutters formerly in the Wittgenstein Album is inscribed "Castel Madrid au Bois de Boulogne près Paris." The house was evidently on the site of François I's Château de Madrid, which had stood on the west side of the Bois de Boulogne. The château was sold by Louis XVI in 1788, but at the time of the Revolution it was repossessed by the State and resold to a speculator who plundered the interior and completed the destruction of the long-derelict building. The former dependencies and stables became respectively a restaurant and a sanatorium, and the remaining land was sold to developers. Before the 1850s when the Bois was laid out as a public park it was described as "a resort of footpads and a haunt of duellists"; but by 1843 it must have been a fairly attractive location if the Wittgensteins chose to live there.

The family took some furniture with them when moving house: the three Boulle cabinets from the boudoir in the place Vendôme (see no. W25) can be recognized here, and the tiny painting in its carved Gothic frame now hangs beside the opening into the room beyond. The late Empire fashion of asymmetrical window-curtaining with the heavy cloth on one side and muslin on the other is used here as in the salon in the place Vendôme. The floor is of parquet in a herringbone pattern. A floral needlework rug is in front of the fireplace, and under the chaise longue is a curious pictorial rug, tapestry-woven with a figure in peasant costume in front of a building.

On the far wall in the room beyond can be seen the portrait of Princess Leonilla that Franz Xaver Winterhalter painted in Paris in 1843 (now in the J. Paul Getty Museum at Malibu). She is reclining Turkish-style in a shimmering white dress with a flowing pink sash, a distant view of the sea beyond. The painting was regarded as one of Winterhalter's most daring conceptions, and it was said that he was in love with his sitter. The brilliant colors of the painting with its wide expanse of blue sky are echoed by the bright blue upholstery of the furniture at that end of the room. The winged Victory candelabra may have been brought from the place Vendôme salon, and the jardinière filled with flowering plants is perhaps the one that stood in the window of the boudoir there.

Literature: Praz, 1964, pl. 300.

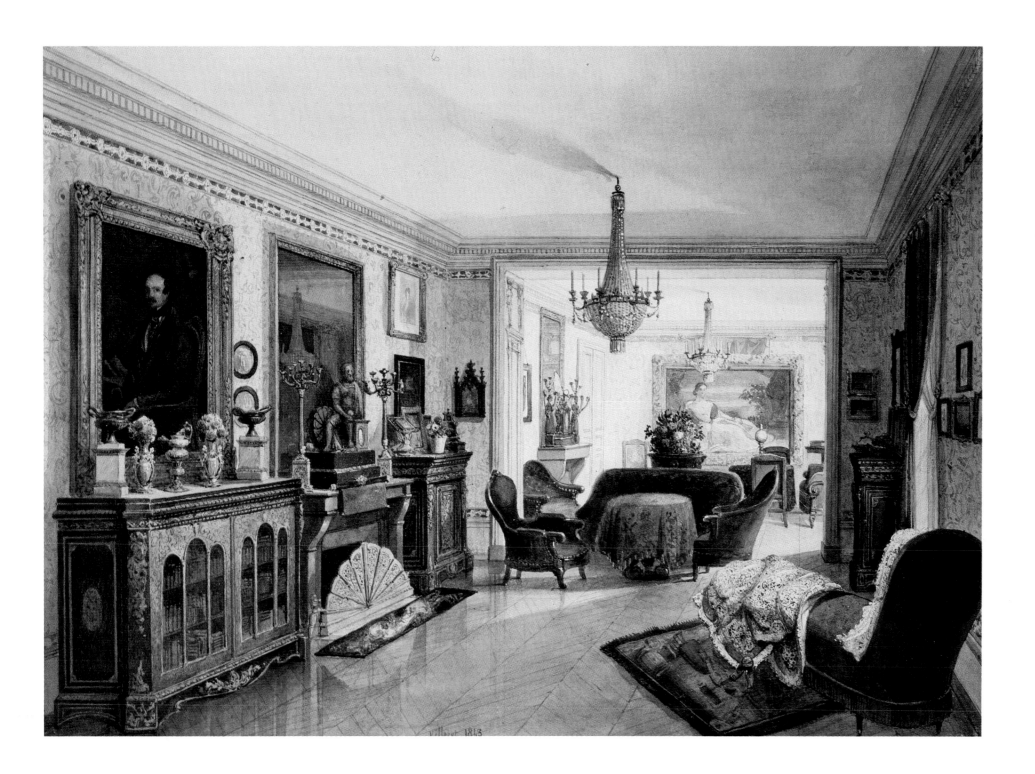

Villaret 1843

W27. *A Bedroom in the Castel Madrid, Paris, 1843*

FRANÇOIS-ÉTIENNE VILLERET (1800-66)

Watercolor and gouache, 9⅛ x 12¼ in. (23.2 x 31.1 cm)
Signed and dated lower right "Villeret 1843," inscribed on the old mount "Villeret / Chambre à coucher de Castel Madrid / 3 Juillet 1843"

The color scheme of the Castel Madrid bedroom is green, ivory, and rose-pink. The dark green of the velvet window curtains and bed draperies is matched by the three-fold screen beyond the bed and the upholstery on the scoop-backed, mahogany-framed chairs. The walls, woodwork, and ceiling are ivory-colored, and the wallpaper is delicately patterned in grey. The bedspreads striped in green, pink, and buff were clearly chosen to match the fitted carpet, which is woven in alternating wide and narrow stripes of the same colors.

The arrangement of the bedroom is very advanced. Twin beds do not appear in furnishing and decoration publications until the 1870s. The single half-tester is a vestige of an earlier type of bed, and emphasizes the newness of this arrangement. There are no night tables, only a chair beside the right-hand bed with a large watch-shaped clock hanging from the back rail. The screen conceals a cheval glass or *psyche* and may have enclosed a dressing area with a washstand. The toilet table between the windows, covered with a frilled "petticoat," is of the type known as a *duchesse*. It is equipped with a silver jug and basin. The ebony casket on the occasional table in the near window, inlaid with ivory or silver and with an ivory or silver figure of a kneeling angel on the lid, is an example of the newly fashionable Renaissance Revival taste. In the far corner an *encoignure* with a scrolled superstructure of two shelves supports more precious ornaments, including a diptych frame of chased gold. Between the *encoignure* and the window on the far wall a worktable stands beneath an oval portrait drawing in a carved frame and a bracket supporting a gilded figure of a standing episcopal saint making a gesture of benediction.

This drawing is the last interior in the Wittgenstein Album and is dated with unusual precision. The watercolors in the album reflect a tranquil period of European history. The devastation of the Napoleonic wars had been largely repaired, and 1848 — the "Year of Revolutions" — was still five years in the future. French decorative art in the first half of the nineteenth century has until very recently been seen in terms of the two Napoleonic Empires. Even so, French influence was still paramount throughout Europe; to some extent the 1830s and 1840s are a lost period in decorative history. The Wittgensteins were clearly active and adventurous patrons of contemporary artists and architects, and for these drawings of their houses in Russia, Germany, Italy, and France they employed a wide range of professional practitioners in this specialized branch of painting. Only Sotira with seven examples seems to have been more admired by them than Villeret, who did all but one of the Parisian interiors.

Literature: Praz, 1964, pl. 301.

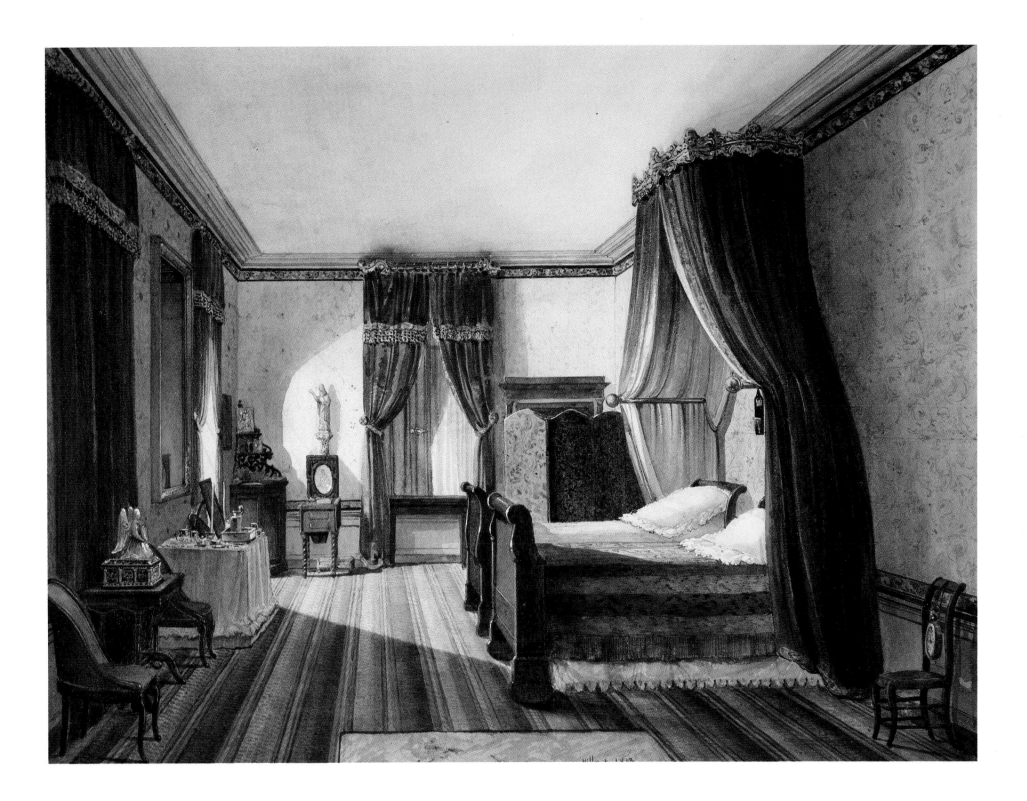

Selected Bibliography

Note: The standard references used for biographical information on the artists have been Emmanuel Bénézit, *Dictionnaire critique et documentaire des peintres, sculpteurs, dessinateurs et graveurs,* and Ulrich Thieme and Felix Becker, *Allgemeines Lexikon der bildenden Künstler.*

Agius, Pauline, *Ackermann's Regency Furniture and Interiors,* Marlborough, 1984

Aldrich, Megan, ed., *The Craces: Royal Decorators, 1768-1899,* London, 1990

Börsch-Supan, Helmut, *Marmorsaal und Blaues Zimmer,* Berlin, 1976

Clemmensen, Tove, *Skaebner og Interiorer* (Danish Interiors from Baroque to Arts and Crafts), Copenhagen, 1984

Cartwright-Hignett, Elisabeth, *Lili at Aynho,* London, 1989

Chenevière, Antoine, *Russian Furniture: The Golden Age 1780-1840,* London, 1988

Collard, Frances, *Regency Furniture,* Woodbridge, 1985

Cornforth, John, *English Interiors 1790-1848: The Quest for Comfort,* London, 1978

Davidson, Caroline, *The World of Mary Ellen Best,* London, 1986

Gere, Charlotte, *Nineteenth-Century Decoration: The Art of the Interior,* London, 1989

Grandjean, Serge, *Empire Furniture,* London, 1966

Himmelheber, Georg, and Simon Jervis, trans, *Biedermeier Furniture,* London, 1974

Himmelheber, Georg, *Biedermeier: Architecture, Painting, Sculpture, Decorative Arts, Fashion,* London, 1989

Lasdun, Susan, *Victorians at Home,* London, 1981

Lynn, Catherine, *Wallpaper in America: From Seventeenth Century to World War I,* New York, 1980

Mayhew, E.M., and M. Myers, *A Documentary History of American Interiors,* New York, 1980

Morley, John, *The Making of the Royal Pavilion Brighton,* London, 1984

Ottomeyer, Hans, *Das Wittelsbacher Album,* Munich, 1974

Praz, Mario, *An Illustrated History of Interior Decoration from Pompeii to Art Nouveau,* London, 1964

Seaman, W.A.L., and J.R. Sewell, *Russian Journal of Lady Londonderry,* London, 1973

Snodin, Michael, ed., *Karl Friedrich Schinkel: A Universal Man,* London, 1991

Teynac, Françoise, Pierre Nolet, and Jean-Denis Vivien, *Wallpaper: A History,* London, 1982

Thornton, Peter, *Authentic Decor: The Domestic Interior, 1620-1920,* London, 1984

Voronchina, A.N., *Views of the Hermitage and Winter Palace,* Moscow, 1983

Wainwright, Clive, intro., *George Bullock: Cabinet Maker,* London, 1988

Wainwright, Clive, *The Romantic Interior,* London, 1989

Watkin, David, *Thomas Hope and the Neo-classical Ideal,* London, 1968

Watkin, David, *Royal Interiors of Regency England,* London, 1984

Wharton, Edith, and Odgen Codman, *The Decoration of Houses,* New York, 1897; reprinted New York, 1978

Wiese, Erich, *Biedermeierreise durch Schlesien,* Darmstadt, 1966

Exhibition Catalogues

Drawings from the Collection of Mr. and Mrs. Eugene Victor Thaw: Part II, Pierpont Morgan Library, New York, 1985

18th and 19th C. Watercolors of European Domestic Interiors, Hartwick College, Oneonta, New York, 1987

Index of Artists Represented

Finito di stampare nel mese di Aprile 1992 da
Arti Grafiche Motta - Milano
Stampato in Italia - Printed in Italy